HEALTH
HAZARDS
□ ## FOR □
PHOTOGRAPHERS

HEALTH HAZARDS FOR PHOTOGRAPHERS

Siegfried Rempel and Wolfgang Rempel

LYONS & BURFORD, PUBLISHERS

NEW YORK

Printed in the United States of America.

10 9 8 7 6 5 4 3 2 1

Design by Ruth Kolbert

Library of Congress Cataloging-inPublication Data

Rempel, Siegfried
 Health hazards for photographers / by Siegfried and Wolfgang Rempel.
 p. cm.
 Includes bibliographical references.
 ISBN 1-55821-181-0
 1. Photographic chemicals—Safety measures. 2. Photographic chemicals—Health aspects. I. Rempel, Wolfgang. II. Title.
TR212.R46 1993
771'.5'0289—dc20 *92-37373*
 CIP

The authors would like to acknowledge the Photo Lab Index, Morgan & Morgan, of Dobbs Ferry, NY for the use of many of the forumlae appearing in the text; and Veritas Inc., for permission to use product illustrations from their 1992 catalog.

Figures adapted by Terry Rempel-Mroz

DISCLAIMER

The information provided in this book has been obtained from sources believed to be reliable. No warranty, expressed or implied, is made regarding the accuracy of this information or concerning the conditions or use of the chemicals and products in the user's control. It is the user's obligation to determine the conditions of safe use of the chemicals and products contained within this book.

*Dedicated
to our parents, John and Maria,
and to Terry and Caleb, who patiently
endured the preparation of this book.*

CONTENTS

❑ ❑ ❑

PREFACE

The motivation for writing this book included several different points, but the most important by far was the need to provide an entry-level text for photographers working with photographic chemistry without a clear idea of the chemical hazards involved. Other texts and information sources are available, but this book provides an introduction to accessing and using those other resources.

The nature of photography, the manner in which it it taught and practiced, can result in situations in which the photographic chemistry responsible for the formation of the image is not fully understood in terms of the chemical hazards involved. The user of these chemical solutions may not be aware of the specific chemical hazards associated with the materials even though more and more information is being required from chemical suppliers, photographic manufacturers, and distributers.

Students of photography—many of whom have an art rather than science background—practicing amateurs, and professional photographers need to develop an understanding of the hazards in photography. The approach in this book is to review the general effects of chemicals on the human body in the first chapter and cover darkroom safety issues in the second. The third and fourth chapters deal with the basic photographic processes, with an emphasis on black-and-white photography and the more common color chromogenic processes.

The information is presented in a format that should be familiar to photographers. The photographic topics are introduced by examining the basic processing sequence and detailing typical photographic formulas. The formulation of the specific processing baths is accompanied by chemical hazard descriptions for each component in the formula.

This approach provides both guidelines for safe practices with the most commonly used photographic processes and a framework for working with other photographic processes. The same approach can be used to compile chemical hazard information on other photographic processes.

Health, Safety, and the Photographer

INTRODUCTION

Significant changes have taken place in the recent past involving personal health and safety awareness. This awareness has now extended into arts, crafts, and recreational activity areas as well as the workplace. A remaining goal is to reach those people who use chemicals in an occasional or intermittent fashion: professional photographers who occasionally process their own images rather than using a commercial photo finisher, or students or amateurs who cannot afford the commercial processing option or enjoy the artistic freedom of fabricating the image by hand.

Casual users, including amateurs, may not realize the problems associated with the chemicals they are using. Or they may not have easy access to information concerning the safety or toxicity of particular chemical substances that are part of their photographic processing routines. In situations like this, the primary concern is exposure to hazards associated with those photographic chemicals.

The two major concerns in photographic health and safety are the poisonous nature of some of the chemicals and the design of the darkroom work space in which the chemicals are mixed and used. All chemicals should be handled and stored properly at all times and the darkroom should have the proper safety features required to deal with these chemicals.

The various aspects of safety discussed in this book are the same that apply in an industrial setting. The primary source for information con-

cerning chemical substances and their interaction with the human body is experience in industry. It is important to note, however, that the chemical substances of interest to photographers may not necessarily be found or documented in industrial use, so portions of the information record may not yet be complete.

The transformation of this industrial experience to information that will be useful to professional and amateur photographers is the goal of this book. Your health and safety need not be compromised because of your photographic profession or hobby. The information in this book has been compiled from a number of different sources. The updating of the hazards for various chemicals is an ongoing process, and the reader is obliged to consult the sources listed in the bibliography for updated information on any particular chemical being used.

CHEMICALS and PHOTOGRAPHY

Photography is based on the interaction of light and a photosensitive chemical compound. Many of these chemicals are harmful to the human body, so it is important for photographers to have a good working knowledge of the hazards associated with the particular chemicals that make up their working environment. Photographic chemicals can exert a number of different effects, ranging from dizziness to serious impairment and in some cases death. Information is needed to work safely and to understand what can happen when chemicals are mishandled or abused. Understanding these hazards gives you control over your environment.

There is no easy way to predict what effect any given chemical will have on an individual. Everyone responds to chemicals differently, based on the following factors:

- The physical state of the chemical. Chemicals delivered in aerosol mists are more easily inhaled and thus absorbed than the same chemical in a solid or liquid form.
- A liquid chemical's vapor pressure. A lower vapor pressure allows faster evaporation of the chemical and a rapid increase of the chemical's concentration in the air.
- The route of exposure to the chemical—that is direct pathways into the body and the bloodstream as opposed to indirect paths. Entry into the body via the lungs is a more direct path than through the skin.

- Individual susceptibility. Different people will have varying responses to a given chemical substance. Smokers, for example, tend to be more sensitive to respiratory exposures than non-smokers.
- The work (darkroom) environment. Adequate ventilation ensures minimal exposure to fumes and dusts, and good housekeeping habits reduce accidental contact. These points are particularly important during the mixing of chemicals to make stock and working-strength solutions.
- The time of exposure to the chemical substance. Generally, increased exposure results in increased risk.
- The amount of chemical the individual has been exposed to. Generally, the greater the exposure the greater the risk.

Depending on the combination and application of these factors, the body becomes stressed. The body's responses vary, but the manner in which it responds often provides the earliest indication that a problem has developed. It is very important that people recognize these warning signs.

In some cases the body does not respond immediately to the introduced stress but continues to cope for a period of time before an illness occurs. It may be weeks or even months later that the person experiences some form of discomfort and becomes ill.

It is not possible to look at the short- and long-term effects of each photographic chemical. In fact, the effects of some of the chemicals in use in modern photographic practice have not yet been defined. The more common effects of chemicals known to pose a health and safety hazard are discussed on a process-by-process basis.

There are two main types of health effects that can result when an individual is exposed to a chemical: local effects and poisoning effects.

Local effects are those that have an immediate and direct effect on some part of the body. For example, the immediate effect of spilling a concentrated acid on your hand is redness, swelling, and pain from the resulting chemical burn.

Poisoning can be considered to have occurred if the individual experiences pain, headaches, nausea, and vomiting. This form of poisoning most often occurs from working in a poorly ventilated area full of solvent fumes. One case of death from solvent poisoning occurred when an individual working with xylene was left in a poorly ventilated area for 18 hours. Xylene might be found in some photographic dyes or possibly in varnishes or cleaners used with prints or negatives.

HEALTH CONCERNS in PHOTOGRAPHY

HEAVY METALS

The heavy metals that have been studied have been observed to produce a wide range of biological effects. They tend to exert their toxic effects on a number of target organs and systems in the body. Because of the wide range of effects, researchers have determined that the critical organ is the one that is most sensitive to a heavy metal and shows adverse effects at the lowest dose.

The complete picture of the biological effects of most heavy metals is not well known except for lead, mercury, and cadmium. These three heavy metals have been studied extensively. The four major target organs for heavy metals are the central nervous system, the peripheral nerves, the kidneys, and the blood cells that are formed in bones.

The absorption of lead by inhalation or ingestion results in it being stored in the bone. The concentration of lead in the blood is an important means of determining recent lead exposure. Urine samples can also be taken to determine lead exposure. Lead poisoning affects the central nervous system, resulting in lead encephalopathy, a condition in which lead causes defects in the structure and function of the brain tissues upon long term-exposure. The individual will become restless and irritable, and have headaches, muscular tremors, and a loss of memory. One of the early manifestations of lead poisoning is anemia.

Mercury has been found to exist in three forms: elemental mercury, inorganic mercury, and organic mercury. All three forms are toxic to the human body. Mercury is absorbed through the respiratory tract. The degree of skin absorption is not known with any degree of precision.

Elemental mercury tends to go to the kidneys once it has been absorbed, but chronic mercury poisoning also results in a disease of the central nervous system. Mercury is similar to lead in that its toxic effects involve a number of organs and their systems. When mercury goes to the central nervous system it can cause hand tremors that can spread to other parts of the body. Some of the early signs of mercury poisoning are constriction of the visual field, loss of hearing, and loss of the senses of smell and taste. Incoordination, paralysis, and abnormal reflexes also occur. To a large extent the toxic effects of mercury depend on the form of mercury and the amount present.

ORGANIC COMPOUNDS

Organic solvents and volatile chemicals are of particular interest in dark-room safety because they evaporate into the atmosphere. These vapors can have a number of effects once sufficient amounts have been inhaled. One effect is irritation of the respiratory passageways upon inhalation. The degree of this effect depends on the vapor pressure of the chemical and the solubility of the chemical in the body. If the vapor pressure is low, the solvent will readily give off vapors into the room's environment. If the chemical is soluble in blood, it will be rapidly absorbed into the body.

If the solvent is highly water soluble, it can dissolve or mix in water-based solutions, and the vapors will dissolve in the upper respiratory tract. Those vapors that are moderately water soluble will dissolve in the respiratory tract and lungs. Vapors that are not water soluble, for example, the organic hydrocarbons such as gasoline or hexane, will dissolve only in the deep recesses of the lungs. These vapors will proceed down to the air sac or alveoli level and pass directly into the blood. The observed effects range from inflammation of the mucous membranes to swelling of individual cells in the lungs.

A second effect of organic solvents is that they can damage the brain and central nervous system. Trichloroethylene and methyl ethyl ketone are two organic solvents that demonstrate this effect. There are various structures within the brain and spinal cord that are composed of organic molecules. The vapors from these organic solvents tend to dissolve in these areas, damaging the brain and causing nerve damage over a long period of exposure.

The use of film-cleaning compounds to remove greasy and oily deposits from film is one of the most dangerous applications a photographer might be involved with. The film-cleaner solvents generally used in both commercial formulations and self-formulated mixtures include trichloroethylene or similar solvents in mixtures which include trifluoroethylene, trichloroethylene, and hexane. It not unusual for a photographer to clean slides and negatives with these types of solutions without providing proper ventilation or wearing a respirator with an organic vapor cartridge designed to filter out these particular solvents.

Chemical substances can cause hypersensitivity reactions in some individuals. A person may work with a chemical for a period of time be-

fore having an allergic reaction to it. An allergic reaction may also occur after an individual returns to using a chemical after a period of not working with the substance, for example, after a vacation. The allergic or sensitization response to the chemical could include difficulty breathing.

Another factor to consider is that some organic solvents used in the past have now been confirmed as carcinogens. A carcinogen is a substance that can cause cancer. An example is benzene, which was used in large quantities in some industrial applications from the 1900s. Today a number of chemicals have been identified as carcinogens, and this should be one of the first hazards to be identified when examining your personal list of photographic chemicals being used.

The various effects that chemicals have on the body are determined by the chemical's functional group. The term *functional group* helps identify the chemical family or group and helps in discussing chemical substances with similar characteristics. Several of the common chemical substance groups are alcohols, esters, ethers, ketones, aldehydes, and alkanes. These may also be described by more general groupings such as the aromatic, halogenated, cyclic, and nitro hydrocarbons. Hydrocarbons can cause the following:

- Local irritation of respiratory passageways
- Swelling of lung tissues
- Depression of the central nervous system
- Skin rashes and other skin-related problems (dermatitis)
- Nausea and vomiting
- Liver and kidney damage

CHEMICALS' EFFECTS on the BODY

LOCAL EFFECTS

There are four local effects that a chemical can have on the body:

1. *Drying.* Some organic solvents can act as defatting agents with ability to dry out the skin. This results in the skin cracking or blistering, which provides a new route of entry into the body for germs and bacteria and which can result in secondary infection. The skin plays an important role in that it is the first line of defense against microorganisms and other chemicals entering the body.

2. *Burning.* Strong acids and bases are corrosive enough to cause nasty burns to the skin and eyes.
3. *Sensitizing.* An individual using a chemical may become sensitive to it in any form—liquid, vapor, or dust.
4. *Irritating.* Some chemicals have an irritating effect when inhaled into the lungs or absorbed through the skin.

Examples of all four groups can be found among photographic chemicals. The film-cleaning compound cited earlier acts as a de-fatting agent, so the use of protective clothing—particularly gloves—is very important. Strong acids and bases are found in older photographic process formulations as well as in modern color-processing chemistry kits, such as the home-processing color kits. The user dilutes these strong acids and bases to prepare working solutions. Sensitization and irritation effects are found in the photographic chemicals provided in these kits.

POISONING

Poisoning can be either acute or chronic. Acute poisoning occurs after short-term exposure to a chemical and can include a one-time-only exposure during which the individual is exposed to large amounts of a chemical. Chronic poisoning refers to long-term exposure to a chemical in relatively smaller quantities, such as a chemical used every day during a person's working lifetime.

Much more is known about acute poisoning than chronic poisoning. It is not possible to project what the chronic effects might be from knowing the acute effects. It often takes 20 years or more before the effects of chronic poisoning manifest themselves as an illness. During this time, other contributing factors could have had some influence in the development of a disease. Contributing factors might include an individual's work history, smoking, or drug abuse.

Acute poisoning is a massive exposure to a chemical over a very short time. An example might include exposure to a hydrocarbon such as gasoline, which can affect the central nervous system if used in a confined area without ventilation. Mild exposure to such chemicals can result in dizziness, nausea, and headaches. Moderate exposure can result in breathing difficulty and the appearance of drunkenness. Severe exposure to these chemicals can cause unconsciousness or death. The latter is rare in individuals practicing photography, but there are processes and chemicals that could result in death if a person is exposed to them in a

particular manner. For example, the possibility of a photographer ingesting a chemical is unlikely, but if children have access to the working environment, accidental poisoning could result. A poorly ventilated darkroom could also have potentially fatal consequences, particularly if solvents are being used for extended periods of time.

Almost all photographic chemicals have some type of acute poisoning effects on individuals. The extent of the poisoning depends on the chemical's toxicity, the individual's susceptibility, the amount of the chemical involved, and the length of time exposed. The chemical's route of entry into the body is also important.

The extent of poisoning depends on the different acute poisoning strengths chemicals have. Some chemicals are similar to medicines, with very strong associated effects. Others are similar to alcohol consumption and their effect may be more moderate.

RISK FACTORS and EXPOSURE

The actual risk that the body is subjected to is determined by a number of different variables: the nature of the exposure, the length of exposure, the frequency of exposure, and the amount of exposure, as well as the toxicity of the chemical substance and the total body burden or total amount of that particular chemical in the body, regardless of its source. Personal susceptibility and the effects of exposure to multiple chemical substances—whether mixed or separate—used at the same time also contribute to the risk.

HOW CHEMICALS ENTER THE BODY

It is important to know the routes by which chemicals can enter the body, since you can then protect yourself. A chemical cannot cause ill health effects if it isn't allowed to come into contact with the body.

The two major routes by which chemicals can enter the body are inhalation and skin absorption. The two minor routes of entry are through the eyes and by accidental swallowing or ingesting.

Depending on the chemical and its specific properties, entry and absorption into the body may occur by more than one route. For example, inhaling vapors from a solvent that also has the ability to penetrate through the skin is a common combination, particularly for organic sol-

vents. When absorption into the bloodstream occurs, a toxic substance may elicit some general effects. More than likely the critical injury will be localized to a specific tissue or organ, generally the one directly involved.

Inhalation or Breathing

Inhalation is the major route by which a chemical can enter the body. The local effect of breathing in organic vapors from solvents is irritation of breathing passages and dizziness. Adequate protection should be provided in the form of good ventilation by using a local exhaust system, and when necessary, a respirator with the appropriate filter.

In situations in which insufficient ventilation is a problem and you are sensitive or allergic to a given chemical, attempt to substitute it with a less toxic one. If this is not feasible, it will be necessary to use personal protective equipment, specifically a respirator with the proper filter cartridge. It is essential that these cartridges be replaced regularly, depending on the length of time used and the amount of chemical present. Breathing is the major route by which fumes, dusts, mists, aerosols, and gases enter the body, making ventilation a high priority. Also, facial hair can affect respirator fit so keep that in mind when selecting one.

This route of entry is one of the major concerns in photographic operations, particularly with color chemistries, which often include an organic solvent to assist in "wetting" the emulsion. It is also a problem in black-and-white and color processing when hardeners or stabilizer baths are used, since these solutions invariably use formaldehyde as a major component of the formulation.

Skin Contact or Absorption

The local effect of skin absorption can result in burns, rashes and allergies. The poisoning effects can range from dizziness to difficulty in breathing. The personal protective equipment available to photographers includes goggles or splash guards, gloves, aprons or lab coats, and an extra change of clothing. The work space should include a sink with running water and, if possible, a shower in the event the chemical is spilled on the photographer. Good housekeeping habits for cleaning up spills and keeping the work area clean and tidy should also be practiced.

When washing the area of skin that has been exposed to a chemical liquid or powder, use ample lukewarm water. Hot water will open the skin's pores, resulting in greater absorption of the chemical into the body.

Chemical contact with the skin can result in four possible events:

1. The skin may act as an effective barrier.
2. The chemical may react with the skin and cause local irritation.
3. The chemical may produce skin sensitization.
4. The chemical may penetrate to the blood vessels underneath the skin and enter the bloodstream.

For some chemical substances, the skin is the main route of entry. For other substances the amount absorbed through the skin may be roughly equivalent to that absorbed by other routes. Some examples of chemicals in the skin absorption category are aniline, nitrobenzene, and phenol formulations. Most organic chemicals must be monitored in terms of their contribution to poisoning through skin absorption and the subsequent effects they create on the body.

The rate of skin absorption of some organic compounds has been found to increase when the room temperature is elevated or perspiration increases. Hence absorption of chemicals will be higher in warm rooms or hot climates. The absorption of liquid organic chemicals may occur as a result of surface contamination of the skin or clothes. For other organic chemicals, skin absorption may occur from vapors.

The properties of the chemical determine whether a material will be absorbed through the skin. There are a number of important properties to consider that will determine whether skin absorption occurs. One is skin pH. Females tend to have a more alkaline skin pH than males, which makes them more susceptible to dermatitis when handling chemicals. Other chemical properties to consider include the extent of ionization, water and lipid solubilities, molecular size, and the corrosive nature of the chemical substance.

Photographic chemicals can include derivatives of the types of organic compounds readily absorbed through the skin. Some of these include dyes used in the various photographic processes as well as some of the developer agents. It is imperative to wear gloves and possibly a barrier cream if contact will be made with developer solutions. Ideally, print tongs for tray processing prints should always be used in preference to hand processing.

Swallowing or Ingestion

The possibility of ingesting chemicals is not likely in the darkroom or in any photographic process. Ingestion is a minor route of exposure that

normally results only when someone eats, drinks, or smokes in the darkroom. None of these activities should occur in the darkroom environment. Personal hygiene is important because hands can transfer chemicals to foods or cigarettes. Hands should always be washed after finishing work in the darkroom and also before eating.

Ingestion of inhaled materials or chemicals may also occur because a chemical can be deposited in the respiratory tract and subsequently carried out to the throat by the body's defense mechanisms. The chemical contaminant is then swallowed and significant absorption can occur in the gastrointestinal tract. After absorption from the intestine into the bloodstream, the toxic chemical goes to the liver, where it is metabolically broken down into another substance. Depending on the chemical, it may be broken down into a harmless substance or remain as a toxic product that will do additional damage.

Ingestion should not be a problem if proper safety and handling practices are used. It should be noted that there are many photographic chemicals that can lead to death if they are ingested, even in small amounts. These types of chemicals are identified in this book as substances to be avoided and include such compounds as mercuric chloride and potassium cyanide. There are also some developer agents still used in black-and-white photography and most color processes that are very toxic and should be avoided if possible.

Eye Contact

The last route of entry is minor in terms of probability but very significant because the corrosive chemicals that are used in color photography can impair vision or even cause blindness. Other chemicals may exert their effects by causing irritation or abrasion. It is essential to use eye protection such as safety glasses or chemical splash goggles when handling powders and concentrates as well as splash guards when handling liquids. Careful handling of chemicals is important and cannot be understated.

HAZARDS and TOXICITY

It is important to point out that toxic chemicals are not necessarily hazardous ones. Toxicity is the ability of a certain chemical to produce an undesirable effect and/or harm when it is absorbed and accumulated in higher-than-normal amounts in the body. A hazard is the possibility or probability that this chemical will accumulate in such high amounts in an individual's body.

Many factors determine the degree of hazard that exists, including the route of entry, the dosage, the physiological state or well-being of the individual, his or her susceptibility, and the environmental conditions of the darkroom. Assessing a hazard involves estimating the probability or likelihood that the chemical will cause harm, and the chemical's toxicity is only one factor. Other factors are the physical and chemical properties of the chemical itself.

Two liquid chemicals may possess the same toxicity, but the degree of hazard may be different. One chemical may be odorless and nonirritating to the eyes, whereas the other may be very irritating to the airways and cause breathing difficulties. The chemical that has the irritating effects possesses an obvious warning characteristic, making it less of a hazard than the chemical with no warning properties. It should be noted that the toxicity does not vary but the hazard can, depending on the way in which the chemical is used and handled.

DURATION OF EXPOSURE

Many guides for exposure to airborne chemicals have been proposed. The guides that have become the most widely used and accepted are those issued by the American Conference of Governmental Industrial Hygienists (ACGIH) and are called threshold limit values or TLVs. In Canada these values can be obtained from the Workers' Compensation Board Industrial Health and Safety Regulations or in some provinces from the Ministry of Labor. The values are recorded in these regulations in an appendix called Permissible Concentrations. In the United States these values can be obtained from the U.S. Department of Labor.

The TLVs refer to airborne concentrations or amounts of substances, usually chemicals, to which nearly all workers may be repeatedly exposed day after day without any adverse effects. However, there are wide variations in individual susceptibility, so a small percentage of workers may experience discomfort from some chemicals even at or below the stated TLV.

The advantage of the TLVs is that they give a rough indication of how much exposure someone might receive from a chemical. However, it is always best to keep one's exposure to any chemical as low as physically possible. The TLVs are based on studies involving accidental exposure of humans to chemicals in industry, animal studies, experimental human studies, and, where possible, a combination of the three. TLVs are intended to be used as a guide in controlling health hazards associated with photographic or other chemicals.

EXPOSURE EFFECTS AND HEALTH

Chemicals such as aliphatic alcohols, aliphatic ketones, hydrocarbons, and ethers have a narcotic or anesthetic effect. They can produce unconsciousness and prevent the central nervous system from functioning normally. Depending on the amount of chemical present in the air, the effects may range from mild symptoms such as dizziness or headache to complete loss of consciousness or death.

Another health effect to be aware of is cardiac sensitization, in which the inhalation of volatile hydrocarbons can sensitize the heart to adrenaline. The term *volatile* refers to the ability of a liquid to easily form gaseous vapors or to liquids that evaporate rapidly. Individuals exposed to volatile hydrocarbons may develop an irregular heartbeat called ventricular cardiac arrhythmia. A ventricular cardiac arrhythmia results when the ventricles of the heart no longer beat normally but are contracting at an increased rate resulting in less blood being pumped. This in turn results in the tissues of the body becoming starved for blood and oxygen. This is a serious condition that can result in death.

Consideration should also be given to neurotoxic agents or chemicals that have an effect on the body's central nervous system. Certain metals such as manganese and mercury have toxic effects. In the central nervous system there is a transfer of energy from one part of the nerve to another that conveys information from the brain to the body. The presence of a chemical called acetylcholine is essential for this process to occur. The enzyme called cholinesterase is responsible for maintaining a certain level of acetylcholine in the body, but manganese and mercury exert their effect by inhibiting this enzyme, which in turn results in elevated acetylcholine levels. When high levels of acetylcholine are achieved it becomes incompatible with the transfer of energy, and the nervous system fails to work.

THE BODY

RESPIRATORY SYSTEM

The respiratory system (see Figure 1) is the quickest and most direct route for a chemical to enter the body, whether it be a gas, vapor, dust, mist, or aerosol. The reason the chemical enters the body so rapidly is that the circulatory system is closely associated with the respiratory system. Oxygen that is inhaled is bound to the blood in the circulatory system and thus distributed throughout the body to the tissues. In a similar

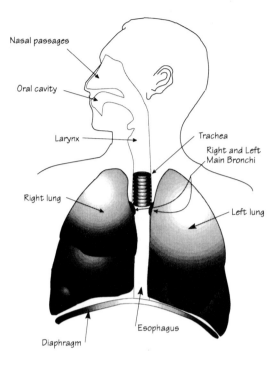

Figure 1. *The respiratory system*

fashion, an inhaled organic chemical travels the same pathway. It is transported into the body and stored at a location compatible with its chemical properties, often being picked up by blood that is processed in the lower lungs.

Anatomy of the Respiratory System

Respiration begins at the nose, with the nasal septum. This is the narrow partition dividing the nose into two cavities. Near the middle and on both sides of the nasal septum are a series of bones called conchae or turbinates. They increase the amount of tissue surface area within the nose so inhaled air can be warmed. The air is also moistened and dust particles are trapped before entering the lungs.

The air moves from the nasal septum into the pharynx or throat and down to the trachea. At the trachea the respiratory passageways divide into two tubes called the right and left bronchi. Each bronchus enters the lung on its own side through an opening. As each bronchus proceeds

deeper into the lung it divides into smaller branches called bronchioles, which are particularly sensitive to chemicals.

The bronchioles have a smooth muscle lining their insides, and this muscle functions by contracting or relaxing the diameter of the tube. Based on the chemical's solubility, it can cause an allergic reaction that narrows the diameter of the bronchioles, causing the individual to experience difficulty breathing.

The bronchioles branch down into several ducts, and each duct ends in a cluster of air sacs resembling a tiny bunch of grapes. These air sacs are called alveoli, and this is where any organic vapors that have entered the lungs will enter into the bloodstream.

When relaxed, a person's frequency of inhaling and exhaling is 10 to 14 times a minute. In one minute a person breathes a volume of 4.3 to 5.7 liters of air. When working in an environment that contains high amounts of organic vapors, breathing may become faster, so more of the chemical will be taken into the body. The result is an increased exposure to more of the chemical and a stronger poisoning effect.

Reactions to Chemicals

The more organically soluble the chemical the more likely it will get down to the alveoli level. If the chemical is very reactive it can evoke acute inflammatory reactions and pulmonary edema. Pulmonary edema is simply the abnormal pooling of fluid in the lung tissue and is similar to pneumonia.

If the substance inhaled is a chemical in dust form, it will be engulfed by macrophages if it reaches the alveoli. The macrophage is a cell that attacks substances not normally found in the lung. Some vapors can produce immediate irritation and inflammation of the respiratory tract. Prolonged exposure to such vapors, gases, and dusts can lead to chronic inflammatory or neoplastic changes or fibrosis of the lung.

Neoplastic changes refer to the new and abnormal growth or development of cells that may be either harmless (benign) or malignant (cancerous). Fibrosis refers to the formation of scar tissue and the loss of stretchability of lung tissue so that the lungs do not expand as easily. Hence an individual will have a decreased ability to breathe in.

Individual susceptibility to various chemicals is difficult to assess. People exposed to the same darkroom environment for an equal time can develop different defense responses to varying degrees for any number of reasons. It could be due to different breathing rates, the depth of

each breath, and/or the associated effects of cigarette smoking, as well as predisposed genetic factors.

Natural Defenses

The respiratory system has a complete set of defensive mechanisms for handling threats. One defense mechanism is the warming and humidifying of air in the nose and throat. The respiratory tract has mucus lining the airways to trap dusts, vapors and gases. Another defense system is the muscular contraction of the bronchioles when they are irritated. This restricts the airflow in an attempt to prevent more of the chemical from getting into the lungs.

CIRCULATORY SYSTEM

The circulatory system works in conjunction with the respiratory system. Chemicals that reach the alveoli pass through the thin, delicate one-cell tissue layer and enter the bloodstream. Once in the bloodstream, the chemical can be transported anywhere in the body. Most chemicals are specific in that they will accumulate in certain organs or tissues of the body.

The circulatory system consists of the heart and a network of tubes called arteries, capillaries, and veins. The arteries are the vessels that carry blood from the heart to the tissues. As they enter the tissues they branch into countless microscopic vessels called capillaries. It is here that the chemical absorbed by the blood may leave the capillaries and enter the tissue or organ. The capillaries that leave the tissue or organ re-unite to form the veins. These are the vessels that bring the blood back to the heart from the tissues. Blood flows through this closed-loop system because of different pressures in various parts of the body. The heart is the pump for the system. Each contraction of the heart pushes blood throughout the closed-loop system.

There are several factors that can affect the blood pressure generated by the heart:

- The amount of blood pumped by the heart
- The volume of blood in the heart
- The resistance to blood flow exerted by the force of friction between the blood and the walls of the blood vessels
- Chemicals absorbed into the blood

There are a number of chemicals in the working environment that can affect blood pressure and hence the blood flow in the body. Some chemicals exert their effects by increasing the heart rate and how hard or forcefully the heart muscle contracts.

The arteries, capillaries, and veins are organized into definite routes in order to circulate the blood throughout the body. The circulatory system has been divided into what are called the systemic and pulmonary circulations. It is the systemic circulation that picks up the chemical and carries it for deposition in the tissues.

INTERNAL ORGANS

There are a number of important internal organs in the body whose functions help keep us alive and healthy.

In the body there is a certain level of organization. At the most basic level, there are four types of cells: muscle, nerve, epithelium, and connective tissue. The next level of organization is tissue—a group of similar cells functioning together to perform a specialized function. When these tissues in turn aggregate to perform a specific function or functions, they are known as an organ. The highest level of organization is a system—a group of organs that perform a function together. An example is the urinary system, which consists of the organs called the kidneys, bladder, and ureters; these organs consist of epithelia tissue, which are epithelium cells.

The internal organs of the body include the heart, lungs, stomach, intestines, pancreas, gallbladder, kidneys, brain, spinal cord, all glands, the reproductive organs, and the skin. Each of these organs has a specific unique function essential for our survival, and each of these organs can be the target site for a variety of chemicals that are used in photography.

Most chemicals that produce some toxic effect will do so in one or two organs. These organs are referred to as the target organs for that chemical. The target organ most frequently involved when hydrocarbon solvents are used is the central nervous system or the brain. The respiratory system is also affected.

The liver and kidneys have the highest capacity to bind chemicals, and these two organs concentrate more chemical toxicants than any other organ. This is because these two organs are involved in the metabolic processes of the body in attempting to remove a chemical from the body. The kidneys attempt to excrete the chemical from the body in the

urine whereas the liver attempts to metabolize and detoxify a chemical through a series of chemical reactions. Sometimes the liver fails to successfully detoxify a chemical and produces another chemical that is more toxic to the body. Since the liver receives a large blood supply the new toxic substance may bind to the blood and be transported to a specific site in the body, resulting in tissue damage.

NERVOUS SYSTEM

The central nervous system is the body's control center and communications network. The central nervous system has three broad functions:

1. It senses changes within the body and in the outside environment
2. It interprets these changes
3. It responds to the interpretation by initiating action in the form of muscular contractions or glandular secretions

It is through sensation and integration of information that the nervous system adapts its response to the conditions in the environment. Chemicals can exert their effects in a number of ways as described previously. The common effects of chemicals are to act as central nervous system depressants or as analgesics.

The central nervous system is protected from some toxic chemicals by an anatomical structure called the blood-brain barrier. Not all substances are kept out by this barrier. Those organic chemicals that can dissolve in fatty tissue have the ability to pass through this barrier if they are small. Research has found that those toxic chemicals that penetrate into the brain do not affect all areas of the brain equally.

The general response of the cells to certain chemicals is *anoxia*, which means a lack of oxygen. The central nervous system is very sensitive about its oxygen requirements, and more than five minutes without oxygen will result in brain death.

The cells in the central nervous system are very specialized cells in that they cannot reproduce. When cell death occurs no reproduction will occur to replace those cells killed. Whatever function those cells were responsible for will be lost forever. However, nearby cells having similar functions may be able to take up the slack in maintaining normal activity. Failing this, other nerve cells may acquire the needed function.

A functional state of the central nervous system called *general de-*

pression usually results from overexposure to organic solvents used in the photographic process. This is a state in which the photographer's awareness or consciousness is impaired. Many solvents containing hydrocarbons or alcohol functional groups depress the brain. The depression of the central nervous system is characterized by the individual feeling drowsy, having difficulty concentrating, undergoing changes in mood, progressing to slurring of speech. It can proceed to total disorientation followed by unconsciousness. The effect is similar to that of being given an anesthetic.

The central nervous system has a remarkable capacity to perform well under the stress of continued exposure. It is capable of developing tolerance or adapting to damage so well that the damage can go unnoticed for a long time. Alterations in gait, emotional state, motor performance, and coordination are the early warning signs of central nervous system poisoning.

Other chemicals may produce their toxic effects by damaging the myelin which surrounds the nerves running throughout the body. When the myelin is damaged, messages passing along the nerves are not fully conveyed to the brain but die out along the way. Some chemicals can cause lesions, which is any form of structural damage to the cells.

REPRODUCTIVE SYSTEM

The survival of any species, be it animal or plant, depends on the integrity of its reproductive system. The genes located in the chromosomes of the germ cells transmit the genetic information to the next generation as well as control cell differentiation. It is the germ cell that is basically responsible for ensuring that the organism's various structures and functions are maintained in its own lifetime and from generation to generation.

The effects of chemicals on the human reproductive process and the risk of exposure are difficult to assess because of the complexity of the system. In general, damage to the reproductive organs and their functions can result from the direct action of a chemical on the germ cell without influencing the endocrine glands. A second possible effect is to act on the accessory secretions of the prostate and seminal vesicles in the male. A third effect is to inhibit or prevent hormone secretions at the gonads or in the brain. Research indicates that different chemical environments exert their effects in one or more of these ways.

Chemical agents can affect the development of the embryo in such

a way that defects in one or more organ systems are produced. If the germ cells escape damage and only the somatic cells are affected, then only the individual will be affected and not the future offspring. Any substance that causes defects of fetal development is called a *teratogen*. The term *mutagenic* refers to any chemical that causes mutations to occur in the process of replicating cells. A considerable amount of research is still being conducted in these areas. Attempts are being made to determine which chemicals are carcinogenic, teratogenic, and mutagenic.

SKIN

The skin is a complex organ because it consists of tissues that are structurally joined together to perform specific functions (see Figure 2). The skin acts as a barrier by protecting the body from infection by bacteria. It also helps to regulate body temperature and prevent the loss of inorganic and organic chemicals from the body.

The skin is composed of a number of layers. The part of the skin we can see is called the epidermis, which is a layer of dead cells. Below the epidermis is the dermis, which is the true skin layer. The dermis layer houses the hair follicles and the sweat and sebaceous glands. These three structures connect with the skin's surface through "holes" called pores. One possible route of absorption that chemicals can take is through these pores.

As long as the surface of the skin is not broken by cuts or abrasions and the natural secretions are not removed or contaminated, the skin is an excellent barrier. Skin rashes or problems such as skin dermatitis occur when the structure of the skin is damaged or the protective mechanisms are upset by external irritants such as dusts, chemical powders, or liquids.

Substances or chemicals used in photography that cause dermatitis can be divided into two groups: primary irritants and sensitizers, which are secondary irritants. Primary irritants cause inflammation and acute dermatitis in the area of contact based on two factors: the strength of the substance and the length of time the substance is in contact with the skin. Primary irritants affect any healthy skin regardless of the individual's susceptibility. If medical treatment is initiated promptly, it will be effective. If contact with the irritant is eliminated or reduced, the dermatitis condition is not likely to recur. However, if the dermatitis is not treated it will worsen. Examples of primary irritants are acids, bases, or alkalies.

Sensitizers or secondary irritants do not affect everyone, only a rela-

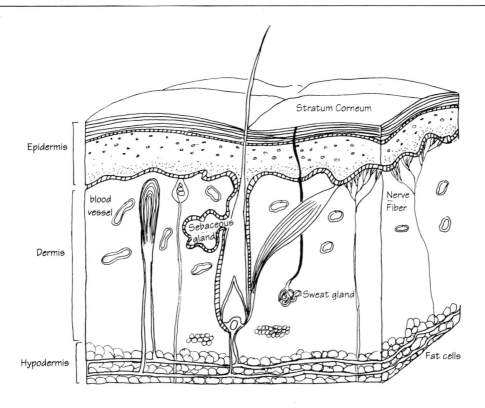

Figure 2. *Skin layer cross section*

tively small proportion of people who, for some reason, are sensitive to them. Sometimes the symptoms may not appear until days or weeks after the initial exposure. When they do develop, the symptoms may be in areas of the body that had no contact with the irritant.

Once an individual becomes sensitive to a particular substance, he or she will remain so, even if exposure or contact is minimal. The individual could also become sensitive to other irritants. Sometimes there is no clear line to distinguish whether an irritant is primary or secondary. Some substances can cause both types of reactions.

Organic solvents such as turpentine and trichloroethylene tend to remove the natural oils of the skin. The skin becomes dry, resulting in itching, cracking, or blistering. When this occurs it leaves the body vulnerable to infection. It may take the skin several hours to replace the natural surface coating that has been removed by the solvent.

It has also been found that keeping the hands or skin immersed in water-soluble chemicals will weaken the skin. Water-soluble chemicals also tend to increase the rate at which cells flake off from the epidermis.

It would be impossible to list all the chemicals that cause dermatitis. However, they have been categorized into four general groups:

1. Acids or alkalies
2. Oxidizing or reducing agents
3. Protein precipitants
4. Allergens

Basically acids, bases, or alkalies remove the skin's natural moisture and may remove the skin too if the concentration or strength is high. Some oxidizing or reducing agents can react with the structure of the tissue in the epidermis. Some chemicals, such as formalin and tannic acid, will cause proteins in the skin cells to coagulate, causing the skin to lose its protective function. Allergens are simply substances that cause irritation in people sensitive to them.

THE EYES

The cornea and conjunctiva are the parts of the eye that are directly exposed to external threats. For the eye to be fully functional, the cornea must maintain its transparency so that vision is not impaired. If a scar forms on the cornea, vision will be affected. Hence, very small amounts of corrosive chemicals can cause blindness if they reach the cornea.

A splash of acid in the eye is a medical emergency. Acid burns to the eyes can vary in severity from those that heal completely to those that cause complete opacity or even holes in the cornea. The eye contains tissues composed of fluids; when a strong acid splashes into the eye, the chemical reaction can result in a tremendous amount of heat being generated. In this situation there are thermal burns to the eye as well as chemical burns. Picric, tungstic, and tannic acids can produce severe lesions in the eye.

With acid burns, their severity can be assessed early; with strong alkalies, the assessment of the severity takes longer. At the time of the alkali burn it may appear to be mild. However, with time, ulceration and perforation of the cornea can occur. The only exception to this is ammonium hydroxide, which exerts its effects just as rapidly as acids. Sometimes the effects of an alkali burn may not become apparent until a week after the incident occurred.

If perforation of the cornea occurs due to an acid or alkali splash, visual function is usually beyond repair. The only hope for useful function is a successful corneal transplant, and the probability of success of the transplant decreases the more seriously the cornea is burned.

The proper procedure following a chemical splash in the eyes is to wash the eyes for a minimum of 15 to 20 minutes while holding them open. Then seek medical attention.

When organic solvents such as ethanol, acetone, ethyl ether, hexane, or toluene are splashed into the eye they cause pain. Examination of eyes that have been splashed by these chemicals have found a dulling of the cornea. If the organic solvents are at room temperature, the damage is usually not long lasting or extensive.

SAFETY IN THE DARKROOM

DARKROOM DESIGN

The room chosen for a darkroom needs to be converted to allow virtually no light in. Although this seems a simplistic point, a light-tight space is often also an airtight space and therefore will need exhaust ventilation to remove the buildup of chemical fumes related to the photographic processes. Other important features include running water, electrical services, and flat open working surfaces.

Commercial darkrooms are often located in business parks and other typically commercial buildings. The electrical and water services usually need to be upgraded to meet the needs of a darkroom. The necessary ventilation and exhaust services are almost always lacking. The importance of proper ventilation for a darkroom can't be overstated. The removal of chemical dusts from chemical mixing, vapors from some processing baths, and aerosols used in finishing is one of the most important functions required within the darkroom environment. Also, the air-handling system will be used both to remove the contaminated air within the work space and to replace it with clean fresh air.

Home darkrooms are often located in kitchens, bathrooms, or basements because they can offer the running water, electricity, and working surfaces required. In addition, they can often be converted into a dark space without a great deal of work. However, there are a number of shortcomings in using these types of locations for a darkroom. The first is that these spaces often do not provide an adequate airflow or ventila-

tion to clear out the vapors associated with the processing solutions. The second is that spaces like kitchen counters can become contaminated from the chemicals being used. These chemicals may then be picked up later by plates and food prepared on the counter, resulting in poisoning by ingestion. The issue of ventilation is one of the most important design concerns for any darkroom.

Some other safety aspects that should be considered in designing a darkroom include having an emergency eyewash station, a sink in which to wash off chemical spills, a vapor-proof electrical switch, a light fixture contained in a vapor-proof enclosure, at least two fire extinguishers, and a smoke or ionization detector. Safety cans will be needed for flammable solvents and solvent-contaminated material as well as a storage cabinet for flammable or dangerous chemicals. The presence of sprinklers is the best insurance of all, since a sprinkler interlocked with an ionization smoke detector provides the fastest response in detecting and extinguishing a fire.

VENTILATION

Some photographic processes involve flammable or combustible liquids, but most often they will include caustic and acidic liquids and toxic powders that give off chemical dusts during mixing. There needs to be some form of local ventilation to remove these fumes and dusts. Ventilation is an engineering control used to dilute and exhaust the vapors to a remote location. The flammable and combustible vapors create not only a fire hazard, but also a health hazard; the dusts represent primarily a health hazard. The benefit of having proper local ventilation is the reduction of the hazard threat and the promotion of a safe operating environment.

In a confined area such as a darkroom, it is a good idea to have an airflow rate of about one cubic foot per minute per square foot of floor area. This is more than adequate to keep the vapors out of the photographer's breathing zone when working with processing chemicals. It will also prevent the buildup of organic solvent vapors, which increases the fire risk.

A proper ventilation system should provide an airflow across the floor area. The makeup air—air used to replace the amount of air exhausted—should enter at the floor level and diffuse into the space, being drawn across the room by the exhaust system. The exhaust, part of the extractor system, should be located close to the working space where the chemicals are being used. Ideally this is at sink level for processing trays. Because the air is being exhausted out of the building, provision must be

made to introduce adequate makeup air. For ideal safety in photographic operations involving the use of large quantities of flammable and combustible liquids, the ventilation system should be interlocked with the power supplied to the darkroom so that the room cannot be used unless the ventilation system has been activated.

Figure 3 shows a generic darkroom layout. The design of a darkroom work space will always be a reflection of the photographer using the space. With this in mind, this layout should be used as a guide to the features that should be present and their relative locations. The spaces are provided with an air supply which flows into the work spaces and through the exhaust systems. There are two exhaust systems, a canopy hood for the chemical mixing space, and a wall-mounted slot exhaust

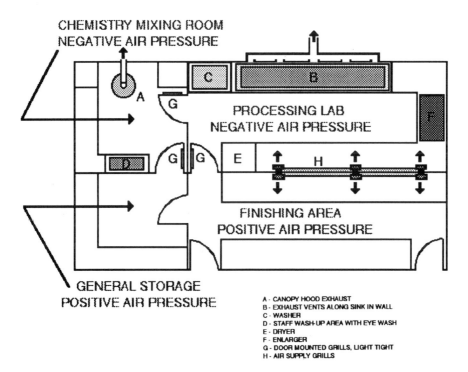

Figure 3. *A generic darkroom layout showing the actual areas and the air supply and exhaust systems.*

system for the processing sink. These two exhaust systems are detailed in figures 4a and b. Figures 5 and 6 show two additional pieces of equipment which should be located in the chemical mixing room—an eye wash station and a drench shower. These are particularly important if concentrated acids are being handled by staff.

CHEMICAL STORAGE

The first step in organizing what chemicals you will be using and their storage location is to complete an inventory list. All containers that have chemicals in them should have a safety label on them (WHMIS labels in Canada). This identifies the chemical as well as gives a warning of the hazardous properties. The label should contain the purchase and expiration dates for the chemical. The inventory should be reviewed at least annually and any expired chemicals removed.

The total volume of chemicals that can be safely stored in a storage location depends on the size and condition of the storage facilities. Cupboards or shelving below eye level with lips to prevent dislodgment is an acceptable storage condition for working quantities of chemicals. The term *working quantities* means only that amount of chemicals you will need for the day. The chemicals should be stored in the smallest practical sizes that are required for processing. Organic solvents, if present, should be stored in safety cans or containers. Keep minimal amounts of these chemicals on hand in the work area.

A safety can has a maximum capacity of five gallons and is equipped with a spring-closing lid and spout cover so that the can will safely relieve internal pressure when subjected to fire exposure (see Figure 7). This is the type of container that should be used for storing and dispensing flammable liquids. The cans are available in various sizes, and the smallest possible size should always be used. It should be noted that the safety can is not intended for use in settings where the periodic release of flammable vapors may create a hazardous atmosphere.

A very important factor to consider when storing chemicals is their compatibility with other chemicals. It is not a good idea to store chemicals on shelves in alphabetical order. The manufacturers' recommendations, found on the chemical's label, should always be followed. As a general rule, flammable or combustible liquids, toxic chemicals, explosive chemicals, oxidizing agents, corrosives, and water-sensitive chemicals should be segregated and kept in these groupings. This information is available on the Material Safety Data Sheet (MSDS) for the chemical.

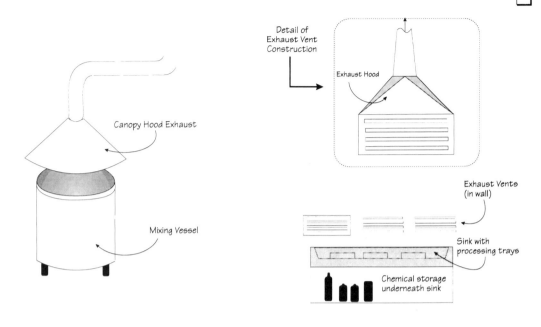

Figures 4a and 4b. *The Canopy hood and wall mounted slot exhaust system, as shown in the layout in Figure 3.*

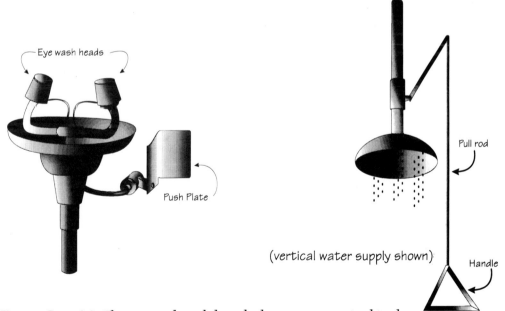

Figures 5 and 6. *The eye wash and drench shower are required in the chemical mixing room, particularly if concentrated acids and alkalies are being handled.*

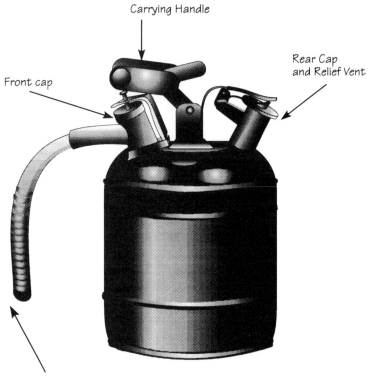

Carrying Handle

Rear Cap
and Relief Vent

Front cap

Flexible delivery hose

Figure 7. *Safety can. These are made out of metal or high-density poly-ethylene, which can resist corrosive chemicals. Safety cans should come with a flame arrester.*

The term "flammable liquid" refers to liquids that have a flash point below 100°F. "Combustible liquids" are those with flashpoints between 100°F and 200°F. Both of these have been further divided into smaller groups. It is important to note that as the flashpoint becomes lower, the risk of fire increases.

The amount of flammable liquid and combustible liquid that may be stored in a flammable storage cabinet is 227 liters and 454 liters respectively. The flammable storage cabinet must be approved by the Underwriters Laboratory and bear labels that clearly identify its contents. It should have the label FLAMMABLE LIQUIDS, KEEP OPEN FLAMES AWAY (see Figure 8).

Chemicals that are known or suspected carcinogens should be kept to single, small, daily-use containers. These containers should be stored according to the manufacturers' recommendations, with any incompatible chemicals segregated. Ideally any carcinogenic chemical should be substituted with a less hazardous chemical.

Oxidizing agents should be stored in single, small, daily-use size containers. The area in which they are stored should be fire resistant, cool, and well ventilated. They should be stored

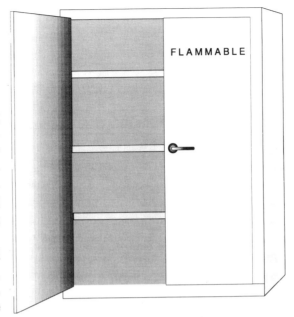

Figure 8. *Chemical storage cabinet*

according to the manufacturers' recommendations and away from incompatible chemicals. The same can be said for corrosive chemicals, with acids and bases kept as far apart from each other as possible.

Most photographic laboratory spaces will have a minimum amount of single chemicals on hand. The bulk of the chemicals will be present in the form of processing kits made up of cans and bottles of prepackaged concentrates and chemicals designed to be mixed to prepare working-strength processing solutions. This situation is generally a less threatening one than if bulk chemicals were on hand, but the kits contain chemicals that could be threatening if inadvertently mixed together. If a processing kit is damaged and the contents are exposed and mixed, resulting in the accidental mixture of acids, bases, and oxidizing chemicals, there could be exposure to hazardous fumes and chemicals.

Ideally, the storage location of chemical processing kits and bulk chemicals should be separate from the processing darkroom. A dedicated exhaust ventilation can be installed just above the mixing table space, and the removal of chemical dusts and chemical vapors can be easily managed. Another advantage of having a separate mixing room for chemicals is that any cleanup of spilled chemicals will be easier, without contamination of the darkroom work space. For example, there are

many chemicals used in photographic solutions that can cause fogging of photographic papers and film. A fine chemical dust suspended in the air from the mixing operation could settle out on sensitized materials after mixing has been completed, resulting in fogged images.

PERSONAL PROTECTIVE EQUIPMENT

To make the darkroom or lab a safe working place, a number of controls can be used: engineering, administrative, and personal protective equipment. Often personal protective equipment is considered the last resort when proper engineering and administrative controls are used. However, because engineering and administrative controls rarely work, the individual ends up depending on personal protective equipment.

The three most common engineering controls are substitution, isolation, and ventilation. If you are using a material that is known to be harmful, make every effort to eliminate it or substitute it with another less harmful chemical. This is not always possible or desirable so we need to consider whether it can be isolated to minimize contact with the chemical. If contact can be avoided by using processing tongs or other handling tools, then use them. Screens and splash guards may be used when working with hazardous liquids. Processing with a mechanized processor, tanks, or a processing drum reduces exposure to hazardous chemicals and often requires less volume of chemicals, reducing the chemical hazard.

Good housekeeping (administrative) techniques are essential and can eliminate potential problems. The work area should be kept clean, dust and solid debris should be removed, and proper spill procedures must be followed.

Protective clothing is usually left as the last control but is often the most common one. Depending on the chemicals being used and the particular photographic process, protective clothing can include coveralls, aprons (figure 9), gloves (figure 10), chemical splash goggles (figure 11), and respirators (figures 12a,b&c). They should protect not only the individual's exposed skin but also the clothing, which could absorb a chemical irritant and prolong the skin's exposure to the chemical. These items of protective clothing need to be worn when mixing color chemistries either from bulk chemicals or from kits. Once the working solutions have been prepared, the use of goggles and respirator might be removed from the list, depending on the particular hazards associated with the process. The balance of the protective clothing needs to be worn throughout the process.

It is essential that overalls and aprons be washed frequently and all protective clothing be inspected regularly for holes or worn areas. This is especially true for gloves, which wear out quickly. Nonfabric gloves such as rubber, polyvinyl chloride (PVC), and neoprene should be used when necessary and with the appropriate chemicals. Some gloves react with chemicals and dissolve or allow the chemicals to penetrate through them, so glove types must be checked for compatibility with the chemicals to be used with them.

Personal cleanliness plays a vital role in preventing skin problems when handling chemicals. It is important to remove all processing dusts and chemicals from the skin when finished working in the darkroom or when taking breaks.

Figure 9. *Safety apron*

For maximum protection against dermatitis, make proper use of soap and rinse the exposed areas of the skin with running water. Dry completely with clean towels. Always wash your hands before eating, smoking, or going to the washroom.

EMERGENCY PROCEDURES, SPILLS, and CLEANUP

Emergency procedures for spills and fires should be written up and posted in the darkroom. The chance of a fire occurring always exists, and being prepared to handle the emergency can mean the difference between saving the darkroom and equipment or losing it. Accidental spills of chemicals must be cleaned up immediately. It is important to note that the spill cleanup procedure is different for various chemicals. The Material Safety Data Sheets for the chemicals provide this information.

To prepare for emergency situations you should review your escape

route in the event that a fire breaks out. Training to use a fire extinguisher is also a good idea. It should be inspected regularly to ensure that it is charged and in good condition. If the fire spreads rapidly, it is advisable to get out and not fight the fire. You could become trapped in a very short time. A fire blanket is a handy item to have for smothering a small fire or to wrap yourself in to escape if you become trapped.

Emergency phone numbers should be posted by the telephone along with clear directions to your location. This list should include the police, fire department, ambulance, family doctor, and poison control center phone numbers. In the event that an emergency does occur, these numbers will be readily available. This will minimize any confusion that could result during the emergency.

One method of cleaning up a chemical spill is to use the commercially available spill kits for flammable liquids, acids, bases, cyanide, mercury, and hydrofluoric acid. Absorbents that can control flammable vapors as well as absorb the flammable material should be used. Flammable liquids should not be cleaned up with inert inorganic absorbent materials such as diatomaceous earth because they do not control flammable vapors. Acid and base spills should be cleaned up with a neutralization medium containing a pH indicator.

Anytime a spill occurs, access to the space should be restricted. Attempt to keep the spill in as small an area as possible if you are not in danger. Wear adequate personal protective equipment if the chemical is corrosive or hazardous. If the spill is small, soak up the spilled solution with absorbent material that does not react with the spilled chemical. Put the material in a suitable covered, labeled container and wash the area of the spill with water, if appropriate.

Organic solvents and flammable wastes must be collected in separate, tightly covered containers and disposed of according to municipal, state or provincial, and federal regulations. Departments in municipalities that have jurisdiction over disposal into sewer systems as well as local offices of the Ministry of the Environment, Waste Management Branch (in Canada), may be helpful with chemical disposal questions.

FIRE PREVENTION

There are three types of fire hazards that the photographer should be aware of when handling chemicals: reactivity, flammability, and health.

In terms of reactivity, some chemicals can explode, burn, or form

Disposable Nitrile Rubber Gloves

Chemical (Splash) Goggles

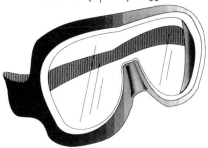

Figure 11.

Figure 10.

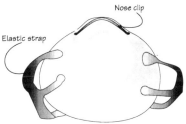

Nose clip

Elastic strap

Figure 12a.

Also available for
acid gasses, sulphur dioxide

Full Face Respirator

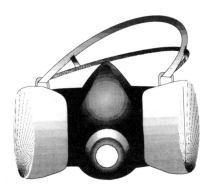

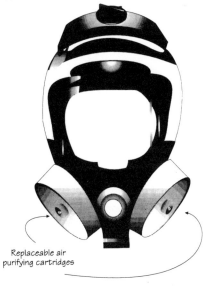

Figure 12b. **Figure 12c.**

Replaceable air
purifying cartridges

toxic vapors when mixed with other chemicals or when exposed to air, water, or heat. Flammability refers to the ability of some chemicals to catch fire easily. The flash point is the lowest temperature at which a liquid will give off enough vapor to form a flammable mixture with air to produce a fire if ignited by a spark or flame.

The autoignition temperature is the lowest temperature at which a material will start to burn in the absence of a flame or spark. When working in an enclosed area such as a darkroom, ventilation becomes an important control when considering safety, particularly when organic solvents are concerned. If there is inadequate ventilation, the photographer must give consideration to explosive limits when handling flammable organic solvents. The explosive limit refers to the percent concentration of flammable materials in the air. There is an upper explosive limit (UEL) and a lower explosive limit (LEL).

The lower flammable limit is the minimum concentration of vapor in the air below which propagation of a flame will not occur in the presence of an ignition source. The upper flammable limit is the maximum vapor concentration in air above which propagation of a flame will not occur. If a vapor-to-air mixture is below the lower flammable limit it is "too lean," and if it is above the upper flammable limit it is "too rich" to transmit flame. It is when the mixture is between the lower and upper limits that ignition can occur and an explosion may result.

The best fire prevention is to have the minimum amount of flammable solvents in use at any time. The remaining flammable solvents should be kept stored in a cool location and according to compatibility. The darkroom should have a safety light in the event that it is needed. Fire extinguishers should be present in the darkroom and should be matched to the type of chemicals used. Smoke detectors should also be present in the room to provide immediate warning. Ideally, these should be linked to a sprinkler system for maximum response to a fire.

CHEMICAL INFORMATION SOURCES

In June 1987, federal legislation in Canada resulted in the implementation of the Workplace Hazardous Materials Information System (WHMIS), which is designed to provide employees with information about chemicals used on the job. Manufacturers are required to put WHMIS labels on their products and to provide Material Safety Data Sheets (MSDSs) with the products. In the United States there is a similar system called HAZCOM (Hazard Communication).

When purchasing or ordering chemicals, ask the manufacturer for the chemical's Material Safety Data Sheet. If the chemicals are ordered in Canada, they must contain the standard WHMIS label. It is advantageous for the photographer to become familiar with the WHMIS label, as it provides the following information:

1. Product identifier
2. Hazard symbol
3. Risk phase(s)
4. Precautionary measures
5. First-aid measures
6. Reference to MSDS
7. Supplier identification

The MSDS is a technical bulletin that provides detailed hazard, precautionary, and emergency information on a controlled product. All data sheets must provide nine sections of information:

1. Product information
2. Hazardous ingredients
3. Physical data
4. Fire and explosion data
5. Reactivity data
6. Toxicological properties (health effects)
7. Preventive measures
8. First-aid measures
9. Preparation information (date of preparation, name and phone number of company to contact for more information)

The photographer should keep or obtain a Material Safety Data Sheet for each chemical stored or used. It is an excellent reference source for information such as first aid, spill procedures, and waste removal. It also informs the individual what the health effects are when working with the chemical and the TLV of the chemical. The MSDSs should be placed in a binder and kept nearby for quick reference. (MSDS sheets are discussed in detail on page 38)

LEGISLATION

As a photographer, you will be handling, using, and storing various chemicals in the form of developers, fixers, bleaches, and other chemical

Material Safety Data Sheet
May be used to comply with
OSHA's Hazard Communication Standard,
29 CFR 1910.1200. Standard must be
consulted for specific requirements.

U.S. Department of Labor
Occupational Safety and Health Administration
(Non-Mandatory Form)
Form Approved
OMB No. 1218–0072

IDENTITY *(As Used on Label and List)*

Note: Blank spaces are not permitted. If any item is not applicable, or no information is available, the space must be marked to indicate that.

Section I

Manufacturer's Name	Emergency Telephone Number
Address *(Number, Street, City, State, and ZIP Code)*	Telephone Number for Information
	Date Prepared
	Signature of Preparer *(optional)*

Section II — Hazardous Ingredients/Identity Information

Hazardous Components (Specific Chemical Identity; Common Name(s))	OSHA PEL	ACGIH TLV	Other Limits Recommended	% *(optional)*

Section III — Physical/Chemical Characteristics

Boiling Point		Specific Gravity (H$_2$O = 1)	
Vapor Pressure (mm Hg.)		Melting Point	
Vapor Density (AIR = 1)		Evaporation Rate (Butyl Acetate = 1)	

Solubility in Water

Appearance and Odor

Section IV — Fire and Explosion Hazard Data

Flash Point (Method Used)	Flammable Limits	LEL	UEL

Extinguishing Media

Special Fire Fighting Procedures

Unusual Fire and Explosion Hazards

(Reproduce locally) OSHA 174, Sept. 1985

Section V — Reactivity Data

Stability	Unstable		Conditions to Avoid
	Stable		

Incompatibility (*Materials to Avoid*)

Hazardous Decomposition or Byproducts

Hazardous Polymerization	May Occur		Conditions to Avoid
	Will Not Occur		

Section VI — Health Hazard Data

Route(s) of Entry: Inhalation? Skin? Ingestion?

Health Hazards (*Acute and Chronic*)

Carcinogenicity: NTP? IARC Monographs? OSHA Regulated?

Signs and Symptoms of Exposure

Medical Conditions
Generally Aggravated by Exposure

Emergency and First Aid Procedures

Section VII — Precautions for Safe Handling and Use

Steps to Be Taken in Case Material Is Released or Spilled

Waste Disposal Method

Precautions to Be Taken in Handling and Storing

Other Precautions

Section VIII — Control Measures

Respiratory Protection (*Specify Type*)

Ventilation	Local Exhaust		Special
	Mechanical (*General*)		Other

Protective Gloves	Eye Protection

Other Protective Clothing or Equipment

Work/Hygienic Practices

solutions. Every chemical, as mentioned earlier, has some harmful effect on the body, depending on a number of factors. You have the right to know what a chemical can do to you, and how it should be handled, stored, and transported.

This section briefly discusses U.S. and Canadian legislation that provides workers in the workplace with information about hazardous materials and chemicals. When ordering or buying chemicals from a supplier, either in bulk or in formulations and kits, you can and should request an MSDS for the product.

The Occupational Health and Safety Act

In December 1970, one of the most comprehensive statutes passed in the United States of America, the Occupational Safety and Health Act (OSH Act), was adopted by overwhelming votes in the Senate and the House of Representatives. The declared congressional purpose of the OSH Act of 1970 was to "assure as far as possible every man and woman in the nation safe and healthful working conditions and to preserve our human resources."

Based on this statute, it is the employer's obligation to provide a safe and healthy working environment. This is achieved by developing standards that define the employer's obligations prospectively and in considerable detail. Currently, under this act there are a number of uniform occupational health regulations that now apply to all businesses in the United States engaged in commerce, regardless of their locations within the jurisdictions. The standards define the employer's obligations to the extent that if there is a hazard that exists for which a standard has not been developed, the employer must comply with the general duty obligation to provide a workplace "free from recognized hazards likely to cause death or serious bodily harm."

Nearly every employer is required to implement some element of an industrial hygiene, occupational health, or hazard communication program to be responsive to the Occupational Safety and Health Administration (OSHA), the Occupational Safety and Health Act (OSH Act), and its health regulations or those of other regulatory agencies.

There has been considerable activity in the history of the OSH Act. OSHA has performed almost one million workplace inspections and has proposed over $150.5 million in civil penalties. OSHA has promulgated detailed health standards for 24 toxic substances, mostly carcinogens, as well as major hazard communication rules.

HISTORY OF NIOSH

The OSH Act established the National Institute for Occupational Safety and Health (NIOSH). The function of NIOSH is to:

- Conduct research on the health effects of exposures in the work environment
- Develop criteria for dealing with toxic materials and harmful agents
- Train professional personnel to meet the purposes of the OSH Act
- Conduct research and assistance programs for improving protection and maintenance of worker health

The OSH Act also authorizes NIOSH programs for medical examinations and tests in the workplace as may be necessary to determine, for the purposes of research, the incidence of occupational illness and the susceptibility of employees to such illness.

Another NIOSH function is the annual publication of a list of known toxic substances and the concentration at which toxicity or some form of harmful effect is known to occur. NIOSH publishes industry-wide studies on chronic or low-level exposure to a variety of industrial materials, processes, and stresses, which can affect the potential for illness and disease or loss of functional capacity in aging adults. NIOSH is also responsible for conducting research on which new standards can be based.

Canadian Regulations:
Workplace Hazardous Materials Information System (WHMIS)

WHMIS is a Canadian system designed to provide employers and workers with detailed information about hazardous materials or chemicals. Under WHMIS there are three ways in which information about hazardous materials is provided:

1. Labels (provided by the supplier) on containers of hazardous materials
2. Material safety data sheets (MSDS)
3. Worker education programs

In July 1981, federal and provincial occupational health and safety regulatory agencies suggested to the Canadian Association of Administra-

tors of Labour Legislation (CAALL) that a nationally consistent system for hazardous materials be established. The Hazardous Products Act was identified as the most applicable legal vehicle to use to control hazardous materials manufactured in Canada or imported from other countries.

The process by which WHMIS came about was the first time that federal and provincial governments, labor and industry worked together to develop a national policy and standard in the occupational health and safety field. The provinces usually legislate occupational health and safety matters within their own jurisdictions. But WHMIS is a national standard. Its intent is to achieve consistency across Canada in terms of the key elements of the system: ingredient disclosure, trade secret protection, labels, Material Safety Data Sheets and worker education.

Although the objective of WHMIS is to ensure the protection of Canadian workers from the adverse effects of hazardous materials through the disclosure of relevant information, it was also recognized that the worker's right to know had to be balanced with industry's need to protect genuine trade secrets and confidential business information. WHMIS has done this by setting up a third-party screening agency that confirms or denies the validity of trade secret claims.

In Canada, manufacturers or suppliers must classify and evaluate their products to determine what hazard symbol and classification that product belongs to. They must also send out supplier labels and MSDSs with those products that meet the hazard criteria laid out in the Hazardous Products Act. In Canada the Controlled Products regulations specify what information must be included on the MSDS. It can be presented in any order.

Hazard Communication

In the United States, employers must be in compliance with the OSHA standard known as the hazard communication standard. Among other requirements, the standard requires employers to ensure that each container of hazardous chemicals in the workplace is labeled, tagged, or marked with appropriate hazard warnings and identified. The employer must maintain copies of the Material Safety Data Sheet for each hazardous chemical in the workplace. These MSDSs may be kept in any form. Last, the employer must provide employees with information and training on hazardous chemicals in their work areas at the time of the initial assignment and whenever a new hazard is introduced. The hazard communication standard in the United States has the exact same pur-

pose as WHMIS in Canada. However, there arc substantial differences in the legislative requirements.

MATERIAL SAFETY DATA SHEETS

How does legislation passed to provide workers in the workplace with information help you, an independent, working photographer? As mentioned earlier, the Material Safety Data Sheet or MSDS provides the most help. The MSDS is a technical document that provides information about a chemical or product. It provides such information as the chemical and physical properties of the chemical, how to handle and store the chemical, what first-aid measures to take, and what personal protective equipment to wear or engineering controls to use to reduce exposure to the chemical.

The differences between U.S. and Canadian MSDSs can be seen in the following pages, Table 1, US Dept Labor MSDS and table 2, Canadian MSDS. The Canadian MSDS requires more information under the Toxicological section than the equivalent U.S section titled Health Hazards.

As a photographer using various chemicals in your darkroom, you will need to know where to find pertinent information on the Material Safety Data Sheet. The various sections of the Material Safety Data Sheet are reviewed below. (Note that the Canadian MSDS has been used because it contains more information.)

Section 1: Product Information

The intent of this section is to provide you with information about the supplier and manufacturer of the product. The important part of this section is the emergency phone number provided by the manufacturer so that someone can be contacted in an emergency.

Section 2: Hazardous Ingredients

This section of the Canadian MSDS is considerably different from that of the U.S. MSDS. The Canadian MSDS provides information on the various chemicals present in the product, except if there is a trade secret exemption. The amount of that chemical present in the product and its toxicity or harmfulness are given. The U.S. MSDS does not indicate how toxic or harmful a chemical may be.

The toxicity of the chemical is indicated by the LC50 and LD50.

MATERIAL SAFETY DATA SHEET

SECTION 1—MATERIAL IDENTIFICATION AND USE

MATERIAL NAME/IDENTIFIER ▶			
MANUFACTURER'S NAME		SUPPLIER'S NAME	
STREET ADDRESS		STREET ADDRESS	
CITY	PROVINCE	CITY	PROVINCE
POSTAL CODE	EMERGENCY TELEPHONE NO.	POSTAL CODE	EMERGENCY TELEPHONE NO.
CHEMICAL NAME	CHEMICAL FAMILY	CHEMICAL FORMULA	
MOLECULAR WEIGHT	TRADE NAME AND SYNONYMS	MATERIAL USE	

SECTION 2—HAZARDOUS INGREDIENTS

HAZARDOUS INGREDIENTS	%	UN, NA OR CAS NUMBER	HAZARDOUS INGREDIENTS	%	UN, NA OR CAS NUMBER

SECTION 3—PHYSICAL DATA

PHYSICAL STATE GAS ☐ LIQUID ☐ SOLID ☐	ODOUR AND APPEARANCE		ODOUR THRESHOLD (PPM)	
VAPOUR PRESSURE (mm Hg)	VAPOUR DENSITY (AIR = 1)	EVAPORATION RATE	BOILING POINT (°C)	FREEZING POINT (°C)
% VOLATILE (BY VOLUME)	SOLUBILITY IN WATER (20°C)	pH	SPECIFIC GRAVITY	

SECTION 4—FIRE AND EXPLOSION DATA

FLAMMABILITY

YES ☐ NO ☐ IF YES, UNDER WHICH CONDITIONS? ▶

MEANS OF EXTINCTION

SPECIAL PROCEDURES

FLASHPOINT (°C) AND METHOD	UPPER EXPLOSION LIMIT (% BY VOLUME)	LOWER EXPLOSION LIMIT (% BY VOLUME)
AUTO IGNITION TEMPERATURE (°C)	TDG FLAMMABILITY CLASSIFICATION	HAZARDOUS COMBUSTION PRODUCTS

EXPLOSION DATA ▶	SENSITIVITY TO IMPACT	RATE OF BURNING	EXPLOSIVE POWER	SENSITIVITY TO STATIC DISCHARGE

SECTION 5—REACTIVITY DATA

CHEMICAL STABILITY

YES ☐ NO ☐ IF NO, UNDER WHICH CONDITIONS? ▶

INCOMPATIBILITY WITH OTHER SUBSTANCES

YES ☐ NO ☐ IF SO, WHICH ONES? ▶

REACTIVITY, AND UNDER WHAT CONDITIONS

HAZARDOUS DECOMPOSITION PRODUCTS

FORM 57M2.

MATERIAL
NAME/IDENTIFIER ▶

SECTION 6—TOXICOLOGICAL PROPERTIES

ROUTE OF ENTRY

SKIN CONTACT ☐　SKIN ABSORPTION ☐　EYE CONTACT ☐　INHALATION ACUTE ☐　INHALATION CHRONIC ☐　INGESTION ☐

EFFECTS OF ACUTE EXPOSURE TO MATERIAL

EFFECTS OF CHRONIC EXPOSURE TO MATERIAL

LD_{50} OF MATERIAL (SPECIFY SPECIES AND ROUTE)	LC_{50} OF MATERIAL (SPECIFY SPECIES AND ROUTE)	LEGISLATIVE EXPOSURE LIMIT OF MATERIAL	IRRITANCY OF MATERIAL
SENSITIZING CAPABILITY OF MATERIAL	CARCINOGENICITY OF MATERIAL	REPRODUCTIVE EFFECTS OF MATERIAL	SYNERGISTIC MATERIALS

SECTION 7—PREVENTIVE MEASURES

PERSONAL PROTECTIVE EQUIPMENT

GLOVES (SPECIFY)	RESPIRATORY (SPECIFY)	EYE (SPECIFY)
FOOTWEAR (SPECIFY)	CLOTHING (SPECIFY)	OTHER (SPECIFY)

ENGINEERING CONTROLS (EG. VENTILATION, ENCLOSED PROCESS, SPECIFY)

LEAK AND SPILL PROCEDURE

WASTE DISPOSAL

HANDLING PROCEDURES AND EQUIPMENT

STORAGE REQUIREMENTS

SPECIAL SHIPPING INFORMATION

SECTION 8—FIRST AID MEASURES

SOURCES USED

ADDITIONAL INFORMATION

PREPARED BY (GROUP, DEPARTMENT, ETC.)	PHONE NUMBER	DATE

FORM 57M2. COPIES OF THIS FORM ARE AVAILABLE FROM THE WORKERS' COMPENSATION BOARD OF B.C.

These terms are measures of the short-term lethality of the chemical based on animal studies. They serve as indicators of the toxicity of the chemical based on the method of exposure and the species studied. Care, however, needs to be taken when using animal data for application to human subjects.

Section 3: Physical Data

This section provides a physical description of the product. This is useful for recognizing or identifying a chemical by color, odor or physical state (gas, liquid, solid). This section has some specific applications for ventilation-system design and emergency situations. Some of the important points for you to know are highlighted:

- *Vapor pressure* is a measure of the ability of a chemical to form vapors. Chemicals with a high vapor pressure can be hazardous, particularly in an enclosed unventilated area.
- *Evaporation rate* is the rate at which a particular material will vaporize (evaporate) in air relative to butyl acetate, ether, or another specified solvent. Because ether evaporates quickly compared to butyl acetate, the chemical used for comparison must be listed. Evaporation rates are useful for estimating the rate of onset of vapor hazard when a liquid or mist aerosol is exposed to air. This may have implications for health and fire hazard potential. Compared to butyl acetate, which has been assigned a rate of 1.0, vaporization rates can be classified as:

 1. *Fast* evaporating if greater than 3.0, such as methyl ethyl ketone or hexane.
 2. *Medium* evaporating if between 0.8 and 3.0, such as ethyl alcohol.
 3. *Slow* evaporating if less than 0.8, such as xylene and mineral spirits.

- *Boiling Point* is an important consideration, because care must be taken to keep stored liquids below their boiling points to prevent them from becoming a fire hazard.
- *pH* is a numerical expression on a scale from 0 to 14 of the extent of acidity or alkalinity of a product. pH values lower than 7 represent acidity and greater than 7 alkalinity. A pH of 7 indi-

cates the material is neither acidic nor alkaline, but is neutral. The pH is one indicator of the material's corrosiveness.

- *Specific gravity* is the ratio of the weight of a volume of the material to the weight of an equal volume of water at a specified temperature. If an insoluble material has a specific gravity more than 1 it will sink in water. If the specific gravity is less than 1 it will float on top of the water. It is important to note the specific gravity of a material for fire-fighting purposes. If the specific gravity of a flammable material is less than 1 you should not use water to fight the fire. The fire will spread if water is applied.

Section 4: Fire and Explosion Data

The intent of this section is to provide information to assist with fire and explosion prevention and procedures in the event of an emergency. This section is particularly important when working with photographic chemicals that are flammable or explosive, solvents, organic peroxides, metal dusts and other unstable substances.

- *Flammability*—if the material is flammable the YES box will be checked off and the conditions under which the material is flammable will be described.
- *Means of extinction* informs you what type of extinguisher is suitable for use on the burning material. Standard fire-fighting agents include water, water fog, foam, alcohol foam, carbon dioxide, and dry chemical.
- *Flash point* is the minimum temperature, under specified test conditions, at which a liquid material gives off enough vapor to be ignited when there is a spark or open flame. The lower the flash point of the material the greater the hazard of vapor ignition. It should be noted that if the flash point of a material is 38°C (100.4°F) or less, the material is a flammable substance. If the flash point is greater than 38°C, it is a combustible material.
- *Flammable limits in air* refers to the upper (maximum) and lower (minimum) concentrations of a gas or vapor in the air between which an explosion or flame propagation will occur when ignited by a spark or flame. These limits are expressed in percent by volume of the gas or vapor in the air. Above the upper flammable limit (UFL) the mixture is too rich to burn; below

the lower flammable limit (LFL) the mixture is too lean to burn. This information is important when evaluating the fire hazard.

- *Auto-ignition temperature* is the lowest temperature at which a vapor or gas will ignite in the absence of a spark or flame. This is an important factor in areas where gases or vapors may be exposed to high temperatures or hot surfaces.
- *Hazardous combustion products* refers to those toxic or hazardous materials likely to be produced when the material is burning.
- *Explosion data: Sensitivity to impact* is a description of the likelihood of the product exploding as a result of mechanical impact such as jarring during transport.
- *Explosion data: Sensitivity to static discharge* refers to the likelihood of a material exploding when a spark occurs due to static buildup. Vapors, dusts, and gases vary in the ease of ignition when exposed to static discharge.

Section 5: Reactivity Data

This section is intended to provide information on the stability of the material and the likelihood of a dangerous reaction with other chemicals. The information provided here has implications for handling procedures and storage arrangements and may be useful along with the previous section for the prevention and control of fires.

- *Chemical stability*—a chemical is unstable if, in the pure state or as it is produced or transported, it becomes self-reactive under the physical conditions of shock, vibration, pressure, or temperature.
- *Incompatibility* refers to the situation in which two substances, when combined, react dangerously and produce toxic or corrosive by-products or an explosion. Incompatible substances must be handled and stored to minimize the likelihood of contact with each other. Acids and bases should be stored far apart because when they are combined a large amount of heat is generated. Any nearby flammable materials can burst into flame when exposed to the heat generated by their mixing.
- *Hazardous decomposition products* lists dangerous products released if the substance is exposed to aging, heating, burning, or oxidation, or is allowed to react.

Section 6: Toxicological Properties

This section provides information on how a material is likely to enter the body and what short- and long-term health effects it is likely to have on an exposed worker, including the signs and symptoms of exposure and preexisting medical conditions that may be aggravated. The information in this section is an important determinant of the preventive and first-aid measures found later in the MSDS.

- *Route of entry* indicates all primary routes of entry or areas of localized effect on the surface of the body. Some chemicals are capable of causing rashes or irritation of the skin or eyes. The material may be inhaled if it is a dust, fume, fiber, mist, vapor, or gas. Another route of entry is absorption of the material through the skin or by ingestion if the material is swallowed. Routes of entry are important from a preventive viewpoint. Inhalation hazards often require air contaminant controls such as ventilation or as a last resort respiratory protection, skin protection, personal hygiene, and other measures.
- *Effects of acute exposure to the material* refers to the adverse health effects resulting from short-term exposure to the material, as either a single exposure or multiple exposures occurring within a short time period—24 hours or less.
- *Effects of chronic exposure to the material* refers to health effects resulting from repeated exposure to the substance over a relatively long time.
- *Exposure limits* are the maximum limits of exposure to an airborne substance as recommended by agencies such as ACGIH and NIOSH or as legislated by a health and safety regulatory agency. Exposure limits generally represent conditions under which it is believed nearly all workers can be repeatedly exposed day after day without adverse effect. There are three types of limits in common use:

1. *Exposure limit—TWA* is the time-weighted average concentration for a normal 8-hour workday or 40-hour workweek to which nearly all workers can be repeatedly exposed without adverse effects.
2. *Exposure limit—STEL* (short term exposure level) is the maximum concentration to which a worker can be periodically

exposed for a period up to 15 minutes without suffering from irritation or chronic or irreversible tissue change.

3. *Exposure limit—C* is the ceiling concentration of an airborne material that must not be exceeded at any time. This limit is applied to substances that are primarily irritant or fast-acting.

- *Irritancy of product* provides information on the primary irritant qualities of the material. Information in this subsection is important when selecting skin and eye protection measures and emergency wash facilities.
- *Sensitizing capability of material.* A sensitizer is a substance that on first exposure is likely to cause little or no reaction. But on repeated exposure, the material may cause a marked response not necessarily limited to the contact site. Skin and respiratory sensitization are common, so appropriate skin and respiratory protective controls should be implemented when handling such materials.
- *Carcinogenicity.* This subsection describes the cancer-causing properties of the material. Information in this subsection may indicate that the material falls under one of the following categories: recognized carcinogen, suspect carcinogen, probably carcinogenic or limited evidence of carcinogenicity. Effective control procedures must be implemented to minimize the risk of exposure to carcinogens. In some cases no exposure may be permitted.
- *Teratogenicity and embryotoxicity* refers to the capability to produce injuries in offspring when pregnant women are exposed to the material at a concentration that has no adverse effect on the mother. The fetus from two to eight weeks gestation is particularly at risk. An example of a teratogen is Thalidomide.
- *Reproductive toxicity* refers to substances that cause sterility or an adverse effect on one's reproductive capacity.
- *Mutagenicity* refers to the capability of a material to cause mutations in the genetic material of living cells. Changes to the reproductive cells may result in heritable genetic defects. Changes that occur to the nonreproductive cells may cause cancer.

Section 7: Preventive Measures

The purpose of this section of the MSDS is to provide you with information on how you can protect yourself while working with these chem-

icals. It also provides some directions or measures that can be taken to protect your health and safety during transportation, storage, use, and disposal of a product.

- Personal Protective Equipment

1. *Gloves.* This subsection specifies what type of glove should be worn whenever the material is likely to contact the hands and also whether it is a primary irritant, sensitizer, or is capable of being absorbed through the skin. The glove should be made of a chemically resistant material.
2. *Respiratory protection.* If the material is likely to constitute an inhalation hazard, this subsection informs the individual what type of respiratory protection to wear. The selection of respiratory protection is based on the nature of the air contaminant, warning properties, irritant qualities, and level of exposure.
3. *Eye protection.* This subsection specifies if the material is likely to pose a hazard to the eyes. This subsection should also specify the appropriate type of eye protection to wear (safety glasses, monogoggles, face shield), the lens material composition, and the circumstances of use.
4. *Footwear.* This subsection specifies if the material is a hazard to the lower legs or feet due to skin absorption, irritation, or sensitization, and if the material may cause deterioration of normal footwear or constitute a slipping hazard.
5. *Clothing.* This subsection specifies whether the chemical may constitute a hazard through skin contact or skin absorption. It describes what type of clothing should be worn—apron, vest, coveralls, and so on.

- *Engineering controls.* This subsection provides information on the recommended engineering controls such as ventilation, process equipment design, and the like.
- *Leak and spill procedures.* This subsection provides information on safe procedures to follow in the event of a spill, leak, or release of the material. It may indicate what neutralizing or absorbing materials to use.
- *Waste Disposal.* This subsection may provide information, as appropriate, relating to the waste-container design, preferred or required disposal locations, safe procedures for handling wastes, and agencies to contact regarding disposal requirements.

- *Handling procedures and equipment.* This subsection describes the particular procedures and equipment needed for protection against primary and special hazards of the material.
- *Storage requirements.* This subsection provides information that is essential for safe storage of the material in terms of temperature, controlling ignition sources, separating incompatible chemicals, and special storage information, such as picric acid being stored underwater because it becomes an explosive when dry.
- *Shipping information.* Information must be provided relating to the safe shipment of the material. Some factors that are considered are sensitivity to shock and sensitivity to temperature. It also lists applicable Transportation of Dangerous Goods classifications.

Section 8: First-Aid Measures

The intent of this section of the MSDS is to provide primary information for the safe evacuation and immediate treatment of a person experiencing the effects of overexposure to the material.

- Specific measures—may have a statement of steps to be taken during the treatment of an injured person. The form of treatment will vary with the degree of exposure to the product and its route of entry. Separate first-aid procedures for each route of entry (inhalation, skin absorption, ingestion) are necessary for most substances.

Section 9: Preparation Date of the MSDS

In Canada, WHMIS legislation requires that Material Safety Data Sheets be kept current and that they be updated every three years prior to receipt of the material in the workplace. Information in this section is designed to ensure compliance with legislation.

LABORATORY AND DARKROOM PROCEDURES

SUBSTITUTIONS

The concept of substituting less-toxic chemicals for toxic ones, or replacing chemicals that are difficult to work with or require special operating

conditions, has already been mentioned. Photographic chemicals can sometimes be substituted for one another and still provide the same visual effect. An example of this would be the replacement of a toxic developer agent such as phenylenediamine with a less toxic developer agent such as phenidone. These substitutions are possible in numerous processing sequences as well as individual baths such as toners and intensifiers, where the very toxic mercury compounds used for image bleaching are replaced with less toxic baths such as sulfide toners or silver intensifiers. This is not to say that the replacement chemistries are harmless; they are less toxic and in some cases easier to manage. Generally, all photographic chemicals have associated health hazards, but some are less hazardous than others, and these should be used as substitutions whenever possible.

It should be noted that the flexibility of substituting chemicals in photographic chemistries applies more to black-and-white processes than to color chemistries. The depth of experimentation that took place in the first hundred years of photographic history concerned black-and-white processes almost exclusively, and much of this work was presented in the literature of the day. The history of color photography is more recent, involving the last 50 or so years, and much of this has been controlled by manufacturers who do not disclose the formulations of their products and are apt to change components within the chemistries without detailing these changes. The ability to substitute less toxic chemicals is severely restricted in color processes, and it follows that greater care and caution must be exercised when working with them.

There are groups of chemicals used in photography that promote similar types of hazards. The use of sulfur-based compounds in photography is very common, and they include thiosulfates, sulfites, sulfates, and sulfides. The most common salts are sodium and potassium; some ammonium salts are also used, particularly ammonium thiosulfate, which is the major component in rapid fixer formulations. The hazards associated with using these compounds is that they may release toxic sulfur gases during processing. The generation of these gases can occur when the processing bath is heated sufficiently to decompose the compound or when the bath is contaminated with acid solutions. The use of ammonium thiosulfate has an additional hazard associated with its contamination by an acidic solution. It can also generate ammonia gas.

Sulfur compounds that include sulfides, particularly when used in toners, can result in the bath giving off hydrogen sulfide gas. This is the classic "rotten egg" smell. This gas is particularly toxic in small concentrations, and it is generated when the toner bath containing the sulfide is

contaminated by an acidic solution. The rotten egg odor is particularly easy to identify at low concentrations but some individuals may lose their sensitivity to the gas and therefore be at higher risk. Hydrogen sulfide paralyzes the olfactory nerves at two parts per million, so when you lose the ability to smell it, higher concentrations are already present.

Control can be exercised by substituting less reactive chemicals, by reducing the possibility of acid solutions contaminating solutions containing hazardous chemicals, and by eliminating processes that require elevated temperatures. If an elevated processing temperature must be used, there are housekeeping techniques available that can help control the process and remove any gas generated during processing. Most color processes are now run at 100°F, so control of the process must include local exhaust ventilation to remove any gases generated because of a contamination problem.

The most common situation in which contamination can occur is acid carryover from the stop bath into the fixer during processing. The fixer is generally acidic in nature and buffered so that some carryover will not create a problem, but in situations in which a plain hypo bath is used or carryover from the stop bath is excessive, an intermediate water bath should be used to reduce the problem.

There are toner baths that contain sulfides, usually potassium or sodium salts, but they can include selenium sulfide found in selenium toners. Acid contamination of these baths can result in hydrogen sulfide and/or hydrogen selenide gases being given off; both gases are toxic. The bleach and redeveloper toner solutions and some intensifier treatment sequences also make use of an acid stop bath between steps and, if improperly washed, a similar type of contamination could occur.

The use of heavy metals can also create hazardous situations. Most toning baths and some intensifiers make use of heavy metals to help realize the chemical reaction. The problems associated with mercury salts have already been mentioned. Other heavy-metal salts that represent a hazard include uranium, cobalt, chromium, lead, and vanadium salts. Solutions containing these salts should not be used. The use of less toxic selenium, iron, and silver salts is recommended, but with caution, appropriate ventilation, and personal protection. It should be noted that chromium salts are considered carcinogenic, and their use requires extreme caution.

The presence of oxidizers should also be mentioned. A number of oxidizing chemicals are used in photographic processing solutions. The application in which they are most commonly found is in reducers.

These chemicals, notably ammonium persulfate and potassium perman-ganate, should not be used. They constitute a hazard because of their very toxic nature as well as the fact that they constitute a fire hazard. The contamination of ammonium persulfate with organic materials can re-sult in the combustion of the chemical.

The use of reducers and intensifiers in photography is in itself ques-tionable. At one time the photographic process and particularly the ex-posure of the negative in the camera was a "hit-or-miss" proposition. These types of solutions were commonly used to save an image. Today the ability to accurately control and predict the results of exposure should relegate these types of treatments to the archives of photograph-ic history. However, since a situation may occur in which these types of chemical treatment techniques are required, they have been included as part of Chapter 3.

HOUSEKEEPING

Housekeeping encompasses those routine procedures that can be used to minimize and control the exposure to hazards while working with photographic chemicals. The preparation of chemical solutions, either from prepackaged materials or from scratch using bulk chemicals, re-quires good local ventilation and proper personal equipment. Ideally, the mixing of solutions will take place in a dedicated room away from the immediate darkroom work space. This will minimize contamination problems, allow for easy and efficient cleanup should a spill take place, and allow for a dedicated exhaust system, which can be designed to pro-vide proper exhaust ventilation on demand during mixing operations.

The exhaust ventilation for this space would include a greater vol-ume rate of exhaust than would be needed in the darkroom, and the ex-haust grill or port would be located immediately above the mixing space. In the darkroom the grill would be immediately above the sink at the working level for processing.

The mixing of working-solution chemistry from bulk chemicals re-quires additional protective clothing that might not be required when using the working-strength solutions in the darkroom. For example, the use of goggles and a cartridge respirator might be mandatory when mix-ing some of the working solutions used in black-and-white photography but not during processing. Gloves and protective clothing such as lab coats and aprons should always be used regardless of the activity. Al-

though the use of tongs could be considered acceptable for some processes, gloves should be worn as part of a darkroom routine.

The housekeeping controls for the darkroom space include tray and tank covers when the solutions are not in use. These covers are designed to reduce the chance of accidental contamination of the baths as well as to help preserve the working life of some of the solutions. The use of water baths between acidic and certain hazardous baths, such as toner baths containing sulfides, reduces the chance of contamination and hazardous gases being generated.

Observing handling rules when mixing chemicals of a hazardous nature is also a housekeeping procedure. For example, the rules of always wearing appropriate gloves and goggles when handling concentrated acids and always adding a small amount of acid to a much larger volume of water should always be followed. The reaction between acids and water produces a great deal of heat, and if the water were accidentally added to the acid, splashing and acid burns to the person mixing the solution could result.

Housekeeping includes the cleanup and regular washing of clothing and maintenance of the various pieces of equipment used for mixing chemicals. Trays should be labeled and never crossed during use. The residual chemicals in a tray, particularly if the tray is improperly cleaned after use, could lead to contamination of another solution placed in that tray. Additionally, contamination could lead to staining of the images being processed in the tray.

Housekeeping also includes the regulation of activities within the darkroom and associated spaces. This includes the restriction of activities such as smoking, eating, and drinking in the work spaces. The darkroom staff must be provided with washup areas with soap and towels to ensure that they wash after processing sessions and before taking breaks or finishing for the day.

CHEMICAL INCOMPATIBILITIES

Haist in *Modern Photographic Processing*, Hedberg's article, "Safe Storage and Handling in Chemicals" in *Hazardous Chemical Desk Reference*, and Shaw and Rossol in *Overexposure* provide lists of chemicals that should not be used.[1] These lists have been compiled and extended

1. Grant Haist, *Modern Photographic Processing* (New York: John Wiley and Sons, 1979), vol. 1, p. 353; Donald D. Hedberg, "Safe Storage and Handling of Chemicals," Richard Lewis and N. Irving Sax, *Hazardous Chemical Desk Reference* (New York: Van Nostrand Reinhold, 1987), section 1, pp. 3-21; Susan D. Shaw and Monona Rossol, *Overexposure, Health Hazards in Photography*, 2nd ed. (New York: Allworth Press, 1991), p. 62.

to summarize below the chemicals that should not be used in photo-graphic processing solutions or that should be used with caution.

Do Not Use

The following chemicals are particularly dangerous or are carcinogens or suspected carcinogens. These compounds are nonessential or can be substituted.

Benzene	Methylene chloride
Benzidine	Mineral spirits
Cadmium compounds	Naphtha
Carbon tetrachloride	6-nitro-benzimidazone nitrate
Chloroform	Perchloric acid
Chromic acid	Petroleum ether
Cyanides	Potassium dichromate
Dioxane	Potassium permanganate
Gasoline	Selenium powder
Iodine	Sodium selenite
Kerosene	Trichloroethylene
Lead compounds	Uranium compounds
Mercury compounds	

Use with Extreme Caution

These chemcials tend to be dangerous, but because of their usefulness or lack of substitutions they are required.

Acetic acid	Heptane
Ammonia	Hydrochloric acid
Benzotriazole	Hydroquinone
Catechol	Organic solvents
Chromates	Peroxides and strong bases
Chlorates and oxidizers	p-phenylenediamine
Concentrated acids	Potassium chrome alum
Color developer CD-3	Pyrogallol
Color developer CD-4	Sulfuric acid
EDTA	Tetrasodium EDTA
Formaldehyde	

Use with Caution

These chemicals tend to have some dangerous characteristics that the user needs to beware of above and beyond the normal safety practices used with all chemicals.

> Acetone
> Amidol
> Diethylene glycol
> Methanol
> Metol
> Phenidone
> Potassium hydroxide
> Sodium hydroxide
> Sodium metaborate
> Toluene

Dangerous Combinations

Do Not Combine	With
Acetic acid	Nitric acid, peroxides
Ammonia	Calcium hypochlorite, halogens
Chlorates	Acids, ammonium salts, combustibles
Hydrogen peroxide	Most metals and metal salts, flammables, combustibles
Nitric acid	Acetic acid, flammables
Oxalic acid	Silver
Sodium peroxide	Glacial acetic acid, alcohol, glycerine, ethylene glycol
Sulfuric acid	Chlorates, perchlorates

CHEMICAL HAZARD STRATEGY

Having reviewed the issues associated with the hazards encountered in the general operation of a darkroom, it is now necessary to evolve a strategy that can be used to establish the information required for an existing darkroom setting. The process might include the following;

- Defining the photographic processes in use in the darkroom.
- Making a list of all the chemicals and solutions (by process) that are being prepared and used in the darkroom, including both prepackaged items and bulk chemicals.
- Contacting the suppliers and chemical manufacturers of the components that have been identified and requesting MSDSs.
- Locating any missing information by using the information resources listed in the bibliography.
- Discontinuing the use of any product or chemical that cannot be supported by the above information search.
- Organizing the information compiled from the MSDSs or other information sources into folders or ring binders on the basis of each specific process, and including all the critical issues associated with the process as a summary at the front of the binder. For example, if the E-6 process is being used, a binder should be created in which all of the MSDS information for the E-6 process has been compiled and organized. This will be the primary information source for first-aid information and other issues that may need to be resolved or clarified by the MSDSs.
- Determining what upgrades are required to the darkroom, the equipment, and the ventilation to provide a safe operating environment. The information in the MSDSs will help in determining these needs; further assistance may be obtained from the resources listed in the bibliography.
- Establishing housekeeping procedures for the darkroom to provide scheduled cleaning and preventive safety measures.
- Providing the darkroom staff or users with an information session or training program to inform them of their rights and providing them with the information that has been compiled.

BLACK-AND-WHITE PHOTOGRAPHIC PROCESSES

INTRODUCTION

The evolution of proper handling of photographic chemicals and safe working techniques needs to be part of the initial learning process. Generally students are introduced first to black-and-white processes, and only after mastering the basic techniques will they move on to color and possibly less common photographic techniques such as platinum printing. Many photographers continue to process their own black-and-white work while sending out color materials for commercial processing. For these reasons, this chapter, concerning black-and-white processes and chemicals used for realizing a black-and-white image, provides greater detail than the next chapter on color photography.

It is also possible to provide more information on chemicals used in black-and-white photography and their associated hazards because more is known about the metal-based compounds used in black-and-white photography than about the organic compounds used in color processing chemistry.

Many chemicals are used in the processing sequences for black-and-white processes, most of which have been characterized for their toxicity. The developers include complex organic compounds as well as other additives that might include alkalies and solvents. The other solutions used in processing may include acids and oxidizing compounds.

The information in this chapter is organized on the basis of a normal processing sequence for black-and-white materials: a developer, an acid stop bath, followed by a fixer solution. The description of a full-preserva-

tion (archival) processing sequence is included because most photographers are now concerned about the permanence of their images, particularly their negatives. Also included is information on the use of cleaning solutions such as those that might be used for cleaning negatives before printing, as well as various testing solutions. The section at the end of this chapter describes some of the less common chemical treatments, including intensification, reduction, toning and hand coloring.

The chemical hazard information, or chemical information units (CIUs), includes a summary of the four routes of entry: skin contact, eye contact, inhalation, and ingestion. The hazards of a given chemical are described as "not very toxic," "moderately toxic," and "toxic." Not very toxic is the least hazardous level, but because all chemicals have some hazard, these materials will require care and consideration during handling and use. Moderately toxic substances are those that can cause damage to the body and therefore require both greater care in handling and improved protection from contact with the substance. Toxic materials represent a very serious hazard; if possible, these substances should be avoided or substituted. If they are used, extreme care and the proper protective environment must be used during handling and processing.

The CIUs also contain information about decomposition products that could occur when the substance is heated or contaminated. Requirements for handling the chemicals during mixing and during processing—such as any special clothing the operator should wear (aprons, gloves, goggles), the mask requirement (dust mask, cartridge respirator, or with particularly hazardous materials, a full face respirator), and the minimum ventilation needed—are also included. The information provided has been compiled from several references (shortened references to sources are provided with the chemical information; see the bibliography for the full references.) Each individual should compile his or her own CIU files for the materials being used and determine risk levels based on that information.

A general recommendation for practicing photographers is to purchase processing chemicals in liquid concentrate form to be mixed and diluted for use rather than powders. Liquids are easier to handle during mixing, thus avoiding dusts generated by powders. Some photographers will have to formulate the various solutions from scratch because of the unique processes they are interested in or because limited demand has resulted in commercial manufacturers discontinuing their production. A small number of specialized mail-order firms now exist to provide this particular service.

DEVELOPERS

Developer solutions usually contain a developing agent or a mixture of agents along with other chemical components that contribute to the image-forming process. The photographic emulsion is exposed to light, and a portion of the light-sensitive silver grains that has been struck by the light forms a "latent image." The ability to "develop" this latent image by introducing a reducing agent to form a metallic silver image is the basis of the image-formation process.

The most common combination of developer agents is hydroquinone and metol (elon) or phenidone. The other developer agents are used for special end uses. Presently, pyro development has been revived as a special technique for use with large-format photography.

Other chemicals added to the developer include alkalies, usually sodium carbonate or borax. These serve as accelerators, providing an oxidizing environment in which the reducing agents (the developer agent) can perform. Sodium sulfite is commonly added as a preservative to prevent the developer from being oxidized before it has had a chance to react with the latent image. Potassium bromide is commonly present in small amounts as a restrainer (antifog), since the developer solution might deposit out smaller amounts of silver into areas that did not receive any exposure.

The primary hazards associated with the safe use of developer solutions involve skin and respiratory allergies. Contact can take place with concentrated solutions or powders during mixing or regular contact with working-strength solutions during processing.

Developers are irritants to both skin and eyes, and they can also be strong allergic sensitizers. Metol is a good example of a developer agent that can cause severe skin irritation and allergies. Photographic developers can also cause inflammatory skin disease, which is characterized by tiny reddish itchy areas that may eventually form rough and scaly skin patches.

The absorption of a developer agent through the skin can also be a problem. The use of particularly toxic developer agents such as paraphenylenediamine, amidol, catechin or pyrogallol requires proper glove protection. The use of phenidone-based developers is recommended because it is the least toxic by skin contact of all available developer agents.

Alkalies added as accelerators to the developer solution may also increase the risk of skin-related ailments due to skin contact.

Inhalation is a concern primarily during the mixing of powdered developers, particularly if exposure is repeated regularly. This situation can result in respiratory irritation and allergies. The use of an appropriate dust mask during mixing operations is imperative.

Ingestion needs to be carefully guarded against, since most developers are quite toxic. Ingestion of small amounts of some developer powders can be fatal to adults. To eliminate the possibility of accidentally consuming liquid solutions, do not drink or eat in the darkroom or chemical storage areas. Children and pets should not have access to darkrooms or mixing rooms even if supervised.

GUIDELINES FOR USING DEVELOPERS

Generally

There are two considerations for choosing your developer. First, using premixed concentrated solutions reduces the hazards associated with mixing powdered developers. Second, you can reduce the danger by replacing known hazardous developers with less toxic ones. Developers containing catechin, para-phenylenediamine, or pyrogallol should be replaced with less toxic ones such as phenidone.

Preparation

If possible, mixing should be done under a canopy head or in a fume hood or inside a specially designed glove box. Wear safety gloves (rubber safety gloves or rubber surgical gloves) and splash goggles when handling developer powders. If there is no canopy hood available, wear an approved dust mask while mixing. Remember, avoid inhalation of powders or skin contact with concentrated developer solutions or powders at all times.

During Use

Do not put bare hands into developer baths; use tongs or rubber gloves. Barrier creams can be used as a second layer of protection under the gloves. Remember that barrier creams alone are not effective against developer agents, which can be absorbed through the skin. It is also possible that the creams may adversely effect the developer bath, resulting in stains on the processed images.

If developer solution splashes on the skin, rinse the affected areas immediately with plenty of water. For eye splashes, continue rinsing for

at least 15 minutes and consult a physician. Darkrooms should be equipped with an eyewash station for emergencies.

Proper precautions need to be taken for housekeeping and ventilation of the processing and mixing areas of the darkroom. Return working solutions to storage containers after use or, if necessary, cover the processing tanks between work sessions to prevent evaporation or release of toxic vapors and gases. This practice also extends the useful life of the solutions. Store corrosive chemicals (acids and alkalies) on lower shelves to prevent injury to the face or eyes in case of breakage.

Remember to keep developer solutions (and other photographic chemicals) out of the reach of children. If the darkroom is at home, either keep the room locked or keep the chemicals in locked cabinets.

DEVELOPER AGENTS

There are hundreds of different chemicals that can function as developer agents, but only a handful have found practical commercial application in photography. The following is a description of 10 of the more useful or popular developer agents.

Amidol

AMIDOL
(Use With Caution)

Amidol was discovered in 1891, and is also known by the trade names Acrol, Diaminophenol, and Dianol. Its chemical name is amidol or 2,4-diaminophenol dihydrochloride.

 Skin contact: moderately toxic—may cause allergic
 reaction or irritation
 Eye contact: moderately toxic
 Inhalation: toxic
 Ingestion: toxic

If heated to decomposition, can emit toxic fumes of nitrogen oxides and hydrogen chloride.

Requires local exhaust ventilation, dust mask, goggles, plastic apron, and rubber gloves during mixing. Requires local exhaust ventilation and plastic gloves during processing.

Due to the short life of this developer, it is usually mixed by the user just prior to use. Amidol is usually used alone with sulfite or bisulfite.

Ilford ID-9 Amidol Developer
Ref.: DeCock 1990, sec. 15, p. 9

This developer is recommended for use with film.

Water, 125°F	750.0 ml
Sodium sulfite, desiccated	100.0 g
Amidol	20.0 g
Potassium bromide	6.0 g
Water to make	1,000.0 ml

There is no alkali in this developer, so swelling of the gelatin emulsion is minimized.

SODIUM SULFITE

Also known as sulfurous acid, sodium salt.

Skin contact: not very toxic–may cause irritation
Eye contact: not very toxic–may cause irritation
Inhalation: moderately toxic–may cause irritation
Ingestion: toxic–could cause death if consumed
in significant amounts

If heated to decomposition or mixed with acid, can emit toxic sulfur dioxide and sodium oxide fumes.

Requires local exhaust ventilation, dust mask, goggles, plastic apron, and plastic or rubber gloves during mixing. Requires local exhaust ventilation and plastic gloves during processing.

POTASSIUM BROMIDE

Also known as bromide salt of potassium.

Skin contact: not very toxic–prolonged exposure
can cause skin rash
Eye contact: not very toxic–temporary discomfort
Inhalation: moderately toxic
Ingestion: moderately toxic–harmful in large amounts

If heated to decomposition, can emit toxic fumes of bromine gas.

Requires local exhaust ventilation, dust mask, goggles, plastic apron, and plastic gloves during mixing. Requires local exhaust ventilation and plastic gloves during processing.

Catechol (Pyrocatechin, Catechin)

CATECHOL (PYROCATECHIN, CATECHIN)
(Use With Extreme Caution)

Catechol was reported as a developer in 1880. It is also known by the trade names Elconal, Kachin, Pyrocatechin, and Pyrocatechol. Its chemical name is catechol or ortho-dihydroxybenzene.

Skin contact: toxic–causes allergic reaction and dermatitis
Eye contact: toxic
Inhalation: toxic–causes severe acute poisoning
Ingestion: toxic–very small amounts, less than 1 g, can be fatal

If heated to decomposition, can emit irritating acrid smoke and toxic gases.

Requires local exhaust ventilation, dust mask, goggles, plastic apron, plastic sleeves, and rubber gloves during mixing. Requires local exhaust ventilation, goggles or safety glasses, and rubber gloves during use.

Pyrocatechin Compensating Developer
Ref.: Adams 1981, appendix 3, p. 255

Solution A

Water, distilled	100.00 cc
Sodium sulfite, desiccated	1.25 g
Pyrocatechin	8.00 g

Solution B

Sodium hydroxide	1.00 g
Water to make	100.00 cc

Mix just prior to use, 20 parts A with 5 parts B and 500 parts water.

This developer agent is not commonly used. It produces a residual stain image in baths with low quantities of preservative (sulfite). The developer is described as being used for retaining definition in high-placement areas, above Zone X. The film will lose a stop in effective speed, and the stain produced will make judging the negative difficult. The developer is discarded after use, and testing with contemporary films is necessary. This developer compound is believed to be a component in the following developer:

- Photographers Formulary: Windisch Pyrocatechin Developer

SODIUM SULFITE

Also known as sulfurous acid, sodium salt.

Skin contact: not very toxic–may cause irritation
Eye contact: not very toxic–may cause irritation
Inhalation: moderately toxic–may cause irritation
Ingestion: toxic–could cause death if consumed
in significant amounts

If heated to decomposition or mixed with acid, can emit toxic sulfur dioxide and sodium oxide fumes.

Requires local exhaust ventilation, dust mask, goggles, plastic apron, and plastic or rubber gloves during mixing. Requires local exhaust ventilation and plastic gloves during processing.

SODIUM HYDROXIDE (USE WITH CAUTION)

Also known as caustic soda, soda lye, and sodium caustic.

Skin contact: toxic–corrosive; causes burns to skin
and mucous membranes
Eye contact: toxic–corrosive; causes burns to eyes
Inhalation: toxic–corrosive; causes burns to respiratory system
Ingestion: toxic–can be fatal; damages all body tissues

Concentrated forms are corrosive to all body tissues, resulting in burns and scarring. Dilute solutions are also very corrosive and have similar hazards.

Requires local exhaust ventilation, dust mask, goggles, rubber apron, and rubber or nitrile gloves during mixing. Requires local exhaust ventilation, plastic or rubber apron, and rubber gloves during use.

Chlorohydroquinone

CHLOROHYDROQUINONE

Chlorohydroquinone was introduced in 1897. It is also known by the trade names Adurol or Chloroquinol. Its chemical name is chlorohydroquinone or 2-chloro-1,4-dihydroxybenzene. This developer agent is found in developer formulation used to develop prints with some image color control.

Skin contact: moderately toxic
Eye contact: moderately toxic
Inhalation: moderately toxic
Ingestion: toxic

If heated to decomposition, can emit toxic chlorine gas fumes.

Requires local exhaust ventilation, dust mask, goggles, plastic apron, and rubber or plastic gloves during mixing. Requires local exhaust ventilation and rubber or plastic gloves during processing.

This developer agent is similar to hydroquinone. It can be used alone or mixed with metol and can be used to make concentrated solutions. This developer compound is believed to be a component in the following developers:

- Edwal: FG-7 Developer, Platinum Developer
- Photographers Formulary: Adural Developer, Paper Developer 111

Glycin

GLYCIN

Glycin was discovered in 1891 and is also known by the trade names Athenon, Glyconol, Inconyl, Monazol, or Kodurol. Its chemical name is glycin or para-hydroxyphenylaminoacetic acid. This developer agent is found in developer formulations used to develop prints with some image color control.

Skin contact: moderately toxic–causes allergic reactions
and irritation
Eye contact: moderately toxic
Inhalation: moderately toxic
Ingestion: moderately toxic

If heated to decomposition, can emit toxic fumes of nitrogen oxides.

Requires local exhaust ventilation, dust mask, goggles, plastic apron, and plastic gloves during mixing. Requires local exhaust ventilation and plastic gloves during processing.

This developer agent can be used alone or mixed with other developer agents such as para-phenylenediamine. This developer compound is believed to be a component in the following developers:

- Edwal: Edwal 12 Developer, Platinum Developer, Super 20 Developer
- Photographers Formulary: Paper Developer 10, Paper Developer 111, Warm Tone Paper Developer 106

Hydroquinone

HYDROQUINONE
(Use With Extreme Caution)

Hydroquinone was discovered in 1880 and is also known by the trade names Hydrochinon, Hydrokinone, Hydroquinol, Quinol, or Tecquinol. Its chemical name is hydroquinone or para-dihydroxybenzene.

Skin contact: moderately toxic–causes allergic reactions and irritation; solid can cause burns, solutions can cause dermatitis
Eye contact: moderately toxic–dust causes irritation
Inhalation: moderately toxic–dust causes irritation
Ingestion: toxic

This chemical is a suspected carcinogen.
If heated to decomposition, can emit acrid fumes, including quinone.
Requires local exhaust ventilation, dust mask, goggles, plastic apron, and rubber gloves during mixing. Requires local exhaust ventilation, plastic apron and rubber gloves during processing.

This developer agent is usually used in combination with metol. These mixtures are referred to as M-Q developers, and hydroquinone represents the contrast development agent. This developer compound is believed to be a component in the following developers:

- Edwal: Edwal G Paper Developer, Platinum Developer, TST Paper Developer
- Ilford: Bromophen Developer, ID-11/ID-11 PWS Developers, Ilfobrom Developer, Ilfosol 2 Developer, Ilfospeed Multigrade Developer, Ilfospeed 2 Developer, Microphen Developer
- Kodak: D-11, D-76, DK-50, D-88, Dektol, Ektaflow, Ektonal, Kodalith, HC-110, Selectol, Versatol
- Photographers Formulary: Warm Toned Paper Developer 106
- Ethol: LPD Paper Developer
- Kodak D76 M-Q Film Developer

Ref.: Haist 1979, p. 340. The chemicals are listed in the order in which they would be mixed.

Water, at about 125°F	750 ml
Elon (metol)	2 g
Sodium sulfite, desiccated	100 g
Hydroquinone	5 g
Borax, granular	2 g
Water to make	1,000 ml

METOL
(Use With Caution)

Skin contact: moderately toxic–may cause allergic
 reaction or irritation; repeated contact
 may result in dermatitis
Eye contact: moderately toxic–may cause irritation
Inhalation: moderately toxic–may cause respiratory tract irritation
Ingestion: toxic

If heated to decomposition, can emit toxic fumes of sulfur dioxide and nitrogen oxide.

Requires local exhaust ventilation, dust mask, goggles, plastic apron, and rubber gloves during mixing. Requires local exhaust ventilation, goggles or safety glasses, and rubber or plastic gloves during processing.

SODIUM SULFITE

Also known as sulfurous acid, sodium salt.

Skin contact: not very toxic–may cause irritation
Eye contact: not very toxic–may cause irritation
Inhalation: moderately toxic–may cause irritation
Ingestion: toxic–could cause death if consumed
 in significant amounts

If heated to decomposition or mixed with acid, can emit toxic sulfur dioxide and sodium oxide fumes.

Requires local exhaust ventilation, dust mask, goggles, plastic apron, and plastic or rubber gloves during mixing. Requires local exhaust ventilation and plastic gloves during processing.

BORAX

Also known as sodium borate or (di)sodium tetraborate.

Skin contact: not very toxic–may cause irritation
Eye contact: moderately toxic–may cause allergic
reaction or irritation
Inhalation: moderately toxic–dust may be irritating
Ingestion: moderately toxic; toxic in large amounts

If heated to decomposition, can emit toxic fumes of sodium oxide gas.

Requires local exhaust ventilation, dust mask, goggles, plastic apron, and rubber or plastic gloves during mixing. Requires local exhaust ventilation, goggles or safety glasses, and rubber or plastic gloves during processing.

Metol

METOL
(Use With Caution)

Metol has been in use since 1891 and is also known by the trade names Atolo, Elon, Genol, Graphol, Monol, Pictol, Photol, Rhodol, Satrapol, Scalol, or Viterol. Its chemical name is metol or monomethyl-para-aminophenol sulfate.

Skin contact: moderately toxic–may cause allergic reaction or
irritation; repeated contact may result in dermatitis
Eye contact: moderately toxic–may cause irritation
Inhalation: moderately toxic –may cause respiratory tract irritation
Ingestion: toxic

If heated to decomposition, can emit toxic fumes of sulfur dioxide and nitrogen oxide.

Requires local exhaust ventilation, dust mask, goggles, plastic apron, and rubber gloves during mixing. Requires local exhaust ventilation, goggles or safety glasses, and rubber or plastic gloves during processing.

This developer agent is usually used in combination with hydroquinone, and these mixtures are referred to as M-Q (metol(hydro) quinone) developers. It is the soft developer agent. It can also be mixed with chlorohydroquinone, glycin or pyro. Individuals reacting to it because of their skin sensitivity have "metol poisoning." This developer compound is believed to be a component in the following developers:

- Edwal: Edwal 12 Developer, TST Paper Developer
- Ilford: ID-11/ID-11 PWS Developers, Perceptol Developer
- Kodak: D-11, D-76, DK-50, Dektol, Ektaflo, Ektonal, Microdol-X, Polydol, Selectol, Selectol soft, Versatol
- Photographers Formulary: Paper Developer 111, WD2D Pyro-Metol Developer, Windisch 665 Fine Grain Developer
- Kodak D-23 Film Developer

Ref.: Anchell 1991, "D-23: An Old Friend Revisited," pp. 21–22, 24

Water, at about 125°F	750.0 ml
Elon (metol)	7.5 g
Sodium sulfite	100.0 g
Water to make	1,000.0 ml

SODIUM SULFITE

Also known as sulfurous acid, sodium salt.

Skin contact: not very toxic–may cause irritation
Eye contact: not very toxic–may cause irritation
Inhalation: moderately toxic–may cause irritation
Ingestion: toxic–could cause death if consumed
in significant amounts

If heated to decomposition or mixed with acid, can emit toxic sulfur dioxide and sodium oxide fumes.

Requires local exhaust ventilation, dust mask, goggles, plastic apron, and plastic or rubber gloves during mixing. Requires local exhaust ventilation and plastic gloves during processing.

Para-Aminophenol

PARA-AMINOPHENOL

Para-aminophenol was first used in 1888. It is also known by the trade names Kodelon, Para, Rodinal, Azol, Activol, or Certinal. Its chemical name is para-aminophenol hydrochloride or parahydroxyaniline hydrochloride.

Skin contact: moderately toxic–may cause allergic reaction
or irritation; may cause dermatitis if absorbed
through the skin
Eye contact: moderately toxic–may cause irritation

Inhalation: moderately toxic
Ingestion: moderately toxic

If heated to decomposition, can emit toxic fumes of hydrogen chloride and nitrogen dioxide.

Requires local exhaust ventilation, dust mask or respirator (organic vapor cartridge), goggles, plastic apron, and rubber gloves during mixing. Requires local exhaust ventilation, plastic apron, and rubber or plastic gloves during processing.

This developer agent, when mixed with hydroquinone, is said to be free of the impurities that cause skin allergy (Haist 1979, p. 176). It can be prepared as a concentrate. This developer compound is believed to be a component in the following developers:

- Agfa-Geveart: Rodinal Developer
- Edwal: Super 20 Developer
- Kodak DK-92 Film and Paper Developer

Ref.: DeCock 1990, sec. 15, p. 25.

This developer is listed as a substitute for people sensitive to metol (elon) in M-Q developers.

Water, 125°F	500.0 ml
p-aminophenol hydrochloride	5.0 g
Sodium sulfite, desiccated	30.0 g
Hydroquinone	2.5 g
Sodium metaborate (Kodalk)	20.0 g
Potassium bromide	0.5 g
Water to make	1,000.0 ml

SODIUM SULFITE

Also known as sulfurous acid, sodium salt.

Skin contact: not very toxic–may cause irritation
Eye contact: not very toxic–may cause irritation
Inhalation: moderately toxic–may cause irritation
Ingestion: toxic–could cause death if consumed
in significant amounts

If heated to decomposition or mixed with acid, can emit toxic sulfur dioxide and sodium oxide fumes.

Requires local exhaust ventilation, dust mask, goggles, plastic apron,

and plastic or rubber gloves during mixing. Requires local exhaust ventilation and plastic gloves during processing.

HYDROQUINONE
(Use With Extreme Caution)

Also known by the trade names Hydrochinon, Hydrokinone, Hydroquinol, Quinol, or Tecquinol. Its chemical name is hydroquinone or para-dihydroxybenzene.

> Skin contact: moderately toxic–causes allergic reactions and irritation; solid can cause burns, solutions can cause dermatitis
> Eye contact: moderately toxic–dust causes irritation
> Inhalation: moderately toxic–dust causes irritation
> Ingestion: toxic

This chemical is a suspected carcinogen.

If heated to decomposition, can emit acrid fumes including quinone.

Requires local exhaust ventilation, dust mask, goggles, plastic apron, and rubber gloves during mixing. Requires local exhaust ventilation, plastic apron, and rubber gloves during processing.

SODIUM METABORATE
(Use With Caution)

Also known as Kodalk or balanced alkali.

> Skin contact: moderately toxic–may cause burns and irritation
> Eye contact: moderately toxic–may cause burns and irritation
> Inhalation: toxic
> Ingestion: toxic

If heated to decomposition, can emit toxic fumes of sodium oxide gas.

Requires local exhaust ventilation, dust mask, goggles, plastic apron and sleeves, and rubber or plastic gloves during mixing. Requires local exhaust ventilation, goggles or safety glasses, and rubber or plastic gloves during processing.

POTASSIUM BROMIDE

Also known as bromide salt of potassium.

> Skin contact: not very toxic–prolonged exposure can cause skin rash
> Eye contact: not very toxic–temporary discomfort

Inhalation: moderately toxic
Ingestion: moderately toxic–harmful in large amounts

If heated to decomposition, can emit toxic fumes of bromine gas.

Requires local exhaust ventilation, dust mask, goggles, plastic apron, and plastic gloves during mixing. Requires local exhaust ventilation and plastic gloves during processing.

Para-Phenylenediamine

PARA-PHENYLENEDIAMINE
(Use With Extreme Caution)

Para-phenylenediamine was described as a developer agent in 1888. It is also known by the trade names Para D, Paramine, Metacarbol, Diamine, or Dianol. Its chemical name is para-phenylenediamine dihydrochloride or 1,4-diaminobenzene dihydrochloride.

Skin contact: toxic–causes severe irritation, dermatitis
Eye contact: toxic–causes severe irritation
Inhalation: toxic–causes upper respiratory irritation
Ingestion: toxic

If heated to decomposition, can emit toxic fumes of hydrogen chloride and nitrogen oxides.

Requires local exhaust ventilation, dust mask, goggles, plastic apron and sleeves, and nitrile gloves during mixing. Requires local exhaust ventilation, goggles or safety glasses, plastic apron, and nitrile or plastic gloves during processing.

Problems with skin sensitivity have been noted with this developer agent due in large part to its ease of penetration of the outer skin layer (Haist 1979, p. 182). It is used in both black-and-white and color chemistry, but primarily as part of a color system. It is also found in mixtures with other developer agents. The hazards of ortho-phenylenediamine, diethyl-para-phenylenediamine, and dimethyl-paraphenylenediamine are similar to those of para-phenylenediamine. This developer compound is believed to be a component in the following developers:

- Edwal: Edwal 12 Developer, Super 20 Developer
- Photographers Formulary: Windisch 665 Fine Grain Developer

Phenidone

PHENIDONE
(Use With Caution)

Phenidone was discovered in 1890 and applied as a developer in 1940. It is also known by the trade names Phenidone and Graphidone and the identifier P-Q (phenidone-(hydroquinone) developers. Its chemical name is phenidone or l-phenyl-3-pyrazolidone.

Skin contact: not very toxic
Eye contact: moderately toxic
Inhalation: moderately toxic
Ingestion: toxic

If heated to decomposition, can emit toxic fumes of nitrogen oxides.

Requires local exhaust ventilation, dust mask, goggles, plastic apron, and rubber gloves during mixing. Requires local exhaust ventilation, goggles or safety glasses, plastic apron, and rubber or plastic gloves during processing.

This developer agent is usually mixed with hydroquinone to make a P-Q developer. The organic restrainers required are benzotriazole or 6-nitrobenzimidazole nitrate. This developer compound is believed to be a component in the following developers:

- Edwal: FG-7 Developer, TST Paper Developer
- Ilford: Bromophen Developer, Ilfobrom Developer
- Photographers Formulary: Modified POTA Developer
- Ethol: LPD Paper Developer
- Ilford ID-68 Phenidone-Hydroquinone-Borax Fine Grain Film Developer

Ref.: DeCock 1990, sec. 15, p. 29

Water, 125°F	750.00 ml
Sodium sulfite, anhydrous	85.00 g
Hydroquinone	5.00 g
Borax	7.00 g
Boric acid	2.00 g
Potassium bromide	1.00 g
Phenidone	0.13 g
Water to make	1,000.00 ml

SODIUM SULFITE

Also known as sulfurous acid, sodium salt.

Skin contact: not very toxic–may cause irritation
Eye contact: not very toxic–may cause irritation
Inhalation: moderately toxic–may cause irritation
Ingestion: toxic–could cause death if consumed in
significant amounts

If heated to decomposition or mixed with acid, can emit toxic sulfur dioxide and sodium oxide fumes.

Requires local exhaust ventilation, dust mask, goggles, plastic apron, and plastic or rubber gloves during mixing. Requires local exhaust ventilation and plastic gloves during processing.

HYDROQUINONE
(Use With Extreme Caution)

Also known by the trade names Hydrochinon, Hydrokinone, Hydroquinol, Quinol, or Tecquinol. Its chemical name is hydroquinone or para-dihydroxybenzene.

Skin contact: moderately toxic–causes allergic reactions
and irritation; solid can cause burns, solutions can
cause dermatitis
Eye contact: moderately toxic–dust causes irritation
Inhalation: moderately toxic–dust causes irritation
Ingestion: toxic

This chemical is a suspected carcinogen.

If heated to decomposition, can emit acrid fumes, including quinone.

Requires local exhaust ventilation, dust mask, goggles, plastic apron, and rubber gloves during mixing. Requires local exhaust ventilation, plastic apron, and rubber gloves during processing.

BORAX

Also known as sodium borate or (di)sodium tetraborate.

Skin contact: not very toxic–may cause irritation
Eye contact: moderately toxic–may cause allergic reaction
or irritation
Inhalation: moderately toxic–dust may be irritating
Ingestion: moderately toxic; toxic in large amounts

If heated to decomposition, can emit toxic fumes of sodium oxide gas.

Requires local exhaust ventilation, dust mask, goggles, plastic apron, and rubber or plastic gloves during mixing. Requires local exhaust ventilation, goggles or safety glasses, and rubber or plastic gloves during processing.

BORIC ACID

Also known as orthoboric acid or boracic acid.

Skin contact: moderately toxic–may cause irritation
Eye contact: moderately toxic–may cause irritation
Inhalation: moderately toxic
Ingestion: toxic

Requires local exhaust ventilation, dust mask, goggles, plastic apron, and rubber gloves during mixing. Requires local exhaust ventilation, goggles or safety glasses, plastic apron, and rubber or plastic gloves during processing.

POTASSIUM BROMIDE

Also known as bromide salt of potassium.

Skin contact: not very toxic–prolonged exposure can
cause skin rash
Eye contact: not very toxic–temporary discomfort
Inhalation: moderately toxic
Ingestion: moderately toxic–harmful in large amounts

If heated to decomposition, can emit toxic fumes of bromine gas.

Requires local exhaust ventilation, dust mask, goggles, plastic apron, and plastic gloves during mixing. Requires local exhaust ventilation and plastic gloves during processing.

Pyrogallol (Pyro)

PYROGALLOL (PYRO)
(Use With Extreme Caution)

Pyro was in use as early as 1850. It is also known as pyrogallol and incorrectly as pyrogallic acid. Commercial trade names include Piral and Pyro. Its chemical name is pyrogallol or 1,2,3-benzenetriol.

Skin contact: toxic–can cause severe allergic reaction and severe
irritation; easily absorbed through the skin
Eye contact: toxic–can cause severe irritation
Inhalation: toxic–causes severe acute poisoning
Ingestion: toxic–can be fatal

If heated to decomposition, can emit acrid smoke and irritating
fumes.

Requires fume hood, dust mask, goggles, plastic apron and sleeves,
and rubber or plastic gloves during mixing. Requires local exhaust venti-
lation, goggles or safety glasses, plastic apron, and rubber or plastic
gloves during processing.

This developer agent can be mixed with other developer agents and
with acetone as the alkali. The working solution is mixed just prior to use
and discarded after development. It produces a residual stain image in
baths with low quantities of preservative. This developer compound is
believed to be a component in the following developers:

- Photographers Formulary: ABC Pyro, WD2D Pyro-Metol
 Developer

The popularity of this developer has recently been revived, particu-
larly by large-format photographers. The following formula is one that
has been provided in a recently published book on the use of pyro de-
velopers with contemporary films.

PMK, Pyro-Metol-Kodalk Film Developer
Ref.: Hutchings 1991, p. 14

Stock Solution A

Distilled water	750.0 cc
Metol	10.0 g
Sodium bisulfite	20.0 g
Pyrogallol	100.0 g
Water to make	1,000.0 cc

Stock Solution B

Distilled water	1,400.0 cc
Sodium metaborate (Kodalk)	600.0 g
Water to make	2,000.0 cc

The working solution is 1 part stock solution A plus 2 parts stock so-
lution B added to 100 parts of water. The mixing of the stock solution A

requires great care, and the instructions provided in the reference text must be followed. This developer should be mixed and used only under the proper conditions.

METOL
(Use With Caution)

Also known by the trade names Atolo, Elon, Genol, Graphol, Monol, Pictol, Photol, Rhodol, Satrapol, Scalol, or Viterol. Its chemical name is metol or monomethyl-para-aminophenol sulfate.

Skin contact: moderately toxic–may cause allergic reaction
or irritation; repeated contact may result in dermatitis
Eye contact: moderately toxic–may cause irritation
Inhalation: moderately toxic–may cause respiratory tract irritation
Ingestion: toxic

If heated to decomposition, can emit toxic fumes of sulfur dioxide and nitrogen oxide.

Requires local exhaust ventilation, dust mask, goggles, plastic apron, and rubber gloves during mixing. Requires local exhaust ventilation, goggles or safety glasses, and rubber or plastic gloves during processing.

SODIUM BISULFITE

Also known as sodium hydrogen sulfite and potassium hydrogen sulfite.

Skin contact: moderately toxic–may cause allergic reaction
or irritation
Eye contact: moderately toxic–may cause irritation
Inhalation: moderately toxic
Ingestion: toxic

If heated to decomposition or mixed with acid solutions, can emit toxic fumes of sulfur dioxide gas.

Requires local exhaust ventilation, dust mask, goggles, plastic apron and gloves during mixing. Requires local exhaust ventilation, goggles or safety glasses, and plastic gloves during processing.

SODIUM METABORATE
(Use With Caution)

Also known as Kodalk or balanced alkali.

Skin contact: moderately toxic–may cause burns and irritation
Eye contact: moderately toxic–may cause burns and irritation

Inhalation: toxic
Ingestion: toxic

If heated to decomposition, can emit toxic fumes of sodium oxide gas.

Requires local exhaust ventilation, dust mask, goggles, plastic apron, and sleeves and rubber or plastic gloves during mixing. Requires local exhaust ventilation, goggles or safety glasses, and rubber or plastic gloves during processing.

PRESERVATIVES

The most common preservatives are sodium sulfite, sodium bisulfite, and potassium metabisulfite. The addition of the preservative prevents the oxidation of the developer, prolonging its useful life. Sodium sulfite is the most extensively used, often replaced by sodium bisulfite either completely or in part. The use of potassium metabisulfite is also common.

SODIUM SULFITE

Also known as sulfurous acid, sodium salt.

Skin contact: not very toxic–may cause irritation
Eye contact: not very toxic–may cause irritation
Inhalation: moderately toxic–may cause irritation
Ingestion: toxic–could cause death if consumed in
significant amounts

If heated to decomposition or mixed with acid, can emit toxic sulfur dioxide and sodium oxide fumes.

Requires local exhaust ventilation, dust mask, goggles, plastic apron, and plastic or rubber gloves during mixing. Requires local exhaust ventilation and plastic gloves during processing.

SODIUM METABISULFITE

Also known as sodium pyrosulfite.

Skin contact: moderately toxic–may cause burns or irritation
Eye contact: moderately toxic–may cause burns or irritation
Inhalation: moderately toxic–may cause irritation
Ingestion: toxic–could cause death if consumed in
significant amounts

If heated to decomposition or mixed with acid, can emit toxic sulfur dioxide and sodium oxide fumes.

Requires local exhaust ventilation, dust mask, goggles, plastic apron, and plastic or rubber gloves during mixing. Requires local exhaust ventilation and plastic gloves during processing.

POTASSIUM METABISULFITE

Also known as potassium pyrosulfite.

Skin contact: moderately toxic–may cause burns or irritation
Eye contact: moderately toxic–may cause burns or irritation
Inhalation: moderately toxic–may cause irritation
Ingestion: moderately toxic

If heated to decomposition or mixed with acid, can emit toxic sulfur dioxide and sodium oxide fumes.

Requires local exhaust ventilation, dust mask, goggles, plastic apron, and plastic or rubber gloves during mixing. Requires local exhaust ventilation and plastic gloves during processing.

SODIUM BISULFITE

Also known as sodium hydrogen sulfite.

Skin contact: moderately toxic–may cause allergic reaction
or irritation
Eye contact: moderately toxic–may cause irritation
Inhalation: moderately toxic
Ingestion: toxic

If heated to decomposition or mixed with acid solutions, can emit toxic fumes of sulfur dioxide gas.

Requires local exhaust ventilation, dust mask, goggles, plastic apron, and plastic gloves during mixing. Requires local exhaust ventilation, goggles or safety glasses, and plastic gloves during processing.

POTASSIUM BISULFITE

Also known as potassium hydrogen sulfite.

Skin contact: moderately toxic–may cause allergic reaction
or irritation
Eye contact: moderately toxic–may cause irritation
Inhalation: moderately toxic
Ingestion: toxic

If heated to decomposition or mixed with acid solutions, can emit toxic fumes of sulfur dioxide gas.

Requires local exhaust ventilation, dust mask, goggles, plastic apron, and plastic gloves during mixing. Requires local exhaust ventilation, goggles or safety glasses, and plastic gloves during processing.

ACCELERATORS (ALKALIES)

The use of an alkaline solution with the developing agents is required to activate or accelerate development within a reasonable time. The use of the alkalies also helps the penetration of the developing agents into the gelatin because they soften the emulsion. The carbonates are the most commonly used alkalies, although hydroxides (caustics), basic phosphates, and borates are also used.

SODIUM CARBONATE

Also known as soda ash.

Skin contact: moderately toxic–may cause burns or irritation
Eye contact: moderately toxic–may cause burns or irritation
Inhalation: moderately toxic
Ingestion: moderately toxic–can be fatal in large quantities

Concentrated forms are corrosive to skin and eyes; dilute solutions may irritate.

If heated to decomposition, can emit toxic fumes of sodium oxide gases.

Requires local exhaust ventilation, dust mask, goggles, plastic apron, and plastic gloves during mixing. Requires local exhaust ventilation, goggles or safety glasses, and plastic gloves during processing.

POTASSIUM CARBONATE

Also known as potash.

Skin contact: moderately toxic–may cause burns or irritation
Eye contact: moderately toxic–may cause burns or irritation
Inhalation: moderately toxic–may cause irritation
Ingestion: toxic–can be fatal in large quantities

Concentrated forms are corrosive to skin and eyes; dilute solutions may irritate.

If heated to decomposition, can emit toxic fumes of potassium oxide and carbon dioxide gases.

Requires local exhaust ventilation, dust mask, goggles, plastic apron,

and plastic gloves during mixing. Requires local exhaust ventilation, goggles or safety glasses, and plastic gloves during processing.

AMMONIUM CARBONATE

Also known as diammonium carbonate.

> Skin contact: moderately toxic–may cause irritation
> Eye contact: moderately toxic–may cause irritation
> Inhalation: moderately toxic–may cause slight irritation
> Ingestion: moderately toxic

If heated to decomposition, can emit toxic fumes of ammonia and nitrogen dioxide gas.

Requires local exhaust ventilation, dust mask, goggles, plastic apron, and rubber gloves during mixing. Requires local exhaust ventilation, goggles or safety glasses, and plastic gloves during processing.

SODIUM HYDROXIDE
(Use With Caution)

Also known as caustic soda, soda lye, or sodium caustic.

> Skin contact: toxic–corrosive; causes burns to skin
> and mucous membranes
> Eye contact: toxic–corrosive; causes burns to eyes
> Inhalation: toxic–corrosive; causes burns to respiratory system
> Ingestion: toxic–can be fatal; damages all body tissues

Concentrated forms are corrosive to all body tissues, resulting in burns and scarring. Dilute solutions are also very corrosive and have similar hazards.

Requires local exhaust ventilation, dust mask, goggles, rubber apron, and rubber or nitrile gloves during mixing. Requires local exhaust ventilation, plastic or rubber apron, and rubber gloves during use.

POTASSIUM HYDROXIDE
(Use With Caution)

Also known as caustic potash.

> Skin contact: toxic–corrosive; causes burns to skin
> and mucous membranes
> Eye contact: toxic–corrosive; causes burns to eyes
> Inhalation: toxic–corrosive; causes burns to respiratory system
> Ingestion: toxic–can be fatal; damages all body tissues

Concentrated forms are corrosive to all body tissues, resulting in burns and scarring. Dilute solutions are also very corrosive and have similar hazards.

Requires local exhaust ventilation, dust mask, goggles, rubber apron, and rubber or nitrile gloves during mixing. Requires local exhaust ventilation, plastic or rubber apron, and rubber gloves during use.

AMMONIA CONCENTRATED (28%)
(Use With Extreme Caution)

Also known as ammonium hydroxide.

Skin contact: moderately toxic–highly corrosive to skin
Eye contact: moderately toxic–highly corrosive to eyes
Inhalation: toxic–severe irritation
Ingestion: toxic–can be fatal

Concentrated forms are corrosive to all body tissues, resulting in burns and scarring. Dilute solutions are also very corrosive and have similar hazards.

If heated to decomposition, can emit toxic fumes of ammonia and nitrogen dioxide gas.

Requires local exhaust ventilation, respirator (ammonia vapor cartridge), goggles, rubber apron, and rubber or nitrile gloves during mixing. Requires local exhaust ventilation, respirator (ammonia vapor cartridge), plastic or rubber apron, and plastic or rubber gloves during use.

SODIUM PHOSPHATE

Also known as tribasic sodium phosphate.

Skin contact: moderately toxic–may cause irritation
Eye contact: moderately toxic–may cause irritation
Inhalation: moderately toxic
Ingestion: not very toxic

If heated to decomposition, can emit toxic fumes of phosphorus oxide and sodium oxide.

Requires local exhaust ventilation, dust mask, goggles, plastic apron, and plastic gloves during mixing. Requires local exhaust ventilation, goggles or safety glasses, and plastic gloves during processing.

ACETONE
(Use With Caution)

Also known as dimethyl ketone or 2-propanone. This solvent has a low flash point, -18°C or 0°F, and it represents a fire/explosion hazard.

Skin contact: moderately toxic–may cause irritation
Eye contact: toxic–may result in blindness
Inhalation: moderately toxic
Ingestion: moderately toxic

If heated to decomposition through ignition, can emit toxic fumes of carbon dioxide and carbon monoxide gases.

Requires fume hood (flameproofed) or respirator (organic vapor cartridge) with local exhaust ventilation, goggles, nitrile apron, and nitrile gloves during mixing. Requires respirator (organic vapor cartridge) with local exhaust ventilation, goggles or safety glasses, and nitrile gloves during processing.

METHYL ALCOHOL
(Use With Caution)

Also known as methanol, wood alcohol, or methylated spirits. This solvent has a low flash point, 12°C or 54°F, and it represents a fire/explosion hazard.

Skin contact: moderately toxic–may cause irritation
 of mucous membranes
Eye contact: toxic–may cause severe allergic reaction
Inhalation: moderately toxic
Ingestion: toxic–may cause blindness, central nervous system
 damage, or may be fatal.

Requires fume hood (flameproofed) or respirator (organic vapor cartridge) with local exhaust ventilation, goggles, nitrile apron, and nitrile gloves during mixing. Requires respirator (organic vapor cartridge) with local exhaust ventilation, goggles or safety glasses, and nitrile gloves during processing.

BORAX

Also known as sodium borate or (di)sodium tetraborate.

Skin contact: not very toxic–may cause irritation
Eye contact: moderately toxic–may cause allergic reaction
 or irritation

Inhalation: moderately toxic–dust may be irritating
Ingestion: moderately toxic; toxic in large amounts

If heated to decomposition, can emit toxic fumes of sodium oxide gas.

Requires local exhaust ventilation, dust mask, goggles, plastic apron, and rubber or plastic gloves during mixing. Requires local exhaust ventilation, goggles or safety glasses, and rubber or plastic gloves during processing.

SODIUM METABORATE
(Use With Caution)

Also known as Kodalk or balanced alkali.

Skin contact: moderately toxic–may cause burns and irritation
Eye contact: moderately toxic–may cause burns and irritation
Inhalation: toxic
Ingestion: toxic

If heated to decomposition, can emit toxic fumes of sodium oxide gas.

Requires local exhaust ventilation, dust mask, goggles, plastic apron and sleeves, and rubber or plastic gloves during mixing. Requires local exhaust ventilation, goggles or safety glasses, and rubber or plastic gloves during processing.

RESTRAINERS

The restrainers are used to restrain and limit the amount of fog in the emulsion.

POTASSIUM BROMIDE

Also known as bromide salt of potassium.

Skin contact: not very toxic–prolonged exposure can
cause skin rash
Eye contact: not very toxic–temporary discomfort
Inhalation: moderately toxic
Ingestion: moderately toxic–harmful in large amounts

If heated to decomposition, can emit toxic fumes of bromine gas.

Requires local exhaust ventilation, dust mask, goggles, plastic apron, and plastic gloves during mixing. Requires local exhaust ventilation and plastic gloves during processing.

BENZOTRIAZOLE
(Use With Extreme Caution)

Also known as 1,2,3-triazaindene and 1,2-aminozophenylene.

Skin contact: moderately toxic–may cause irritation and dermatitis
Eye contact: moderately toxic–may cause irritation
Inhalation: may be toxic
Ingestion: may be toxic

This chemical is a possible carcinogen.

If heated to decomposition, can emit toxic fumes of nitrogen dioxide gas.

Requires local exhaust ventilation, dust mask, goggles, plastic apron, and rubber or plastic gloves during mixing. Requires local exhaust ventilation, goggles or safety glasses, and rubber or plastic gloves during processing.

6-NITRO-BENZIMIDAZOLE NITRATE
(Do Not Use)

Also known as 5-nitro-1H-benzimioazone.

Skin contact: may be toxic
Eye contact: may be toxic
Inhalation: may be toxic
Ingestion: moderately toxic

This chemical has been identified as a carcinogen.

If heated to decomposition, can emit toxic fumes of nitrogen dioxide gas.

Requires local exhaust ventilation, dust mask, goggles, plastic apron, and rubber or plastic gloves during mixing. Requires local exhaust ventilation, goggles or safety glasses, and rubber or plastic gloves during processing.

DEVELOPER SUMMARY

The use of phenidone-based developers is recommended because they are the least toxic by Skin contact of the available developer agents. Mixtures of this developer with hydroquinone, P-Q developers, have greater toxicity due to the hydroquinone addition. Most of the common developer formulations are mixtures of metol and hydroquinone, M-Q devel-

opers, which have a greater associated hazard than the P-Q developers but still less than many other developer agents such as phenylenediamine and the exotic pyro developers.

Avoid using solvents as part of the developer solution. The use of these chemicals will introduce new, additional hazards that will need to be considered.

The important point of this section is that developer agents have different toxicities, and the use of the least hazardous chemical should always be the goal of safe darkroom practice. If a developer is used that has greater associated hazards, the photographer should ensure that the operating environment for the developer's use is consistent with the hazards created by the use of that chemical. Also remember that all the component parts of a processing solution contribute to the final hazard represented by the solution. The photographer needs to recognize this fact and accommodate all these different hazards during use.

STOP BATHS, FIXERS, AND HARDENERS

The stop bath is usually a dilute acetic acid solution that is used immediately after the developer. The image has been formed through the reduction of the exposed silver by the developer agent. The acidic stop bath solution neutralizes the developer to stop development. Any of the unexposed silver salts remaining in the emulsion are then removed in the third or fixer bath. Initially the stop bath was a water bath rather than a weak solution of acetic acid, but this was insufficient in stopping the development process. Significant density could continue to build up in the image if the developer was not neutralized. Problems with staining of the negative also became an issue if developer carryover into the fixer solution occurred. The use of the weak acetic acid bath eliminated both of these problems.

The last addition to the stop bath is an indicating dye that is color sensitive to the solution pH. This unit of measurement, pH, indicates the degree of acidity or alkalinity in a liquid solution. The indicator used is bromocresol purple. It is yellow below a pH of 5.2, but when the acid becomes exhausted at a pH of 6.8, the indicator turns blue. The use of an indicator stop bath ensures that the bath is not used beyond its useful capacity. When printing under a yellow safelight, the yellow color of the fresh stop bath appears clear; but when the acid is exhausted, the blue color appears black under the safelight.

The use of hardeners is often included in a stop bath formulation to minimize the excessive softening of the emulsion by the alkaline developer solution. The alkalinity of the developer bath can be quite high, particularly if an accelerator like sodium hydroxide has been used. The alkaline solution causes the emulsion to swell, and if stressed or contacted the emulsion could be damaged or separate from its base support. The use of a hardener at this point in the processing sequence can assist in preparing the emulsion for the remaining processing steps. Chrome alum and formaldehyde are commonly used as hardeners, and sodium sulfate may be added as an antiswelling agent.

STOP BATHS

The stop bath is a weak solution of acetic acid diluted from 28% stock solution. Three parts of glacial acetic acid diluted with eight parts of water will provide a 28% acetic acid stock solution. This is then further diluted about 30 times, 1:30, to prepare a working-strength solution.

Kodak Stop Bath SB-5, Nonswelling
Ref.: DeCock 1990, sec. 15, p. 47

Water	500.0 ml
Acetic acid, 28%	32.0 ml
Sodium sulfate, desiccated	45.0 g
Water to make	1,000.0 ml

Kodak Stop Bath SB-4, Hardening and Nonswelling
Ref.: Haist 1979, vol. 1, p. 555

Chrome alum	30.0 g
Sodium sulfate	60.0 g
Water to make	1,000.0 ml

Potassium Alum Hardening Stop Bath
Ref.: Haist 1979, vol. 1, p. 556

Sodium sulfite	22.7 g
Glacial acetic acid	17.0 ml
Sodium citrate	5.7 g
Potassium alum	22.7 g
Water	236.6 ml

GLACIAL ACETIC ACID (concentrated)
(Use With Extreme Caution)

Also known as vinegar acid and ethanoic acid.

Skin contact: toxic–causes burns, dermatitis, and ulcers; corrosive
Eye contact: toxic–causes burns, severe irritation; corrosive
Inhalation: moderately toxic–causes irritation of mucous
membranes; corrosive
Ingestion: toxic–causes burns; corrosive

If heated to decomposition, can emit toxic fumes of carbon dioxide and carbon monoxide gases.

Requires fume hood and local exhaust ventilation, respirator (organic vapor cartridge), plastic or rubber apron, goggles, and nitrile gloves during mixing. Requires local exhaust ventilation, respirator (organic vapor cartridge), plastic or rubber gloves, goggles, and plastic gloves during processing.

ACETIC ACID (dilute)
(Use With Caution)

Skin contact: not very toxic–may cause allergic reaction or irritation
Eye contact: not very toxic–may cause allergic reaction or irritation
Inhalation: not very toxic–may cause allergic reaction, irritation,
or possibly chronic bronchitis
Ingestion: not very toxic

If heated to decomposition, can emit toxic fumes of carbon dioxide and carbon monoxide gases. Contamination of the stop bath solution by developer during processing can result in the emission of toxic sulfur dioxide gas when sulfur-based chemicals are part of the bath's formulation.

Requires local exhaust ventilation, respirator (organic vapor cartridge), plastic or rubber apron, goggles, and plastic gloves during processing.

POTASSIUM CHROME ALUM
(Use With Extreme Caution)

Also known as chrome alum or potassium chromium sulfate.

Skin contact: moderately toxic–may cause burns, allergic
reaction, or irritation
Eye contact: moderately toxic–may cause burns or irritation

Inhalation: toxic–powder may cause respiratory irritation
Ingestion: moderately toxic

Chromium compounds have been identified as carcinogenic. Try to substitute potassium alum for this compound whenever possible.

If heated to decomposition, can emit toxic fumes of sulfur dioxide and chromium oxides.

Requires fume hood and local exhaust ventilation, dust mask, goggles or safety glasses, plastic apron, and rubber or plastic gloves during mixing. Requires local exhaust ventilation, safety glasses and plastic apron and gloves during processing.

POTASSIUM ALUM

Also known as alum, aluminium potassium sulfate, or potassium aluminum sulfate.

Skin contact: not very toxic–may cause allergic reaction or irritation
Eye contact: not very toxic–dust may cause irritation
Inhalation: not very toxic–dust may cause irritation
Ingestion: not very toxic

If heated to decomposition, can emit toxic fumes of sodium dioxide gas.

Requires local exhaust ventilation, fume hood or dust mask, goggles, plastic apron, and rubber or plastic gloves during mixing. Requires local exhaust ventilation, goggles or safety glasses, and plastic gloves during processing.

SODIUM CITRATE

Also known as tri-sodium citrate.

Skin contact: not very toxic–may cause irritation
Eye contact: not very toxic–may cause irritation
Inhalation: not very toxic–may cause irritation
Ingestion: not very toxic

If heated to decomposition, can emit acrid fumes of sodium oxide gases.

Requires local exhaust ventilation, dust mask, safety glasses, and plastic gloves during mixing. Requires local exhaust ventilation, safety glasses, and plastic gloves during processing.

SODIUM SULFATE

Also known as salt cake or sulfuric acid, disodium salt.

Skin contact: not very toxic
Eye contact: not very toxic–may cause temporary discomfort
Inhalation: not very toxic
Ingestion: not very toxic

If heated to decomposition, can emit toxic fumes of sulfur dioxide and sodium oxide gases.

Requires local exhaust ventilation, dust mask, goggles and plastic gloves during mixing. Requires local exhaust ventilation, safety glasses, and plastic gloves during processing.

FIXING BATHS (SILVER HALIDE SOLVENTS)

The fixer provides the most important function in the photographic process, after that of image development. The fixer is a silver halide solvent that preferentially removes the light-sensitive silver salts remaining in the unexposed, unprocessed portions of the image. The developer has not interacted with these light-sensitive silver compounds in the highlight (Dmin) areas, and the fixer dissolves them from the photograph, providing a product that is stabilized to light. If the light-sensitive silver halide salts are not removed by the fixer bath, the photograph will still be light sensitive and, during continued exposure to light, will continue to darken in the highlight (Dmin) areas.

The silver halide solvent action of the fixer varies, depending on the particular chemical used. In general, the fixer dissolves the unexposed silver halide salts before it begins to show a reduction of the developed image. Ammonium thiosulfate is a rapid-acting silver halide solvent that must be carefully monitored to prevent attack on the developed silver image. This is particularly important when considering an acidic rapid-fixer formulation.

A typical fixing bath formulation, also known as "hypo," might contain a thiosulfate as the silver halide solvent, a weak acetic acid solution to neutralize any developer solution carryover and therefore eliminate staining, and a weak acidic salt compound to assist in maintaining the weak acidic environment. Strong acids cannot be used; they cause sulfur to be precipitated out of the thiosulfate solution. Sodium bisulfite, potassium metabisulfite, and sodium sulfite are some of the commonly used acidic salts, and acetic acid, citric acid, and boric acid are the weak acids commonly used.

An acid-hardening fixing bath includes a hardening agent, usually potassium alum (potassium aluminum sulfate) or chrome alum (chromium aluminum sulfate). The acid buffer in these baths must be sufficient to prevent the precipitation of aluminum sulfite or aluminum hydroxide; acetic acid and sulfuric acid are commonly used. Sodium sulfite is present in the formulation to assist in redissolving any sulfur that might precipitate out during use; it converts the sulfur into thiosulfate.

SODIUM THIOSULFATE, PENTAHYDRATE

Also known as sodium hyposulfite or hypo.

Skin contact: not very toxic
Eye contact: not very toxic–may cause temporary discomfort
Inhalation: not very toxic–toxic if contaminated with acid
Ingestion: moderately toxic–may cause cyanosis

If heated to decomposition or contaminated with acid, can emit toxic fumes of sulfur dioxide gas.

Requires local exhaust ventilation, safety glasses, and plastic gloves during mixing and processing.

AMMONIUM THIOSULFATE

Also known as rapid fixer.

Skin contact: not very toxic–may cause irritation
Eye contact: not very toxic–may cause irritation
Inhalation: not very toxic; highly toxic if contaminated–may
cause irritation
Ingestion: moderately toxic

If heated to decomposition or contaminated with acid, can emit toxic fumes of ammonia, hydrogen sulfide, or sulfur dioxide gas.

Requires local exhaust ventilation, goggles, rubber or plastic gloves, and plastic apron during mixing. Requires local exhaust ventilation, safety glasses, plastic gloves and apron during use. Cotton clothing is also recommended.

Kodak Fixer F-24, Nonhardening Fixer
Ref.: DeCock 1990, sec. 15, p. 52

Water, 125°F	500.0 ml
Sodium thiosulfate, pentahydrate	240.0 g
Sodium sulfate, desiccated	10.0 g
Sodium bisulfite	25.0 g
Water to make	1,000.0 ml

There are some nonsilver printing processes in which a non-hardened print is required, but in general all film and print images use a hardening fixer bath to protect the gelatin emulsion from mechanical damage during processing.

SODIUM SULFATE

Also known as salt cake or sulfuric acid, disodium salt.

Skin contact: not very toxic
Eye contact: not very toxic–may cause temporary discomfort
Inhalation: not very toxic
Ingestion: not very toxic

If heated to decomposition, can emit toxic fumes of sulfur dioxide and sodium oxide gas.

Requires local exhaust ventilation, dust mask, goggles and plastic gloves during mixing. Requires local exhaust ventilation, safety glasses, and plastic gloves during processing.

SODIUM BISULFITE

Also known as sodium hydrogen sulfite and potassium hydrogen sulfite.

Skin contact: moderately toxic–may cause allergic reaction
 or irritation
Eye contact: moderately toxic–may cause irritation
Inhalation: moderately toxic
Ingestion: toxic

If heated to decomposition or mixed with acid solutions, can emit toxic fumes of sulfur dioxide gas.

Requires local exhaust ventilation, dust mask, goggles, plastic apron, and plastic gloves during mixing. Requires local exhaust ventilation, goggles or safety glasses, and plastic gloves during processing.

Kodak Fixer F-6, Acid Hardening Fixer
Ref.: DeCock 1990, sec. 15, p. 49

Water, 125°F	600.0 ml
Sodium thiosulfate, pentahydrate	240.0 g
Sodium sulfite, desiccated	15.0 g
Acetic acid, 28%	48.0 ml
Kodak Kodalk	15.0 g

Potassium alum 15.0 g
Water to make 1,000.0 ml

This formulation has been recommended for people who have a sensitivity to sulfur dioxide even in small amounts.

Agfa Rapid Fixer 304
Ref.: DeCock 1990, sec. 15, p. 53

Water, 125°F 750.0 ml
Sodium thiosulfate, pentahydrate 200.0 g
Ammonium chloride 50.0 g
Potassium metabisulfite 20.0 g
Water to make 1,000.0 ml

The mixture of sodium thiosulfate with ammonium chloride in the same bath provides the same type of fixing bath as if ammonium thiosulfate had been used instead.

GLACIAL ACETIC ACID (concentrated)
(Use With Extreme Caution)

Also known as vinegar acid and ethanoic acid.

Skin contact: toxic–causes burns, dermatitis, and ulcers; corrosive
Eye contact: toxic–causes burns, severe irritation; corrosive
Inhalation: moderately toxic–causes irritation of mucous
membranes; corrosive
Ingestion: toxic–causes burns; corrosive

If heated to decomposition, can emit toxic fumes of carbon dioxide and carbon monoxide gases.

Requires fume hood and local exhaust ventilation, respirator (organic vapor cartridge), plastic or rubber apron, goggles, and nitrile gloves during mixing. Requires local exhaust ventilation, respirator (organic vapor cartidge), plastic or rubber apron, goggles, and plastic gloves during processing.

ACETIC ACID (dilute)
(Use With Caution)

Skin contact: not very toxic–may cause allergic reaction or irritation
Eye contact: not very toxic–may cause allergic reaction
or irritation
Inhalation: not very toxic–may cause allergic reaction,
irritation, or possibly chronic bronchitis
Ingestion: not very toxic

If heated to decomposition, can emit toxic fumes of carbon dioxide and carbon monoxide gases. Contamination of the stop bath solution by developer during processing can result in the emission of toxic sulfur dioxide gas when sulfur-based chemicals are part of the bath's formulation.

Requires local exhaust ventilation, respirator (organic vapor cartridge), plastic or rubber apron, goggles, and plastic gloves during processing.

BORIC ACID

Also known as orthoboric acid and boracic acid.

> Skin contact: moderately toxic–may cause irritation; toxic if
> absorbed through abraded skin
> Eye contact: moderately toxic–may cause irritation
> Inhalation: moderately toxic
> Ingestion: toxic

Requires local exhaust ventilation, dust mask, goggles, plastic apron, and rubber gloves during mixing. Requires local exhaust ventilation, goggles or safety glasses, plastic apron, and rubber or plastic gloves during processing.

POTASSIUM METABISULFITE

Also known as potassium pyrosulfite.

> Skin contact: moderately toxic–may cause burns or irritation
> Eye contact: moderately toxic–may cause burns or irritation
> Inhalation: moderately toxic–may cause irritation
> Ingestion: moderately toxic

If heated to decomposition or mixed with acid, can emit toxic sulfur dioxide and sodium oxide fumes.

Requires local exhaust ventilation, dust mask, goggles, plastic apron, and plastic or rubber gloves during mixing. Requires local exhaust ventilation and plastic gloves during processing.

POTASSIUM ALUM

Also known as alum, aluminium potassium sulfate, or potassium aluminum sulfate.

> Skin contact: not very toxic–may cause allergic reaction or irritation
> Eye contact: not very toxic–dust may cause irritation

Inhalation: not very toxic–dust may cause irritation
Ingestion: not very toxic

If heated to decomposition, can emit toxic fumes of sodium dioxide gas.

Requires local exhaust ventilation, fume hood or dust mask, goggles, plastic apron, and rubber or plastic gloves during mixing. Requires local exhaust ventilation, goggles or safety glasses, and plastic gloves during processing.

HARDENERS

Hardening baths are used in processing sequences when the durability of the photograph's gelatin layer is in question. Hardeners are used in situations involving high-temperature processing, highly alkaline processing solutions, and extended or rough physical handling. Hardeners might also be added if the photograph is to receive additional processing treatments or extended washing to prevent the gelatin emulsion from frilling and blistering.

Hardening baths are commonly based on the dilution of a 40% solution of formaldehyde, 5% methanol, and an alkali carbonate. Substitution of succinaldehyde for the formaldehyde (formalin) is recommended.

FORMALDEHYDE
(Use With Extreme Caution)

Also known as formalin.

Skin contact: toxic–burns; may cause irritation
Eye contact: toxic–burns; may cause irritation
Inhalation: toxic–may cause irritation to mucous membranes
Ingestion: toxic

Formaldehyde is a suspected carcinogen.

If heated to decomposition, can emit acrid smoke and fumes.

Requires local exhaust ventilation, fume hood or respirator (formaldehyde cartridge), goggles, rubber apron, and nitrile gloves during mixing. Requires local exhaust ventilation, respirator (formaldehyde cartridge), goggles or safety glasses, rubber or plastic apron, and nitrile gloves during processing.

SUCCINALDEHYDE

Also known as succinaldehyde disodium bisulfite.

Skin contact: moderately toxic
Eye contact: moderately toxic
Inhalation: moderately toxic
Ingestion: moderately toxic

Succinaldehyde is less allergenic than formaldehyde.

Requires local exhaust ventilation, dust mask, goggles, plastic or rubber apron, and plastic or rubber gloves during mixing. Requires local exhaust ventilation, goggles or safety glasses, rubber or plastic apron, and rubber or plastic gloves during processing.

POTASSIUM CHROME ALUM
(Use With Extreme Caution)

Also known as chrome alum or potassium chromium sulfate.

Skin contact: moderately toxic–may cause burns, allergic
reaction, or irritation
Eye contact: moderately toxic–may cause burns or irritation
Inhalation: toxic–powder may cause respiratory irritation
Ingestion: moderately toxic

Chromium compounds have been identified as carcinogenic. Substitute potassium alum for this compound whenever possible.

If heated to decomposition, can emit toxic fumes of sulfur dioxide and chromium oxides.

Requires fume hood and local exhaust ventilation, dust mask, goggles or safety glasses, plastic apron, and rubber or plastic gloves during mixing. Requires local exhaust ventilation, safety glasses, and plastic apron and gloves during processing.

Kodak Formaldehyde Hardener SH-1
Ref. DeCock 1990, sec. 15, p. 55

Water	500.0 ml
Formalin (37% formaldehyde solution)	10.0 ml
Sodium carbonate, monohydrated	6.0 g
Water to make	1,000.0 ml

This hardener can usually be replaced with either a chrome alum or a potassium alum hardener. Note that this solution needs to be mixed and used under appropriate ventilation.

Kodak Chrome Hardener SB-3
Ref. DeCock 1990, sec. 15, p. 55

Water	1,000.0 ml
Potassium chrome alum	30.0 g

METHYL ALCOHOL
(Use With Caution)

Also known as methanol, wood alcohol, or methylated spirits. This solvent has a low flash point, 12°C or 54°F, and it represents a fire/explosion hazard.

Skin contact: moderately toxic–may cause irritation of
 mucous membranes
Eye contact: toxic–may cause severe allergic reaction
 Inhalation: moderately toxic
 Ingestion: toxic–may cause blindness, central nervous system
 damage, or may be fatal

Requires fume hood (flameproofed) or respirator (organic vapor cartridge) with local exhaust ventilation, goggles, nitrile apron, and nitrile gloves during mixing. Requires respirator (organic vapor cartridge) with local exhaust ventilation, goggles or safety glasses, and nitrile gloves during processing.

SODIUM CARBONATE

Also known as soda ash.

Skin contact: moderately toxic–may cause burns or irritation
Eye contact: moderately toxic–may cause burns or irritation
 Inhalation: moderately toxic
 Ingestion: moderately toxic–can be fatal in large quantities

Concentrated forms are corrosive to skin and eyes; dilute solutions may irritate.
 If heated to decomposition, can emit toxic fumes of sodium oxide gas.
 Requires local exhaust ventilation, dust mask, goggles, plastic apron and gloves during mixing. Requires local exhaust ventilation, goggles or safety glasses, and plastic gloves during processing.

STOP BATH, FIXER, AND HARDENER SUMMARY

The choice of the stop bath, fixer, and hardening bath is usually based on convenience. The use of concentrated liquid stop bath and rapid fixers is now common. These allow quick dilution and mixing, with minimum exposure to the powder dusts and the concentrated acetic acid needed to mix stock stop solutions. This is the safest approach.

There may, however, be a number of individuals who wish to mix their own solutions from scratch. If this is the case, ensure that the handling hazards have all been identified and that the appropriate environment can be maintained during the mixing and handling of these chemicals.

FINISHING AND ARCHIVAL PROCESSING

WASHING

After fixing, the next step in the processing sequence is washing. The primary function of washing is to remove the processing chemicals that have been used to this point. The removal of residual fixer is the primary goal, since large amounts of residual hypo have been identified with staining and discoloration of the photographic image.

A hypo clearing bath or a hypo eliminator step has been added as an important part of the processing sequence. This allows for both improved archival keeping and water conservation.

There may be confusion about the difference between a hypo clearing agent—a chemical that helps wash residual thiosulfate out of the emulsion—and a hypo eliminator—a chemical that breaks down the thiosulfate into water-soluble sulfates.

Use of a hypo eliminator results in the total breakdown of the hypo. Its two-component formulation requires mixing immediately before use because both the peroxide and the ammonia are volatile. It has, however, been determined that photographs treated with the HE-1 treatment discolor on aging. Therefore, hypo eliminator should not be used. It should be replaced with a solution of hypo clearing agent or a washing aid.

The washing aids tend to be mild alkali salt solutions that increase the solubility of the residual thiosulfates left in the photograph. The emulsion also washes more efficiently in slightly alkaline conditions.

Sodium or potassium sulfites are commonly used as commercial washing aids. The use of a hypo clearing agent should be part of a routine processing sequence both to reduce washing time and to improve image permanence.

Hypo clearing agents and washing aids are not significantly toxic.

HYPO ELIMINATION

Hypo eliminators should not be used in a processing sequence. The resulting long-term instability of the silver image and the health problems associated with preparation and use of the solution eliminate any advantages it might have had. The formulations for the various hypo eliminators have not been included in this section both because of the toxicity and reactive nature of the chemicals involved and because of the damage they can cause to the image's permanence.

There are other eliminators, all of which are active oxidizing agents and all of which can attack the silver image. Their use as hypo eliminators is questionable and should be discontinued. The chemicals used in some of the formulations are included here only as a guide.

AMMONIA (concentrated (28%))
(Use With Extreme Caution)

Also known as ammonium hydroxide.

> Skin contact: toxic–highly corrosive
> Eye contact: toxic–highly corrosive
> Inhalation: toxic–severe irritation
> Ingestion: toxic–can be fatal

Concentrated forms are corrosive to all body tissues, resulting in burns and scarring. Dilute solutions are also very corrosive and have similar hazards.

If heated to decomposition, can emit toxic fumes of ammonia and nitrogen dioxide gas.

Requires local exhaust ventilation, respirator (ammonia vapor cartridge), goggles, rubber apron, and rubber or nitrile gloves during mixing. Requires local exhaust ventilation, respirator (ammonia vapor cartridge), plastic or rubber apron, and plastic or rubber gloves during use.

AMMONIUM PERSULFATE

Also known as ammonium peroxydisulfate.

Skin contact: moderately toxic–may cause irritation
Eye contact: moderately toxic–burns; may cause irritation
Inhalation: moderately toxic–may irritate mucous membranes
Ingestion: moderately toxic

If heated to decomposition, can emit toxic fumes of ammonia, sulfur dioxide, and nitrogen dioxide gases.

Requires local exhaust ventilation, dust mask, goggles, plastic apron, and nitrile gloves during mixing. Requires local exhaust ventilation, safety glasses, plastic apron, and nitrile gloves during processing.

HYDROGEN PEROXIDE (30% SOLUTION)

Skin contact: moderately toxic–may cause blisters, allergic
reaction, or irritation
Eye contact: moderately toxic–may cause allergic reaction
or irritation
Inhalation: moderately toxic–may cause irritation of
mucous membranes
Ingestion: moderately toxic

If heated, shocked, or contaminated, can explode.

Requires local exhaust ventilation, goggles, plastic apron, and nitrile gloves during mixing. Requires local exhaust ventilation, safety glasses, plastic apron, and plastic gloves during processing.

IODINE
(Do Not Use)

Also known as iodine, sublimed.

Skin contact: toxic–burns; may cause irritation
Eye contact: toxic–may cause irritation
Inhalation: toxic–may cause irritation of mucous
membranes and lungs
Ingestion: toxic–small amounts can cause death

If heated to decomposition, can emit toxic fumes of iodine gas and iodine compounds.

Requires local exhaust ventilation, positive pressure fume hood, respirator (acidic gas cartridge), goggles, plastic apron, and nitrile gloves

during mixing. Requires local exhaust ventilation, respirator (acidic gas cartridge), goggles or safety glasses, plastic apron, and nitrile gloves during processing.

POTASSIUM PERBORATE

Skin contact: moderately toxic; highly toxic if absorbed
through abraded skin
Eye contact: moderately toxic
Inhalation: moderately toxic
Ingestion: moderately toxic

Can be explosive when in contact with combustible materials.

Requires local exhaust ventilation, dust mask, goggles, plastic apron, and plastic or rubber gloves during mixing. Requires local exhaust ventilation, goggles or safety glasses, and plastic apron and gloves during processing.

POTASSIUM PERMANGANATE
(Do Not Use)

Also known as permanganate of potash.

Skin contact: toxic–burns; may cause irritation; corrosive
Eye contact: toxic–may cause irritation
Inhalation: toxic–may cause irritation of mucous membranes
Ingestion: toxic

Can react with organic materials.

Concentrated solutions are corrosive; dilute solutions are irritating.

Requires local exhaust ventilation, fume hood, dust mask, goggles, plastic apron, and rubber or plastic gloves during mixing. Requires local exhaust ventilation, goggles or safety glasses, plastic apron, and rubber or plastic gloves during processing.

POTASSIUM PERSULFATE

Also known as potassium peroxydisulfate or dipotassium persulfate.

Skin contact: moderately toxic–may cause irritation
Eye contact: moderately toxic–may cause irritation
Inhalation: moderately toxic
Ingestion: moderately toxic

If heated to decomposition, can emit toxic fumes of sulfur dioxide gas. It can react explosively when contacting combustible materials.

Requires local exhaust ventilation, dust mask, goggles, and plastic apron and gloves during mixing. Requires local exhaust ventilation, goggles or safety glasses, and plastic apron and gloves during processing.

SODIUM HYPOCHLORITE

Also known as chlorox.

Skin contact: toxic–burns; may cause irritation
Eye contact: toxic–burns; may cause irritation
Inhalation: toxic–poisonous vapor
Ingestion: toxic–corrosive

If heated to decomposition or acid, can emit toxic fumes of chlorine gas.

Requires local exhaust ventilation, dust mask, goggles, plastic apron, and nitrile gloves during mixing. Requires local exhaust ventilation, goggles or safety glasses, and plastic apron and gloves during processing.

DRYING

After the washing sequence, a surfactant is used to help remove water droplets and reduce spotting on the dry negative. The use of Kodak photo-flo, listed by Kodak in the MSDS as propylene glycol and a complex alcohol, is common practice. The safety-related information for these solutions is often not available, and they should therefore be handled with care.

There may also be occasions when an alcohol bath might be used to facilitate drying. The alcohol can be mixed with water and can be used to displace water contained within the gelatin emulsion layer, reducing the drying time. The alcohol bath is a 9:1 alcohol to water mixture. The use of straight alcohol can result in dehydration of the gelatin emulsion and formation of a cloudiness in the image layer.

TONING FOR IMAGE PROTECTION

The use of extended processing baths can include toning or specialized processes such as reduction and intensification. The use of these techniques is generally not encouraged. Many of the solutions tend to be more toxic than the chemicals used in the basic processing steps, and many of these solutions introduce metallic salts with questionable long-term stability when applied to the image.

Some toner baths will impart an increased image stability, and these can be added to the processing sequence. These image permanence toners are discussed as part of the recommended processing sequence for the black-and-white process. The second group of toners, those used primarily for image color alteration, are described separately in a later section.

Traditionally, toning was used primarily for changing or altering the image color of a photographic print. Archival processing now includes using some of these same toner baths in very dilute formulations to provide increased image stability on black-and-white negatives. Toners either replace the silver image or deposit other metals onto the silver image. The photographic image is now more resistant to chemical contaminants present in the environment and more resistant to staining and discoloration.

Modern toners may also include color dyes. These processes are not toners in the true sense and are not considered here because they do not contribute to image permanence. They are discussed under hand coloring and retouching in the image modification section.

Traditional toners use gold and platinum to improve the silver image's stability. Both of these metals were used early in the history of photography as image stabilizing toners, as well as to change image color. The use of toners using uranium, mercury, or iron should be discontinued, since they usually result in increased image fading.

Another group of toners converts the silver image into a silver compound such as silver sulfide. The silver sulfide image is very stable because sulfide is not easily attacked by other chemicals. This process has also been available from the earliest days of photography.

Due to cost, gold and platinum baths have largely been replaced by less expensive sulfiding baths. Selenium toner, in a diluted form, is presently the recommended toner. The dilution provides a sulfide coating that is thin enough that the image color does not change. The image density and the contrast increase slightly.

Recently a safer and less expensive direct sulfiding toner has been investigated to provide a silver sulfide image without having to use a bleach redevelopment procedure such as the sepia toner. The use of a brown toner based on a polysulfide formulation like Kodak's Brown Toner has been promoted as an image stabilizing toner. Again the dilution is adjusted to provide image protection without significantly changing the image color.

One of the hazards associated with toners used for increased image stability is inhalation of gases created as by-products from toning bath solutions. There are two sources: baths contaminated with acid, or baths like the hypo-alum toner, which is heated to 125°F. The toners recommended for image stabilization include sulfide toners and selenium toners, both of which contain sulfide chemicals that could release poisonous hydrogen sulfide gas if the toner bath is contaminated by acid carryover from an acid fixer. In the case of a selenium toner bath, contamination could produce toxic hydrogen selenide or sulfur dioxide gases because of acid contamination.

Selenium toners should be purchased premixed in liquid concentrate form. The literature contains formulations for selenium toners that use selenium powder as the basis for the formulation. *Do not attempt to mix selenium toners from a selenium powder.* The hazards associated with selenium powder are great enough to avoid any contact.

Presently there are three commercial toners available that can be recommended for use as image permanence baths. They are the rapid selenium toner (Kodak T55), the brown toner, and the polysulfide (Kodak T-8) toners. These are usually sold as liquid concentrates to reduce the hazards associated with the mixing of the powders.

The use of a sepia toner, which uses a bleach and redevelopment procedure, is not included in this section because of the difficulty in obtaining predictable results and because of color change of the image. They are described later in the image modification section.

The image permanence toners are usually incorporated into the processing line following the hypo clearing agent and wash steps. The toners may have sensitivity to residual hypo, so proper washing is an important processing step. After toning, a rinse is used before drying, and a wetting agent is used for film.

Direct Sulfide Toners

Brown toner and polysulfide toners are both available commercially and are easy to mix and safer to use than mixing from scratch. The formulation listed below is a good protective toner that can be mixed from scratch if proper ventilation is available.

POTASSIUM SULFIDE

Also known as liver of sulfur or potassium polysulfide. Potassium sulfide and sodium sulfide are often used interchangeably and have similar hazards.

> Skin contact: moderately toxic–may cause irritation
> Eye contact: moderately toxic–may cause irritation
> Inhalation: moderately toxic–may cause irritation;
> toxic if contaminated
> Ingestion: toxic

If heated to decomposition or contaminated with acid solution, can emit toxic fumes of hydrogen sulfide and sulfur dioxide gas. Hydrogen sulfide (odor of rotten eggs) poisoning can be fatal.

Requires local exhaust ventilation, fume hood or respirator (acidic gas cartridge), goggles, plastic apron, and plastic or rubber gloves during mixing. Requires local exhaust ventilation, goggles or safety glasses, and plastic apron and gloves during processing.

Kodak Polysulfide Toner T-8
Ref.: DeCock 1990, sec. 15, p. 63

Water	750.0 ml
Polysulfide (potassium sulfide)	7.5 g
Sodium carbonate, monohydrate	2.4 g
Water to make	1,000.0 ml

Dissolve in the order given

SODIUM CARBONATE

Also known as soda ash.

> Skin contact: moderately toxic–may cause burns or irritation
> Eye contact: moderately toxic–may cause burns or irritation
> Inhalation: moderately toxic
> Ingestion: moderately toxic–can be fatal in large quantities

Concentrated forms are corrosive to skin and eyes; dilute solutions may irritate.

If heated to decomposition, can emit toxic fumes of sodium oxide gas.

Requires local exhaust ventilation, dust mask, goggles, and plastic apron and gloves during mixing. Requires local exhaust ventilation, goggles or safety glasses, and plastic gloves during processing.

Direct Selenium Toner

The two compounds listed below, selenium powder and sodium selenite, are both toxic. The best way to use this type of toner for image protec-

tion is to mix the toner from the commercially prepared liquid concentrate. Do not mix this toner from scratch.

SELENIUM POWDER
(Do Not Use)

Also known as selenium dust and elemental selenium.

> Skin contact: moderately toxic–may cause irritation
> Eye contact: moderately toxic–may cause irritation
> Inhalation: toxic
> Ingestion: toxic

If heated to decomposition, can emit toxic fumes of selenium gas.

Requires local exhaust ventilation, fume hood and dust mask, goggles, plastic apron and sleeves, and plastic or rubber gloves during mixing. Requires local exhaust ventilation, goggles or safety glasses, plastic apron, and rubber or plastic gloves during processing.

SODIUM SELENITE
(Do Not Use)

Also known as selenious acid, disodium salt.

> Skin contact: toxic–burns; may cause irritation or dermatitis;
> can be absorbed through skin
> Eye contact: toxic–burns; may cause irritation
> Inhalation: toxic
> Ingestion: toxic

If heated to decomposition or contaminated with acid solutions, can emit toxic fumes of hydrogen selenide, selenium compounds, and sodium oxide gas.

Requires local exhaust ventilation, fume hood and dust mask, goggles, plastic apron and sleeves and plastic or rubber gloves during mixing. Requires local exhaust ventilation, goggles or safety glasses, plastic apron, and rubber or plastic gloves during processing.

Direct Gold Toner

The use of a gold compound to provide a protective coating to the image silver has been used in photography from the earliest times as well as being used as a toner for the daguerreotype. The following formulation is used for silver images in black-and-white prints.

Kodak Gold Protective Solution GP-1
Ref.: DeCock 1990, sec. 15, p. 58

Water	750.0 ml
Gold chloride, 1% stock solution	10.0 ml
Sodium thiocyanate	10.0 g
Water to make	1,000.0 ml

The thiocyanate solution needs to be dissolved separately and added slowly to the gold solution.

GOLD CHLORIDE

Also known as auric chloride.

Skin contact: moderately toxic–may cause irritation
Eye contact: moderately toxic–may cause irritation and burns
Inhalation: moderately toxic–may cause irritation
Ingestion: moderately toxic

If heated to decomposition, can emit toxic hydrogen chloride and chlorine gas.

Requires local exhaust ventilation, dust mask, goggles or safety glasses, and rubber gloves during mixing. Requires local exhaust ventilation, safety glasses, and rubber gloves during processing.

SODIUM THIOCYANATE

Also known as sodium rhodanate.

Skin contact: moderately toxic–may cause irritation and skin rash
Eye contact: moderately toxic–may cause irritation and
temporary discomfort
Inhalation: moderately toxic
Ingestion: moderately toxic

If heated to decomposition or contaminated with acid solutions, can emit toxic fumes of hydrogen cyanide, hydrogen chloride, sulfur dioxide, and sodium oxide gases.

Requires local exhaust ventilation, fume hood and dust mask, goggles or safety glasses, and rubber or plastic gloves during mixing. Requires local exhaust ventilation, safety glasses, and rubber or plastic gloves during processing.

RESIDUAL SILVER AND RESIDUAL HYPO TESTING

There are several tests that have reappeared regularly in the photographic literature over the years for testing processing solutions. The idea is to monitor the degree of exhaustion of key processing baths as they are used and to stop before a bath becomes exhausted. The need to use these types of tests is questionable for anyone who maintains a use record of the number of square inches of film or paper processed in each bath. This can then be compared to the manufacturer's recommended capacities for the respective baths, and fresh chemistry can be mixed when required.

Avoid using residual hypo testing baths that include mercuric chloride as a test reagent. When it is necessary to test process baths, the following testing solutions have been used in black-and-white photography.

Residual Thiosulfate Tests

These tests monitor the efficiency of print washing. Because of the inaccuracy of the tests, they provide only a practical indication of the amount of residual hypo. A positive test indicates that more washing is required. A negative test may not necessarily mean that all the residual hypo has been removed.

In general, if the archival processing sequence is followed and the use of a hypo clearing solution is included in that sequence, these tests are not necessary. This is important when considering the fact that the testing solutions contain strong chemical agents as well as caustics and acids.

There are several different tests available, but the following two are most common. The first uses an acidified silver nitrate solution, the second an alkaline permanganate solution.

ACID SILVER NITRATE TEST (HT-2)

The reaction of silver nitrate in the test solution with residual thiosulfate produces a brown-colored silver sulfide stain. The solution is acidified to eliminate interference from alkaline materials that might be present in the solution. The acid is usually a 2% acetic acid, although a 0.5% sulfuric acid can also be used.

For application to photographic prints, excess surface water is blotted and a drop of the test solution is applied to a nonimage edge area, allowed to stand for two minutes, rinsed, and compared to a commercially (Kodak) prepared set of color patches.

Kodak Acid Silver Nitrate Test (HT-2)
Ref.: DeCock 1990, sec. 15, p. 57

Water	750.0 ml
Acetic acid (28%)	125.0 ml
Silver nitrate	7.5 g
Water to make	1,000.0 ml

SILVER NITRATE

Also known as lunar caustic.

Skin contact: moderately toxic–may cause irritation; corrosive
Eye contact: moderately toxic–may cause irritation; corrosive
Inhalation: moderately toxic–may cause irritation to mucous
membranes
Ingestion: moderately toxic

If heated to decomposition, can emit toxic fumes of nitrogen dioxide gas.

Requires local exhaust ventilation, dust mask, goggles, plastic apron, and rubber gloves during mixing. Requires local exhaust ventilation, goggles or safety glasses, plastic apron, and rubber gloves during processing.

GLACIAL ACETIC ACID (concentrated)
(Use With Extreme Caution)

Also known as vinegar acid and ethanoic acid.

Skin contact: toxic–causes burns, dermatitis, and ulcers; corrosive
Eye contact: toxic–causes burns, severe irritation; corrosive
Inhalation: moderately toxic–causes irritation of mucous
membranes; corrosive
Ingestion: toxic–causes burns; corrosive

If heated to decomposition, can emit toxic fumes of carbon dioxide and carbon monoxide gases.

Requires fume hood and local exhaust ventilation, respirator (organic vapor cartridge), plastic or rubber apron, goggles, and nitrile gloves during mixing. Requires local exhaust ventilation, respirator (organic vapor cartridge), plastic or rubber apron, goggles, and plastic gloves during processing.

ACETIC ACID (dilute)
(Use With Caution)

Skin contact: not very toxic–may cause allergic reaction or irritation
Eye contact: not very toxic–may cause allergic reaction or irritation
Inhalation: not very toxic–may cause allergic reaction, irritation,
or possibly chronic bronchitis
Ingestion: not very toxic

If heated to decomposition, can emit toxic fumes of carbon dioxide and carbon monoxide gases. Contamination of the stop bath solution by developer during processing can result in the emission of toxic sulfur dioxide gas when sulfur-based chemicals are part of the bath's formulation.

Requires local exhaust ventilation, respirator (organic vapor cartridge), plastic or rubber apron, goggles, and plastic gloves during processing.

HYPO TEST SOLUTION (HT-1a)

The color change of the test solution when wash water from the photograph is dropped into it provides the basis of this test. Any change from the violet color indicates the need for continued washing.

Kodak Hypo Test Solution (HT-1a)
Ref.: Haist 1979, vol. 1, p. 671

Distilled water	180.0 ml
Potassium permanganate	0.3 g
Sodium hydroxide	0.6 g
Distilled water to make	250.0 ml

POTASSIUM PERMANGANATE
(Do Not Use)

Also known as permanganate of potash.

Skin contact: toxic–burns; may cause irritation; corrosive
Eye contact: toxic–may cause irritation
Inhalation: toxic–may cause irritation of mucous membranes
Ingestion: toxic

Can react with organic materials.
Concentrated solutions are corrosive; dilute solutions are irritating.
Requires local exhaust ventilation, fume hood, dust mask, goggles, plastic apron, and rubber or plastic gloves during mixing. Requires local

exhaust ventilation, goggles or safety glasses, plastic apron, and rubber or plastic gloves during processing.

SODIUM HYDROXIDE
(Use With Caution)

Also known as caustic soda, soda lye, and sodium caustic.

Skin contact: toxic–corrosive; causes burns to skin and
mucous membranes
Eye contact: toxic–corrosive; causes burns to eyes
Inhalation: toxic–corrosive; causes burns to respiratory system
Ingestion: toxic–can be fatal; damages all body tissues

Concentrated forms are corrosive to all body tissues, resulting in burns and scarring. Dilute solutions are also very corrosive and have similar hazards.

Requires local exhaust ventilation, dust mask, goggles, rubber apron, and rubber or nitrile gloves during mixing. Requires local exhaust ventilation, plastic or rubber apron, and rubber gloves during use.

Residual Silver Test (ST-1)

The presence of residual silver and silver thiosulfate complexes in photographic materials can result in staining and discoloration of the image over time. The basis of this test is the application of a drop of a diluted formulation of sodium sulfide to the nonimage edge area of the photograph. After two to three minutes the excess is blotted. The presence of more than a just-visible cream color indicates residual silver. This test is based on the same sulfide reaction used for testing residual hypo.

The corrosive nature of the sulfides is less of an issue for testing for residual silver, since small amounts of a dilute sulfide solution are used and these do not pose significant hazards. It is important, however, that great care be taken when mixing the testing solutions.

An alternative test for residual silver can be accomplished with a dilute (1:9) solution of Kodak rapid selenium toner.

Kodak Residual Silver Test (ST-1)
Ref.: DeCock 1990, sec. 15, p. 56

Water	100.0 ml
Sodium sulfide	2.0 g

Dilute 1:9 for testing.

SODIUM SULFIDE

Also known as liver of sulfur. Potassium sulfide and sodium sulfide are often used interchangeably and have similar hazards.

Skin contact: moderately toxic–may cause burns and irritation
Eye contact: moderately toxic–may cause burns and irritation
Inhalation: moderately toxic–may cause irritation; toxic if contaminated
Ingestion: toxic

If heated to decomposition or contaminated with acid solution, can emit toxic fumes of hydrogen sulfide and sulfur dioxide gas. Hydrogen sulfide (odor of rotten eggs) poisoning can be fatal.

Requires local exhaust ventilation, fume hood or respirator (acidic gas cartridge), goggles, plastic apron, and plastic or rubber gloves during mixing. Requires local exhaust ventilation, goggles or safety glasses, and plastic apron and gloves during processing.

NEGATIVE AND PRINT CLEANING

The solutions used to clean negatives before printing and to remove dirt, grease, and other materials from prints are generally organic solvents, usually chloro- and/or fluorohydrocarbons. Aqueous-based solutions are not used because of their interaction with the gelatin layer of the photograph, although cleaners might include mixtures of alcohol and water. Freons (di- and trichlorofluoromethanes) have been the norm for canned air cleaners, but many of these are being replaced with less reactive and more environmentally safe gases.

Products containing the following solvents should not be used; benzene, toluene, xylene, carbon tetrachloride, trichloroethylene, methylene chloride, dioxane, methyl butyl ketone and cellosolve formulations. Benzene is a known carcinogen, and carbon tetrachloride, trichloroethylene, methylene chloride, and dioxane are suspected carcinogens.

It is appropriate to mention the increased hazards associated with solvents delivered by aerosol sprays, since some cleaners are applied in this way. The spray is made up of finely divided particles of the solvent and any other component dissolved in the solvent. The hazard is increased because the fine mist is able to penetrate the lungs more efficiently than vapors and gases. Avoid using aerosol sprays, particularly if organic solvents are involved.

If an aerosol spray is to be used, it may be necessary to work in a

spray booth. The use of an exhaust fan and a spray respirator may be acceptable in some situations. Avoid the temptation of working in a work space with a cartridge respirator, since the particles delivered by the aerosol will remain suspended in the air for considerable periods of time and will be inhaled once the respirator is removed. These particles could also cover and contaminate equipment and supplies in the work space.

Film Cleaners

Kodak film cleaner contains heptane and a trichloro-trifluoroethane. The following solvents might also be found in various commercial cleaning products recommended for use with photographic materials. The list is not exhaustive.

Alcohols are used for a number of applications, including cleaning. They are generally the least hazardous of the chemicals used as cleaners but, as with all organic solvents, they must be used in properly ventilated environments. In situations that involve heavy exposure to a solvent, a cartridge respirator with an organic cartridge should be used.

ETHYL ALCOHOL

Also known as ethanol, grain alcohol, or denatured alcohol. This solvent has a low flash point, 16°C or 60°F, and it represents a fire/explosion hazard.

 Skin contact: not very toxic
 Eye contact: not very toxic–may cause allergic reaction or irritation
 Inhalation: not very toxic–may cause allergic reaction or
 irritation; intoxicates
 Ingestion: moderately toxic–intoxicates

Denatured ethyl alcohol may contain 5% methyl alcohol or some other solvent and therefore can have an increased toxicity by ingestion.

Requires fume hood (flameproofed) or respirator (organic vapor cartridge) with local exhaust ventilation, goggles, and nitrile apron and gloves during mixing. Requires respirator (organic vapor cartridge) with local exhaust ventilation, goggles or safety glasses, and nitrile gloves during processing.

METHYL ALCOHOL
(Use With Caution)

Also known as methanol, wood alcohol, or methylated spirits. This solvent has a low flash point, 12°C or 54°F, and it represents a fire/explosion hazard.

Skin contact: moderately toxic–may cause irritation of mucous
 membranes
Eye contact: toxic–may cause severe allergic reaction
 Inhalation: moderately toxic
 Ingestion: toxic–may cause blindness, central nervous system
 damage, or may be fatal

Requires fume hood (flameproofed) or respirator (organic vapor
cartridge) with local exhaust ventilation, goggles, and nitrile apron and
gloves during mixing. Requires respirator (organic vapor cartridge) with
local exhaust ventilation, goggles or safety glasses, and nitrile gloves dur-
ing processing.

ISOPROPYL ALCOHOL

Also known as rubbing alcohol. This solvent has a low flash point, 12°C
or 53°F, and it represents a fire/explosion hazard.

Skin contact: not very toxic–may cause irritation
 Eye contact: moderately toxic–may cause burns and irritation
 Inhalation: not very toxic
 Ingestion: moderately toxic

Requires fume hood (flameproofed) or respirator (organic vapor
cartridge) with local exhaust ventilation, goggles, and nitrile apron and
gloves during mixing. Requires respirator (organic vapor cartridge) with
local exhaust ventilation, goggles or safety glasses, and nitrile gloves dur-
ing processing.

Aromatic Hydrocarbons

Aromatic hydrocarbons may be used in cleaners as a vehicle rather than
the cleaning agent. Historically benzene was used as a cleaning agent,
but it should not be used under any circumstances.

HEPTANE
(Use With Extreme Caution)

Also known as heptyl hydride. This solvent has a low flash point, -4°C or
25°F, and it represents a fire/explosion hazard.

Skin contact: moderately toxic–may cause irritation; acts
 as a degreaser

Eye contact: moderately toxic–may cause irritation
Inhalation: toxic
Ingestion: toxic

Requires fume hood (flameproofed) or respirator (organic vapor cartridge) with local exhaust ventilation, goggles, and rubber or plastic apron and gloves during mixing. Requires respirator (organic vapor cartridge) with local exhaust ventilation, goggles or safety glasses, and rubber or plastic gloves during processing.

BENZENE
(Do Not Use)

Also known as benzol. This solvent has a low flash point, -11°C or 52°F, and it represents a fire/explosion hazard.

Skin contact: toxic–may cause irritation; readily absorbed
 through skin
Eye contact: toxic–may cause irritation
Inhalation: toxic
Ingestion: toxic

This chemical is a known carcinogen.

Requires fume hood (flameproofed) or respirator (organic vapor cartridge) with local exhaust ventilation, goggles, and nitrile or plastic apron and gloves during mixing. Requires respirator (organic vapor cartridge) with local exhaust ventilation, goggles or safety glasses, and nitrile or plastic gloves during processing.

TOLUENE
(Use With Caution)

Also known as toluol and aromatic naphtha. This solvent has a low flash point, 4°C or 40°F, and it represents a fire/explosion hazard.

Skin contact: moderately toxic–may cause irritation; readily
 absorbed through skin; acts as a degreaser
Eye contact: moderately toxic–may cause irritation
Inhalation: toxic–may cause irritation of mucous membranes
Ingestion: toxic

Requires fume hood (flameproofed) or respirator (organic vapor cartridge) with local exhaust ventilation, goggles, and plastic apron and gloves during mixing. Requires respirator (organic vapor cartridge) with

local exhaust ventilation, goggles or safety glasses, and plastic gloves during processing.

XYLENE

Also known as xylol. This solvent has a low flash point, 22°C or 72°F, and it represents a fire/explosion hazard.

Skin contact: moderately toxic–may cause irritation; readily
absorbed through skin; acts as a degreaser
Eye contact: moderately toxic–may cause irritation
Inhalation: toxic–acts as a narcotic
Ingestion: moderately toxic

Requires fume hood (flameproofed) or respirator (organic vapor cartridge) with local exhaust ventilation, goggles, and plastic apron and gloves during mixing. Requires respirator (organic vapor cartridge) with local exhaust ventilation, goggles or safety glasses, and plastic gloves during processing.

Chlorinated and Fluorinated Hydrocarbons

One of the most common applications of chlorinated and fluorinated solvents is for cleaning and degreasing. These fluorinated and chlorinated hydrocarbons are skin degreasers (defatters) and can be absorbed through skin. Many of these solvents are suspected carcinogens. The best practice is to avoid their use or use them under carefully controlled conditions.

DICHLORODIFLUOROMETHANE

Also known as freon 12.

Skin contact: not very toxic–may cause irritation
Eye contact: not very toxic–may cause irritation
Inhalation: not very toxic
Ingestion: not very toxic

Requires fume hood or respirator (organic vapor cartridge) with local exhaust ventilation, goggles, and nitrile apron and gloves during mixing. Requires respirator (organic vapor cartridge) with local exhaust ventilation, goggles or safety glasses, and nitrile gloves during processing.

METHYL CHLOROFORM

Also known as 1,1,1-trichloroethane.

Skin contact: moderately toxic–may cause irritation
Eye contact: moderately toxic–may cause irritation
Inhalation: moderately toxic
Ingestion: moderately toxic

Exposure to heat or ultraviolet light can cause the formation of toxic phosgene gas.

Requires fume hood or respirator (organic vapor cartridge) with local exhaust ventilation, goggles, and nitrile apron and gloves during mixing. Requires respirator (organic vapor cartridge) with local exhaust ventilation, goggles or safety glasses, and nitrile gloves during processing.

TRICHLOROETHYLENE
(Do Not Use)

Also known as TCE.

Skin contact: moderately toxic
Eye contact: moderately toxic
Inhalation: toxic
Ingestion: toxic

This chemical is a known carcinogen. Exposure to heat or ultraviolet light can cause the formation of toxic phosgene gas.

Requires fume hood or respirator (organic vapor cartridge) with local exhaust ventilation, goggles, and nitrile apron and gloves during mixing. Requires respirator (organic vapor cartridge) with local exhaust ventilation, goggles or safety glasses, and nitrile gloves during processing.

CARBON TETRACHLORIDE
(Do Not Use)

Skin contact: toxic–may cause irritation; readily absorbed
through skin; dermatitis after repeated contact
Eye contact: toxic–burns; may cause irritation
Inhalation: toxic
Ingestion: toxic

This chemical is a known carcinogen. Exposure to heat or ultraviolet light can cause the formation of toxic phosgene gas.

Requires fume hood or respirator (organic vapor cartridge) with local exhaust ventilation, goggles, and nitrile apron and gloves during mixing. Requires respirator (organic vapor cartridge) with local exhaust ventilation, goggles or safety glasses, and nitrile gloves during processing.

METHYLENE CHLORIDE
(Do Not Use)

Also known as MC, methylene dichloride, or dichloromethane

Skin contact: moderately toxic–may cause irritation; skin degreaser
Eye contact: moderately toxic–may cause irritation
Inhalation: toxic
Ingestion: moderately toxic

This chemical is a known carcinogen. Exposure to heat or ultraviolet light can cause the formation of toxic phosgene gas.

Requires fume hood or respirator (organic vapor cartridge) with local exhaust ventilation, goggles, and nitrile apron and gloves during mixing. Requires respirator (organic vapor cartridge) with local exhaust ventilation, goggles or safety glasses, and nitrile gloves during processing.

TRICHLOROFLUOROMETHANE

Also known freon 11.

Skin contact: not very toxic–may cause irritation
Eye contact: not very toxic–may cause irritation
Inhalation: not very toxic
Ingestion: not very toxic

Requires fume hood or respirator (organic vapor cartridge) with local exhaust ventilation, goggles, and nitrile apron and gloves during mixing. Requires respirator (organic vapor cartridge) with local exhaust ventilation, goggles or safety glasses, and nitrile gloves during processing.

Petroleum Distillates

These are used as general solvents for cleaning. This group of solvents should be avoided because they are composed of mixtures rather than individual, specific solvents. They often have associated problems due to this lack of purity—problems related to both health hazards and hazards to the photographic materials they are being used on.

PETROLEUM ETHER
(Do Not Use)

Also known as petroleum spirits, petroleum benzin or lactol spirits.

GASOLINE
(Do Not Use)

Also known as petrol. It may contain toxic benzene as an impurity.

NAPHTHA

Also known as benzine, ligroin, or high-boiling petroleum ether.

MINERAL SPIRITS

Also known as white spirits, substitute turpentine, odorless paint thinner, and Stoddard solvent.

KEROSENE

Also known as # 1 fuel oil.

Other Solvents of Interest

The only other solvent of interest in terms of solvent cleaners is dioxane, which has been used as a movie film cleaner. Do not use this solvent; it is a suspected carcinogen.

FINISHING AND ARCHIVAL PROCESSING SUMMARY

The finishing and archival processing chemistries have some components that can be either eliminated or replaced with less hazardous substitutions. For example, hypo eliminators can and should be replaced with hypo clearing agents. The protective toning of the silver image can be achieved with a direct sulfide toner mixed from a liquid concentrate, thereby eliminating the more hazardous selenium toner and the expensive gold toner. Testing solutions are unnecessary if you keep careful records of the volumes of materials processed in the various solutions based on the manufacturer's recommendations. Cleaning of film and prints can be made less hazardous by using the less hazardous solutions in very small amounts under proper ventilation and operating conditions. The proper housekeeping techniques for the storage and filing of negatives may even eliminate the need to clean negatives.

IMAGE MODIFICATION

Chemical treatments to change a photographic image include procedures such as use of a particular type of developer agent, intensification, reduction, toning, and coloring. Some of these procedures are aesthetic in nature and can often be avoided if hazardous. The use of reduction or intensification baths, for example, was a regular practice in earlier photographic practice due in large part to the poor repeatability of the photographic materials in use at that time. Modern photographic manufacturing practices provide us with materials of predictable quality, and the need for treatment steps such as intensification or reduction tends to be the result of poor practice or technique.

The use of these types of remedial treatment applications should be avoided because both the photograph and the photographer are subjected to a hostile environment. In the case of the photograph, the archival quality of the treated image is significantly altered, generally for the worse. In the case of the photographer, there are health hazards associated with the chemicals being used. A good example is the use of mercury bleaching baths as part of an intensifier treatment. The image stability of mercury-treated images is known to be poor, and the toxicity of the mercury compound used, mercuric chloride, is very high.

In general, the treatments and procedures described in this section should be avoided unless special applications are part of the photographer's routine, such as hand coloring and toning for artistic effect. Regardless of the reason for using these procedures, pay special attention to the hazards and safety precautions outlined, and if the procedures can be avoided or replaced with less dangerous ones, do so.

DEVELOPERS FOR IMAGE COLOR MODIFICATION

The use of a specific developer agent for a particular color effect was popular in the past and was possible because of the wide range of papers that used to be available. The composition of the developer combined with the type of silver image formed resulted in some control over the image color. The color effects are often subtle and may not be available with some of the contemporary types of silver papers. Experimentation may be necessary to determine which effects can be achieved.

Generally the colors available relate to the size of the developed silver grain. Developers with just hydroquinone tend to be warm toned, and developers with just metol tend to black or blue-black colors. Ami-

dol produces a blue-black, glycin is brownish, and chlorohydroquinone is reddish brown. Of these, the glycin-hydroquinone and chlorohydroquinone developers mentioned by Haist (1979, vol. 2, p. 93) provide the greatest tonal range with variable dilution.

TONERS FOR IMAGE COLOR MODIFICATION

The use of toners for image permanence has already been discussed. Toners can also be used to achieve changes in image color for aesthetic reasons. The changes to the image due to the action of the toner may provide beneficial features for the photograph as well as image color change, but some toners have been shown to cause long-term damage to the image and instability to the photograph.

Most toners employ metal compounds, many of which are particularly toxic, including lead (lead acetate, lead nitrate, lead oxalate), gold (gold chloride), selenium (sodium selenite), mercury (mercuric chloride), and uranium (uranium nitrate). The absorption of even small amounts of mercury or uranium compounds, which are particularly toxic, can result in serious injury and in some cases even death.

Toners using thiourea (thiocarbamide) are not discussed in this section because this chemical is a suspected carcinogen. It appears in some brown toners as a replacement for the sulfide redeveloper as well as in some blue toners. Soluble lead compounds can also pose high risks resulting in lead poisoning. They have also been identified as causing birth defects (teratogens).

Toners based on formulations including chlorides of vanadium, gold, palladium, or platinum, as well as selenium compounds, copper sulfate, and ammonium persulfate, can produce irritation and skin allergies.

Operational Points

Toners are generally used in one of two ways: either directly by immersion, resulting in a color change or indirectly by bleaching and reforming (redeveloping). The two major concerns during the use of these processes are the metal salts being used, many of which are very toxic, and the inhalation exposure to toxic gas by-products that can be produced during the toning process. The inhalation hazards occur when gases are produced from solutions that are heated to assist the progress of the toning bath, or when the toner is contaminated by acids from an acidic stop bath or acid-based fixer. For example, highly toxic hydrogen sulfide gas can originate from sulfide and selenium toners if the toner is contami-

nated with acid carryover from an acid fixer bath. The same problem occurs with selenium toners contaminated with an acid fixer, producing toxic hydrogen selenide and sulfur dioxide gases.

Some hypo-based (sodium thiosulfate) toners, particularly hypo-alum or hypo-sulfide toners, require heating to increase the toning action. This situation could result in toxic sulfur dioxide gas being given off as a by-product.

The proper washing of prints after fixing can help minimize the problems associated with acid fixer carryover as well as help provide a properly processed print. Whenever possible, use toners that are supplied as concentrated solutions rather than powders.

Brown Toners

Traditionally, brown toners have been the most popular color-modifying toners used by photographers. Older silver enlarging papers manufactured for commercial use included warm-toned papers that did not require toning to achieve the warmer, brownish tones. With modern silver papers, there is less of a selection available, so a toning bath may be an important component of a photographer's technique.

The two methods of toning commonly used to achieve brown tones in silver gelatin prints are either a direct bath or a bleach and redevelopment treatment. In both cases a sulfur compound is used to realize a conversion of the silver image to silver sulfide, which provides a brownish color.

HYPO-ALUM DIRECT SULFIDE TONING

This is a direct toning technique in which a hypo bath ripened with silver is heated to 110°F to facilitate the toning action. A variation of this basic bath containing potassium iodide is recommended for use with prints made on an enlarging paper. Remember that when a sodium thiosulfate bath is heated or when acid is added, toxic sulfur dioxide gas can be generated.

The fact that this bath is used at an elevated temperature and the fact that sediment may form on the toned print's surface (requiring careful removal) suggest that another toner formulation would be easier and safer to use. Heating this bath can result in the decomposition of the bath and the formation of toxic gases. The process must be carefully monitored to ensure that the temperature does not rise too high. If gas

by-products are generated, a properly designed ventilation system is required. A water bath is needed because the print requires cleaning at the end of the toning process. This bath should not be used. Try the polysulfide formulation (below) as an alternative.

POLYSULFIDE DIRECT SULFIDE TONING

This direct toning technique has already been mentioned as a protective toner that helps increase image stability. The use of this toner to produce a strong brown tone is the basis of Kodak's Polysulfide Toner T-8 (see below). The toner works well with enlarging papers, producing a range of tones from sepia to dark brown. This toner is recommended for brown tones because it is not used in a heated bath. It is important to remember, however, that if acid is added to a bath containing potassium sulfide or sodium sulfide, poisonous hydrogen sulfide gas is formed.

The production of hydrogen sulfide gas is a problem for both the photographer and for any unprocessed photographic materials that might be kept in the same space. The toxic nature of the hydrogen sulfide gas requires proper ventilation, and other photographic materials will need to be protected from being fogged by the gas. The application of the toning bath should take place in an area remote from the regular darkroom, away from any light-sensitive photographic materials.

The availability of this toner in a liquid concentrate eliminates the need to mix the toner from scratch. The formulation is listed below, and details on its use should be referenced from the literature.

Kodak Polysulfide Toner T-8
Ref.: DeCock 1990, sec. 15, p. 63

Water	750.0 ml
Polysulfide (potassium sulfide)	7.5 g
Sodium carbonate, monohydrate	2.5 g
Water to make	1,000.0 ml

Dissolve in the order given.

POTASSIUM SULFIDE

Also known as liver of sulfur or potassium polysulfide. Potassium sulfide and sodium sulfide are often used interchangeably and have similar hazards.

Skin contact: moderately toxic–may cause irritation
Eye contact: moderately toxic–may cause irritation
Inhalation: moderately toxic–may cause irritation; toxic
if contaminated
Ingestion: toxic

If heated to decomposition or contaminated with acid solution, can emit toxic fumes of hydrogen sulfide and sulfur dioxide gas. Hydrogen sulfide (odor of rotten eggs) poisoning can be fatal.

Requires local exhaust ventilation, fume hood or respirator (acidic gas cartridge), goggles, plastic apron, and plastic or rubber gloves during mixing. Requires local exhaust ventilation, goggles or safety glasses, and plastic apron and gloves during processing.

SODIUM CARBONATE

Also known as soda ash.

Skin contact: moderately toxic–may cause burns or irritation
Eye contact: moderately toxic–may cause burns or irritation
Inhalation: moderately toxic
Ingestion: moderately toxic–can be fatal in large quantities

Concentrated forms are corrosive to skin and eyes; dilute solutions may irritate.

If heated to decomposition, can emit toxic fumes of sodium oxide gas.

Requires local exhaust ventilation, dust mask, goggles, and plastic apron and gloves during mixing. Requires local exhaust ventilation, goggles or safety glasses, and plastic gloves during processing.

NELSON GOLD TONER (DO NOT USE)

The use of the Nelson Gold Toner for direct brown tones should be avoided. The toner makes use of a heated bath in which ammonium persulfate is used. When heated, ammonium persulfate can produce toxic sulfur dioxide gas. Ammonium persulfate is also a handling hazard because when it contacts organic materials it becomes a fire and explosion hazard.

SEPIA BLEACH AND SULFIDE REDEVELOPMENT TONER

This is the most popular brown toner in use today. It is the sepia toner marketed by Kodak, and it makes use of two solutions. The first bath is a

bleach bath that converts the silver image to a colorless silver compound. The second bath is a sulfide compound that darkens the silver to create a stable, permanent silver sulfide image. The difficulties with this technique are that the original print must be overprinted, and gauging the proper exposure and development for the print can involve some trial and error. Also, the prints must be carefully processed to ensure that they are free of hypo, or the print image will dissolve. Hypo (thiosulfate) and the ferricyanide used in the bleach bath form a silver reducer that dissolves the silver image. This toner can be recommended.

An example of this traditional toner formula is listed below. For the proper application of these baths, use the procedures listed in the literature.

GAF Sepia Toner, 221
Ref.: DeCock 1990, sec. 15, p. 64

Bleach Bath, Solution 1

Water, 125°F	750.0 ml
Potassium ferricyanide	50.0 g
Potassium bromide	10.0 g
Sodium carbonate, monohydrated	20.0 g
Water to make	600.0 ml

Redeveloper Bath, Solution 2

Sodium sulfide, desiccated	345.0 g
Water to make	500.0 ml

Use Solution 2 diluted with 8 parts water.

POTASSIUM FERRICYANIDE

Also known as red prussiate of potash.

Skin contact: not very toxic–may cause irritation
Eye contact: not very toxic–may cause irritation
Inhalation: not very toxic
Ingestion: moderately toxic

If heated to decomposition, mixed with acid solutions, or exposed to ultraviolet light, can emit toxic fumes of hydrogen cyanide and potassium oxide gas.

Requires local exhaust ventilation, dust mask, goggles, plastic apron, and plastic or rubber gloves during mixing. Requires local exhaust ventilation, goggles or safety glasses, plastic apron, and plastic or rubber gloves during processing.

POTASSIUM BROMIDE

Also known as bromide salt of potassium.

> Skin contact: not very toxic–prolonged exposure can cause skin rash
> Eye contact: not very toxic–temporary discomfort
> Inhalation: moderately toxic
> Ingestion: moderately toxic–harmful in large amounts

If heated to decomposition, can emit toxic fumes of bromine gas.

Requires local exhaust ventilation, dust mask, goggles, plastic apron, and plastic gloves during mixing. Requires local exhaust ventilation and plastic gloves during processing.

SODIUM CARBONATE

Also known as soda ash.

> Skin contact: moderately toxic–may cause burns or irritation
> Eye contact: moderately toxic–may cause burns or irritation
> Inhalation: moderately toxic
> Ingestion: moderately toxic–can be fatal in large quantities

Concentrated forms are corrosive to skin and eyes; dilute solutions may irritate.

If heated to decomposition, can emit toxic fumes of sodium oxide gas.

Requires local exhaust ventilation, dust mask, goggles, and plastic apron and gloves during mixing. Requires local exhaust ventilation, goggles or safety glasses, and plastic gloves during processing.

SODIUM SULFIDE

Also known as liver of sulfur. Potassium sulfide and sodium sulfide are often used interchangeably and have similar hazards.

> Skin contact: moderately toxic–may cause burns and irritation
> Eye contact: moderately toxic–may cause burns and irritation
> Inhalation: moderately toxic–may cause irritation;
> toxic if contaminated
> Ingestion: toxic

If heated to decomposition or contaminated with acid solution, can emit toxic fumes of hydrogen sulfide and sulfur dioxide gas. Hydrogen sulfide (odor of rotten eggs) poisoning can be fatal.

Requires local exhaust ventilation, fume hood or respirator (acidic gas cartridge), goggles, plastic apron, and plastic or rubber gloves during

mixing. Requires local exhaust ventilation, goggles or safety glasses, and plastic apron and gloves during processing.

MERCURY FERRICYANIDE BLEACH AND SULFIDE REDEVELOPMENT TONER (DO NOT USE)

This is a variation of the bleach and development procedure described above. The advantages in manipulation of the image tone are offset by the undesirable use of mercuric chloride in the formulation. This bath is not recommended.

Purple and Purple Sepia Toners

Selenium toners provide an interesting shade of purple to purple-brown on many contemporary silver papers. The use of diluted selenium toner for improved image stability has already been discussed.

Selenium toning is a direct toning bath, and the toner is available in a liquid concentrate. This eliminates the need to mix the solution from very toxic selenium compounds. Do not attempt to mix this toner from scratch; use the commercially available liquid concentrate.

Selenium toners can decompose to produce poisonous hydrogen sulfide gas, hydrogen selenide gas if concentrated acids contaminate the toning bath, and toxic sulfur dioxide gas if hypo (sodium thiosulfate) or sodium sulfite carryover into the toning bath occurs. All three of these gases require local ventilation exhaust. Kodak Rapid Selenium Toner can also give off toxic ammonia gas as well as sulfur dioxide gas if contaminated with a strong acid.

Red and Brown Toners

The use of copper compounds to obtain red and red-brown tones involves a direct toning bath. The range of colors obtained is a function of the time of immersion, and toning can be stopped at any point. The following formulation can be used, taking care with the ferricyanide bath.

Wall's Dark Brown to Chalk Red Toner
Ref.: Wall et al. 1975, p. 249

Stock Solution A

Copper sulfate	4.0 g
Potassium citrate (neutral)	6.0 g
Water to make	590.0 cc

Stock Solution B

Potassium ferricyanide	3.3 g
Potassium citrate (neutral)	16.0 g
Water to	590.0 cc

Mix in equal parts and consult the literature for details on its use.

COPPER SULFATE

Also known as cupric sulfate or blue vitriol.

Skin contact: not very toxic–may cause allergies or irritation
Eye contact: moderately toxic–burns; may cause irritation
Inhalation: moderately toxic–may cause irritation to
 mucous membranes
Ingestion: toxic

If heated to decomposition, can emit toxic fumes of sulfur dioxide and copper oxide gases.

Requires local exhaust ventilation, dust mask, goggles, plastic or rubber apron, and rubber gloves during mixing. Requires local exhaust ventilation, goggles or safety glasses, plastic apron, and rubber gloves during processing.

POTASSIUM CITRATE

Also known as tri-potassium citrate.

Skin contact: not very toxic
Eye contact: not very toxic–may cause temporary discomfort
Inhalation: not very toxic–may cause irritation
Ingestion: not very toxic

If heated to decomposition, can emit toxic fumes of carbon dioxide and carbon monoxide gases.

Requires local exhaust ventilation, dust mask, safety glasses, and plastic gloves during mixing. Requires local exhaust ventilation, safety glasses, and plastic gloves during processing.

POTASSIUM FERRICYANIDE

Also known as red prussiate of potash.

Skin contact: not very toxic–may cause irritation
Eye contact: not very toxic–may cause irritation

Inhalation: not very toxic
Ingestion: moderately toxic

If heated to decomposition, mixed with acid solutions, or exposed to ultraviolet light, can emit toxic fumes of hydrogen cyanide and potassium oxide gas.

Requires local exhaust ventilation, dust mask, goggles, plastic apron, and plastic or rubber gloves during mixing. Requires local exhaust ventilation, goggles or safety glasses, plastic apron, and plastic or rubber gloves during processing.

DIRECT BLUISH TONERS

The use of the gold protective toner for increasing image stability was described in an earlier section and can also be used to obtain a cooler, bluer tone on enlarging papers.

Wall's Direct Cool (Bluish) Toner
Ref.: Wall et al 1975, p. 250

Ammonium thiocyanate	9.0 g
Gold chloride	0.6 g
Boiling water	590.0 cc

AMMONIUM THIOCYANATE

Also known as ammonium sulfocyanate.

Skin contact: moderately toxic may cause irritation;
 prolonged contact can result in blisters
Eye contact: moderately toxic–may cause irritation
Inhalation: not very toxic–may cause irritation
Ingestion: toxic

If heated to decomposition or contaminated with acid solutions, can emit toxic fumes of hydrogen cyanide, hydrogen sulfide, ammonia, or nitrogen dioxide gas.

Requires local exhaust ventilation, dust mask, goggles, plastic apron, and rubber or plastic gloves during mixing. Requires local exhaust ventilation, goggles, plastic apron, and plastic or rubber gloves during processing.

GOLD CHLORIDE

Also known as auric chloride.

Skin contact: moderately toxic–may cause irritation
Eye contact: moderately toxic–may cause irritation and burns
Inhalation: moderately toxic–may cause irritation
Ingestion: moderately toxic

If heated to decomposition, can emit toxic hydrogen chloride and chlorine gas.

Requires local exhaust ventilation, dust mask, goggles or safety glasses, and rubber gloves during mixing. Requires local exhaust ventilation, safety glasses, and rubber gloves during processing.

Direct (Intense) Blue Toner
Ref.: DeCock 1990, sec. 15, p. 67
This iron toner produces a rich blue tone directly.

Kodak Toner T-12

Ferric ammonium citrate (green)	4.0 g
Oxalic acid, crystals	4.0 g
Potassium ferricyanide	4.0 g
Water to make	1,000.0 ml

FERRIC AMMONIUM CITRATE

Also known as ammonium ferric citrate.

Skin contact: not very toxic–may cause irritation
Eye contact: not very toxic–may cause irritation
Inhalation: not very toxic
Ingestion: not very toxic

If heated to decomposition, can emit toxic fumes of ammonia gas.

Requires local exhaust ventilation, dust mask, safety glasses, and plastic apron and gloves during mixing. Requires local exhaust ventilation, safety glasses, and plastic apron and gloves during processing.

OXALIC ACID

Also known as ethanedioic acid.

Skin contact: toxic–burns; may cause irritation and dermatitis
Eye contact: toxic–burns
Inhalation: toxic
Ingestion: toxic

If heated to decomposition, can emit toxic fumes of formic acid and carbon monoxide gas.

Requires local exhaust ventilation, dust mask, goggles, rubber apron, and rubber or plastic gloves during mixing. Requires local exhaust ventilation, goggles, rubber or plastic apron, and rubber or plastic gloves during processing.

POTASSIUM FERRICYANIDE

Also known as red prussiate of potash.

Skin contact: not very toxic–may cause irritation
Eye contact: not very toxic–may cause irritation
Inhalation: not very toxic
Ingestion: moderately toxic

If heated to decomposition, mixed with acid solutions, or exposed to ultraviolet light, can emit toxic fumes of hydrogen cyanide and potassium oxide gas.

Requires local exhaust ventilation, dust mask, goggles, plastic apron, and plastic or rubber gloves during mixing. Requires local exhaust ventilation, goggles or safety glasses, plastic apron, and plastic or rubber gloves during processing.

Green Toners

The use of an indirect treatment sequence to obtain a green image tone includes the following bleach and redevelopment sequence. Different greens can be obtained by changing the redevelopment bath's cobalt compound and substituting other metal salts such as vanadium chloride. Care must be exercised if these metal salts are used.

Wall's Bleach and Redeveloper Green Toner
(USE WITH CAUTION)

Bleach Bath

Potassium bichromate	0.3 g
Potassium ferricyanide	1.6 g
Water	60.0 cc

Redevelopment Bath

Cobalt chloride	1.3 g
Ferrous sulfate	0.3 g
Hydrochloric acid	1.2 cc
Water	60.0 cc

POTASSIUM BICHROMATE
(Do Not Use)

Also known as potassium dichromate.

Skin contact: toxic–may cause allergies, ulcers, or burns
Eye contact: toxic–may cause allergies or burns
Inhalation: toxic
Ingestion: toxic

Dichromates and most chromate salts are carcinogens or suspected carcinogens.

If heated to decomposition or contaminated with acid solutions, can emit toxic fumes of chromium oxide gas or form dangerous chromic acid.

Requires a self-contained respirator or a dust mask and a positive pressure fume hood as well as local exhaust ventilation, goggles, and rubber apron and gloves during mixing. Requires local exhaust ventilation, goggles, and rubber apron and gloves during processing. Solution spills must be washed clean before they dry to prevent the formation of dichromate dusts.

POTASSIUM FERRICYANIDE

Also known as red prussiate of potash.

Skin contact: not very toxic–may cause irritation
Eye contact: not very toxic–may cause irritation
Inhalation: not very toxic
Ingestion: moderately toxic

If heated to decomposition, mixed with acid solutions, or exposed to ultraviolet light, can emit toxic fumes of hydrogen cyanide and potassium oxide gas.

Requires local exhaust ventilation, dust mask, goggles, plastic apron, and plastic or rubber gloves during mixing. Requires local exhaust ventilation, goggles or safety glasses, plastic apron, and plastic or rubber gloves during processing.

COBALT CHLORIDE

Also known as cobaltous chloride.

Skin contact: moderately toxic–avoid repeated skin contact;
may cause irritation or rash
Eye contact: moderately toxic–may cause temporary discomfort

Inhalation: moderately toxic–avoid inhalation of powder
Ingestion: moderately toxic

If heated to decomposition, can emit toxic fumes of cobalt oxide gas.

Requires local exhaust ventilation, dust mask, goggles, plastic apron, and plastic or rubber gloves during mixing. Requires local exhaust ventilation, safety glasses, plastic apron, and plastic or rubber gloves during processing.

FERROUS SULFATE

Also known as iron sulfate.

Skin contact: not very toxic–may cause irritation
Eye contact: moderately toxic–may cause irritation
Inhalation: not very toxic–may cause irritation
Ingestion: not very toxic

If heated to decomposition, can emit toxic fumes of sulfur dioxide gas.

Requires local exhaust ventilation, dust mask, safety glasses, and plastic apron and gloves during mixing and processing.

HYDROCHLORIC ACID (concentrated)
(Use With Extreme Caution)

Also known as muriatic acid.

Skin contact: toxic–burns, causes tissue damage
Eye contact: toxic–burns, causes tissue damage
Inhalation: toxic–burns, causes tissue damage
Ingestion: toxic–burns, causes tissue damage

If heated to decomposition, can emit toxic fumes of hydrogen chloride gas.

Requires local exhaust ventilation and fume hood or respirator (acidic gas cartridge), goggles, rubber apron, and rubber or plastic gloves during mixing. Requires local exhaust ventilation, goggles or safety glasses, rubber or plastic apron, and rubber or plastic gloves during processing.

VANADIUM CHLORIDE
(Use With Caution)

Also known as vanadium tetrachloride.

Skin contact: moderately toxic–corrosive, may cause irritation
Eye contact: moderately toxic–corrosive, may cause irritation

Inhalation: toxic
Ingestion: toxic

If heated to decomposition, can emit toxic fumes of hydrogen chloride gas.

Requires local exhaust ventilation, dust mask, goggles, plastic apron, and plastic or rubber gloves during mixing. Requires local exhaust ventilation, safety glasses, plastic apron, and rubber or plastic gloves during processing.

Toner Summary

The safe use of toners presents more problems than most of the other toxic chemicals dealt with to this point. The bulk of black-and-white images created for commercial requirements are not toned and are left in their natural black, grey, and white images. Toners are commonly applied to change the image color for creative and artistic effect. In situations such as this, the desired color or tone is defined by the image, and less hazardous formulations and substitutions are often not available.

Generally speaking, the warmish tones associated with sepia images are the most popular. The same toner used for protective toning mentioned in the previous section can also be used here to provide a relatively safe image toner. When other colors are desired, it may be necessary to institute additional housekeeping and equipment improvements to the darkroom to provide safe mixing and processing environments for the use of toners.

COLORING AND RETOUCHING

Coloring, particularly hand coloring black-and-white photographs, has become quite popular in recent years as a form of artistic expression. These coloring techniques use some of the traditional materials used for coloring gelatin emulsions such as oil colors formulated specifically for photographic emulsions and color dyes. Artists have also added color pencils, watercolors, watercolor pencils, and food color as techniques for coloring photographic images.

Retouching represents a more subtle correction of flaws and blemishes in the negative or on the print that are intended to be invisible or detected only by trained observers. These techniques include the removal of light spots by spotting with dyes or pigments, the reduction of dark spots by chemical etching or physical scraping, and the application

of graphite pencil to the negative to soften wrinkles and creases in the subject's face.

These different materials serve different visual end uses, but they are used in the same way. The essential difference lies in the fact that one is used extensively to create a strong visual effect, and the other is used to enhance the photograph in an inconspicuous way.

Coloring

The coloring of a photographic image generally involves the application of colored dyes or pigments to a black-and-white print, often to produce a color-like image. The process allows a skilled operator to produce a full-color photograph with a selective color scale that may not be available with normal color photographic processes. The use of iridescent colors, pastel colors, or even grey colors is an example of this type of control.

The use of oil-based colors has been part of the professional photographer's repertoire for decades. The hand coloring of black-and-white photographs was a standard commercial product offered by photographers from the beginnings of photography right through to the 1960s and has recently resurfaced as a fine art process. The popularity of oil-based colors has experienced a resurgence in the last decade, and Marshall's Photo Oils for photographs are still available for this purpose.

The hazards associated with the use of these types of materials are described in artist materials textbooks, in the *Art Hazards News* newsletter, and, to a lesser degree, in books such as *Health Hazards Manual for Artists*. These are the primary sources of information for photographers using art-based techniques.

The pigments used in the oils have the same obvious hazards as the chemicals they are associated with. For example, lead- and mercury-based pigments such as white lead (lead carbonate) and vermilion (mercuric sulfide) are highly toxic, similar to mercuric chloride or lead acetate used as photographic intensifiers and toners.

Other hazards are present in the form of solvents used to dissolve gums or resins for varnishes, which are in turn used to prepare the photograph's surface for the pigment or to protect its surface after working up.

Aerosol propellants containing dissolved gums or resins are another source of hazardous material, since the gases used as propellants, the resins, and any solvent used to keep them in solution may all have varying degrees of toxicity and are delivered in a fine spray.

The use of dyes for the coloring of black-and-white photographic

images has also become quite popular. The azo family of dyes is commonly used; other dye family groups are quinone- and phthalocyanine-based dyes. Dr. Martins is one of the most popular commercial products available for this work.

The use of watercolors, either in the traditional tubes or pans or in the more contemporary pencils, involves hazards associated with pigments, since most watercolors are pigment based. However, unlike oils, solvents are not a problem, since the solvent used in this case is water. Lacquers and surface-preparation materials may, however, still be an issue if they are needed to prepare the photograph's surface or stabilize the applied color.

OILS

The hazards associated with oils include the pigment itself, the solvents used as dilution media, and varnishes for finishes. The more permanent pigments should be used to ensure longevity of the coloring, and toxic pigments should be replaced with other less toxic ones. Replace antimony white (barium sulfate and antimony trioxide), lead white (lead carbonate), and barium white (barium sulfate) with titanium white (titanium dioxide), zinc white (zinc oxide), or aluminum white (aluminum oxide). Replace carbon black (lamp black) with ivory black (bone black). When substitution is not possible, the use of the pigment will have to be carefully controlled to minimize the hazard. There are specific oil kits manufactured for the coloring of photographs, but regular oils are also used.

Painting medium (linseed oil and petroleum distillate) or turpentine is often used to dilute the oil colors. These solvents are skin irritants and can be very hazardous if inhaled into the lungs and absorbed into the bloodstream. Turpentine is an allergic sensitizer and is poisonous if ingested.

Often the finishing of the print includes a varnish layer applied as a protective coating. The hazards associated with these applications involve the presence of solvents, resins, and gums, and are exacerbated if the solution is applied by airbrush or spray. The use of a commercial aerosol spray varnish introduces very fine particle mists into the working environment; if inhaled, they can penetrate deep into the lungs and thus into the circulatory system. The application of a lacquer by spray should be conducted only in a spray booth with a high-volume air exhaust. The operator should also wear a respirator with a solvent cartridge. The sol-

vent used in these commercial sprays often includes amyl acetate, which is used to dissolve cellulose acetate or cellulose nitrate.

An alternative is to apply the finish with a brush. The cellulose compound is dissolved in a solvent and coated onto the surface of the colored photograph. This technique still requires that the work take place in a fume hood, and the operator should wear a cartridge respirator with an organic solvent cartridge. A disadvantage is that it is difficult to attain an even coating of the photograph's surface, which is not a problem with a spray application.

DYES, WATERCOLORS, AND FOOD DYES

Hand-coloring techniques that use food dyes are the least hazardous since these products are safe for human use. The problems associated with them tend to involve their lack of permanence. Photographic retouching dyes are also available for this type of application and are more vibrant than the food colors, since they have been formulated for application to photographic images. Their stability is generally better than many of the food dyes, but may still be quite fugitive. The toxicity of these types of dyes is also largely unknown, and so the application of the color and exposure to the dyes must be viewed from the perspective that they may be toxic.

Watercolors represent the most stable color system, since many of the colors are pigments rather than dyes. The toxicity of these pigments is the same as that of the pigments used in oils, and the same precautions must be taken.

The most hazardous aspect of the use of water-based colors is the brush technique of the operator. Many photographers have the habit of licking the brush to help it form a fine tip. This procedure must not be used. Control of the amount of pigment, dye, or color on the brush is possible by using blotting paper or semi-absorbent paper.

Retouching

The retouching of color and black-and-white photographs is done in basically the same way as coloring. For lighter spots on black-and-white images, liquid dyes may be used, Spot-tone being one of the products available. Opaque pigments in various shades of grey may be used for retouching prints. The dyes are used for both negatives and prints, but the pigments are limited to prints. The Grambacher photographic retouch-

ing pigments are among the available products. For light spots on colored prints and negatives, dye solutions are generally used.

Retouching often requires local reduction of darker spots. The two methods in general use are chemical reduction or physical scraping (etching). The removal of unwanted silver in a black-and-white image can be completed using a Farmer's reducer formulation applied locally with a brush. The control of the solution's application to the spot requires considerable skill and practice. The alternative, particularly for small areas, is to scrape the black spot of silver off the photograph using a scalpel or x-acto knife.

As is the case with the coloring techniques, retouching may require preparation of the photograph's surface with varnishes that contain solvents and may require application using a spray propellant. These chemicals can include chlorinated and aromatic hydrocarbons as well as alcohols and freons.

The hazards associated with retouching photographs with dyes are the same as those associated with coloring techniques. The use of bleach baths such as Farmer's reducer to etch out dark spots on black-and-white images has the same hazards as using Farmer's reducer to reduce the density of a negative (see the Reduction section below). The use of a bleaching bath for the removal of black spots requires considerable skill, and the print will require subsequent washing to stabilize the area worked on. These two aspects of the technique limit its usefulness, and retouching the negative may be a more appropriate treatment approach.

Pencil or graphite retouching on black-and-white negatives requires the surface preparation of the gelatin emulsion with a retouching varnish containing a gum—traditionally dammar or tragacanth—and an oil or solvent such as turpentine. The retouching medium is usually rubbed on locally or sprayed onto the entire surface.

INTENSIFICATION

Some intensifiers listed in the historic literature contain hazardous chemical compounds including mercury, cyanide, and uranium salts. The formulations using these chemical salts also have image-stability problems, so they are not reviewed in detail.

Intensification is used primarily for the treatment of silver negative materials that have been incorrectly exposed and/or developed. The use of this technique as a contemporary photographic tool is generally limited to beginners still coming to terms with their materials and a few

professionals and photographic artists who are deliberately modifying their materials.

In general, intensification should be avoided whenever possible and should not be applied to the original negative. The chemicals used are generally quite toxic and in most cases can introduce instabilities into the treated image, resulting in eventual discoloration or fading.

Intensification attempts to increase the optical density of the silver image by adding silver to the existing image or by depositing some other metal onto the silver image. This increase in density on top of the existing silver image then provides a printable negative.

The intensification method, like the toners described in the previous section, can be either a direct or a bleach and redevelopment process. As is the case with the toners, metal compounds are often used in the formulation. Several of the toners described previously also lead to an intensification of the image by the deposition of another metal onto the silver.

It may also be necessary to include a hardening bath as part of the treatment sequence because the intensifier solutions tend to stain and soften the gelatin binder during treatment. The proper processing of the image is required prior to treatment as is the case with toner treatments. An appropriate hardener can be found in the section on Stop Baths, Fixers, and Hardeners.

There are three types of intensification processes: proportional, superproportional, and subproportional. Each provides a different type of intensification to the image, and the choice is made on the basis of the type of problem the image suffers from. Proportional baths increase the image density based on the amount of silver present, resulting in an increase in image density similar to extended development of the original. Superproportional baths build up the higher-density areas more than the low-density areas, resulting in increased image contrast. Subproportional baths build up the lower densities more than the high densities, resulting in greater shadow detail.

Direct Intensification

SILVER INTENSIFIER, PROPORTIONAL

Silver intensifiers tend to deposit finely divided silver directly onto the original silver image as a proportional intensifier. The application is best on underdeveloped negatives. Once the desired degree of intensification has been achieved, the negative is removed from the bath and fixed in an acid fixer followed by proper washing. The silver bath tends to have a

limited application time and treatment needs to be completed in 25 to 30 minutes or the bath needs to be replaced by a fresh one.

Kodak Silver Intensifier In-5
Ref.: DeCock 1990, sec. 15, p. 78

Stock Solution 1
Silver nitrate, crystals	60.0 g
Distilled water to make	1,000.0 ml

Stock Solution 2
Sodium sulfite, desiccated	60.0 g
Water to make	1,000.0 ml

Stock Solution 3
Sodium thiosulfate	105.0 g
Water to make	1,000.0 ml

(Please note that a mistake has been made in the printing of the formulation in the reference. The correct chemical in this solution is thiosulfate, not sulfite.)

Stock Solution 4
Sodium sulfite, desiccated	15.0 g
Metol	25.0 g
Water to make	3,000.0 ml

One part of Solution 2 is added to one part of Solution 1 and mixed well. Then one part of Solution 3 is added to the mixture to dissolve the white precipitate that formed. When clear, stir in three parts of Solution 4. The mixture should be used immediately. The negative to be intensified should be given a prehardening bath before intensification. The SH-1 formulation is recommended by Haist (1979, vol. 2, p.10). The intensified negative is fixed in a plain (30%) thiosulfate bath and properly washed.

SILVER NITRATE

Also known as lunar caustic.

Skin contact: moderately toxic–may cause irritation, corrosive
Eye contact: moderately toxic–may cause irritation, corrosive
Inhalation: moderately toxic–may cause irritation to
mucous membranes
Ingestion: moderately toxic

If heated to decomposition, can emit toxic fumes of nitrogen dioxide gas.

Requires local exhaust ventilation, dust mask, goggles, plastic apron, and rubber gloves during mixing. Requires local exhaust ventilation, goggles or safety glasses, plastic apron, and rubber gloves during processing.

SODIUM SULFITE

Also known as sulfurous acid, sodium salt.

Skin contact: not very toxic–may cause irritation
Eye contact: not very toxic–may cause irritation
Inhalation: moderately toxic–may cause irritation
Ingestion: toxic–could cause death if consumed in
significant amounts

If heated to decomposition or mixed with acid, can emit toxic sulfur dioxide and sodium oxide fumes.

Requires local exhaust ventilation, dust mask, goggles, plastic apron, and plastic or rubber gloves during mixing. Requires local exhaust ventilation and plastic gloves during processing.

SODIUM THIOSULFATE, PENTAHYDRATE

Also known as sodium hyposulfite or hypo.

Skin contact: not very toxic
Eye contact: not very toxic–may cause temporary discomfort
Inhalation: not very toxic; toxic if contaminated with acid
Ingestion: moderately toxic–may cause cyanosis

If heated to decomposition or contaminated with acid, can emit toxic fumes of sulfur dioxide gas.

Requires local exhaust ventilation, safety glasses, and plastic gloves during mixing and processing.

METOL
(Use With Caution)

Metol has been in use since 1891 and is also known by the trade names Atolo, Elon, Genol, Graphol, Monol, Pictol, Photol, Rhodol, Satrapol, Scalol, or Viterol. Its chemical name is metol or monomethyl-para-aminophenol sulfate.

Skin contact: moderately toxic–may cause allergic reaction
or irritation; repeated contact may result in dermatitis
Eye contact: moderately toxic–may cause irritation
Inhalation: moderately toxic–may cause respiratory tract irritation
Ingestion: toxic

If heated to decomposition, can emit toxic fumes of sulfur dioxide and nitrogen oxide.

Requires local exhaust ventilation, dust mask, goggles, plastic apron, and rubber gloves during mixing. Requires local exhaust ventilation, goggles or safety glasses, and rubber or plastic gloves during processing.

Two-Step Intensification: Bleach and Redevelopment

CHROMIUM INTENSIFICATION, PROPORTIONAL INTENSIFICATION

The use of a chromium intensifier is proportional and ideal if the negative requires an increase in density and contrast. It is easy to use and, most important, it can be repeated several times until the desired effect is achieved.

The image is prehardened in an SH-1 hardener and then placed into the chromate solution. The image is converted to silver chloride in the chromate bleaching bath, and a deposit of a chromium compound is laid down in proportion to the amount of silver present. The silver chloride is exposed to light and redeveloped in a conventional developer. The image is now made up of darkened metallic silver and deposit of a chromium compound.

Kodak Formalin Hardener SH-1
Ref.: DeCock 1990, sec. 15, p. 55

Water	500.0 ml
Formaldehyde, (37% solution)	10.0 ml
Sodium carbonate, monohydrated	6.0 g
Water to make	1,000.0 ml

Mixing this hardener requires local exhaust ventilation or a mask with a formaldehyde cartridge.

Kodak Chromium Intensifier IN-4 Stock Solution
Ref.: DeCock 1990, sec. 15, p. 77

Water	750.0 ml
Potassium dichromate	90.0 g
Hydrochloric acid, concentrated	64.0 ml
Water to make	1,000.0 ml

Chromic acid, a suspected carcinogen, can form when a strong acid like hydrochloric acid is added to a dichromate solution. Local exhaust ventilation is required during mixing, and safety gloves and glasses must be worn.

For use, the stock solution is diluted 1 part to 10 parts water. The treatment sequence includes hardening in SH-1 followed by bleaching in the chromate solution, a good washing and redevelopment in a low silver solvent developer such as Kodak D-72, followed by a rinse, fixing, and a wash.

FORMALDEHYDE
(Use With Extreme Caution)

Also known as formalin.

Skin contact: toxic–burns; may cause irritation
Eye contact: toxic–burns; may cause irritation
Inhalation: toxic–may cause irritation to mucous membranes
Ingestion: toxic

Formaldehyde is a suspected carcinogen.
If heated to decomposition, can emit acrid smoke and fumes.

Requires local exhaust ventilation, fume hood or respirator (formaldehyde cartridge), goggles, rubber apron, and nitrile gloves during mixing. Requires local exhaust ventilation, respirator (formaldehyde cartridge), goggles or safety glasses, rubber or plastic apron, and nitrile gloves during processing.

SODIUM CARBONATE

Also known as soda ash.

Skin contact: moderately toxic–may cause burns or irritation
Eye contact: moderately toxic–may cause burns or irritation
Inhalation: moderately toxic
Ingestion: moderately toxic–can be fatal in large quantities

Concentrated forms are corrosive to skin and eyes; dilute solutions may irritate.
If heated to decomposition, can emit toxic fumes of sodium oxide gas.

Requires local exhaust ventilation, dust mask, goggles, and plastic apron and gloves during mixing. Requires local exhaust ventilation, goggles or safety glasses, and plastic gloves during processing.

POTASSIUM DICHROMATE
(Do Not Use)

Also known as potassium bichromate.

Skin contact: toxic–may cause allergies, ulcers, or burns
Eye contact: toxic–may cause allergies or burns
Inhalation: toxic
Ingestion: toxic

Dichromates and most chromate salts are carcinogens or suspected carcinogens.

If heated to decomposition or contaminated with acid solutions, can emit toxic fumes of chromium oxide gas or form dangerous chromic acid.

Requires a self-contained respirator or a dust mask and a positive pressure fume hood as well as local exhaust ventilation, goggles, and rubber apron and gloves during mixing. Requires local exhaust ventilation, goggles, and rubber apron and gloves during processing. Solution spills must be washed clean before they dry to prevent the formation of dichromate dusts.

HYDROCHLORIC ACID (concentrated)
(Use With Extreme Caution)

Also known as muriatic acid.

Skin contact: toxic–burns; causes tissue damage
Eye contact: toxic–burns; causes tissue damage
Inhalation: toxic–burns; causes tissue damage
Ingestion: toxic–burns; causes tissue damage

If heated to decomposition, can emit toxic fumes of hydrogen chloride gas.

Requires local exhaust ventilation and fume hood or respirator (acidic gas cartridge), goggles, rubber apron and rubber or plastic gloves during mixing. Requires local exhaust ventilation, goggles or safety glasses, rubber or plastic apron, and rubber or plastic gloves during processing. Always add the acid to the water.

MERCURY INTENSIFICATION (DO NOT USE)

The intensification formulas using mercuric compounds such as mercuric chloride, mercuric bromide, or mercuric iodide are bleach and redevelopment intensifiers. The historic literature is full of formulations for this type of bath, but both the toxicity of these compounds and the lack of image stability eliminate them from serious consideration for intensification use.

URANIUM INTENSIFICATION (DO NOT USE)

The intensification of underexposed negatives with a uranium intensifier has often been used when the developed image was extremely weak. The same points made for mercury intensifiers hold for the uranium treatment, and it should not be used.

LEAD FERRICYANIDE INTENSIFICATION (DO NOT USE)

This intensifier is also a strong intensifier to be used with very low-density images. The image silver is converted to a silver ferricyanide in the bleach bath and, in the presence of a lead salt, forms lead ferricyanide. This image is then washed and developed by sulfiding. The hazards associated with the use of lead salts in the bleach bath and the sulfides in the redevelopment bath are significant enough to avoid this intensifier.

COPPER INTENSIFICATION

The copper intensifier provides the opportunity to repeat the intensification procedure several times, similar to the chromium bath. The negative is treated in a copper bleach solution and the image is bleached, followed by an extended wash for 20 minutes. The redevelopment is completed in a 2% solution of silver nitrate followed by a wash or by immersion in an ammonia solution, followed by immersion in a nonstaining developer such as amidol. This procedure is described in Wall (1975, p. 174), and a copper and tin process is described in Haist (1979, vol. 2, p. 30). The involved nature of the procedure and the lack of contemporary information of the application of these baths to photographic images make them unlikely for use.

QUINONE THIOSULFURIC ACID INTENSIFICATION

This is Kodak's IN-6 formulation. It represents a very strong intensifier solution on coarse-grained films, but is described as having less effect on medium-speed materials and is not recommended for slow, fine-grained films. Images treated by this intensifier are not considered permanent.

DYE INTENSIFICATION: PYRO INTENSIFIER, PROPORTIONAL INTENSIFICATION

Pyro development provides a stain image in conjunction with the silver image. This same characteristic can be used for the bleaching and redevelopment of a silver image if a staining developer such as pyrogallol is used as the redeveloper. The process is permanent.

Wilsey Pyro Intensifier
Ref.: Haist 1979, vol. 2, p. 36

Bleach Solution

Potassium bromide	10.0 g
Potassium ferricyanide	30.0 g
Water to make	1,000.0 ml

After bleaching and washing, the negative is exposed to a bright light and redeveloped in an alkaline pyro solution.

Redeveloper Solution

Pyrogallol	5.0 g
Sodium carbonate	10.0 g
Water to make	1,000.0 ml

POTASSIUM BROMIDE

Also known as bromide salt of potassium.

Skin contact: not very toxic–prolonged exposure can
cause skin rash
Eye contact: not very toxic–temporary discomfort
Inhalation: moderately toxic
Ingestion: moderately toxic–harmful in large amounts

If heated to decomposition, can emit toxic fumes of bromine gas.
Requires local exhaust ventilation, dust mask, goggles, plastic apron, and plastic gloves during mixing. Requires local exhaust ventilation and plastic gloves during processing.

POTASSIUM FERRICYANIDE

Also known as red prussiate of potash.

> Skin contact: not very toxic–may cause irritation
> Eye contact: not very toxic–may cause irritation
> Inhalation: not very toxic
> Ingestion: moderately toxic

If heated to decomposition, mixed with acid solutions, or exposed to ultraviolet light, can emit toxic fumes of hydrogen cyanide and potassium oxide gas.

Requires local exhaust ventilation, dust mask, goggles, plastic apron, and plastic or rubber gloves during mixing. Requires local exhaust ventilation, goggles or safety glasses, plastic apron, and plastic or rubber gloves during processing.

PYROGALLOL (PYRO)
(Use With Extreme Caution)

Pyro was in use as early as 1850. It is also known as pyrogallol and incorrectly as pyrogallic acid. Commercial trade names include Piral and Pyro. Its chemical name is pyrogallol or 1,2,3-benzene-triol.

> Skin contact: toxic–can cause severe allergic reaction and
> severe irritation; easily absorbed through the skin
> Eye contact: toxic–can cause severe irritation
> Inhalation: toxic–causes severe acute poisoning
> Ingestion: toxic–can be fatal

If heated to decomposition, can emit acrid smoke and irritating fumes.

Requires fume hood, dust mask, goggles, plastic apron and sleeves, and rubber or plastic gloves during mixing. Requires local exhaust ventilation, goggles or safety glasses, plastic apron, and rubber or plastic gloves during processing.

SODIUM CARBONATE

Also known as soda ash.

> Skin contact: moderately toxic–may cause burns or irritation
> Eye contact: moderately toxic–may cause burns or irritation
> Inhalation: moderately toxic
> Ingestion: moderately toxic–can be fatal in large quantities

Concentrated forms are corrosive to skin and eyes; dilute solutions may irritate.

If heated to decomposition, can emit toxic fumes of sodium oxide gas.

Requires local exhaust ventilation, dust mask, goggles, and plastic apron and gloves during mixing. Requires local exhaust ventilation, goggles or safety glasses, and plastic gloves during processing.

MORDANT DYE INTENSIFICATION

The silver image can be prepared to receive dyes if a mordant is used. The addition of the dye may provide an intensification effect if the colors chosen have an effect on the printing materials. For example, a yellow-green dye will increase the image density of a negative silver image because the printing paper is blue sensitive. A copper sulfate and ammonium thiocyanate bath will bleach and mordant the silver image in preparation for the dye, which adheres to the silver image. It should be noted that dye images are not permanent.

The negative is immersed for two minutes in a copper bleach bath, followed by a water rinse, and placed into the redeveloper dye solution. Treatment time in the dye bath extends up to 15 minutes and the surface of the negative needs to be gently swabbed during the treatment. The negative is washed at the end of the treatment. The potential for damage to the negative is high.

REDUCTION

Reducers are used by photographers to reduce or remove image density, generally from a negative. Reduction techniques can be viewed as the opposite of intensifier techniques. The negative will have a dense, poor contrast range due to overexposure, overdevelopment, or both. Modern silver enlarging papers are designed to print a specific and rather narrow contrast range and so it might be necessary to chemically treat the negative with a reducer treatment to remove excess density. Generally speaking, this technique is not required very often, as most images tend to underexposure or underdevelopment rather than excessive densities.

The chemicals used in direct reduction treatments–ones in which the negative is reduced in a single bath rather than a two-step bleach and redevelopment sequence—are based on very aggressive, oxidizing chemicals which have serious associated health hazards. The chemical baths recommended in this section are limited to the least aggressive

and easiest to fabricate and use. Many of the formulations listed in the historic literature will not be required by photographers working with contemporary silver photographic materials.

There are three kinds of reducers: (1) ones that remove the same amount of image silver from all areas of the negative, (2) ones that remove silver from the image in proportion to the amount of silver present, and (3) ones that remove greater amounts of image silver from the highlight or high-density image areas. The first reducer, the subproportional or subtractive reducer, helps reduce overexposed negatives. The second reducer, the proportional reducer, helps reduce overdeveloped negatives. The third reducer, which removes the image density superproportionally primarily from the high density areas, helps reduce contrast from overdevelopment.

The negative to be reduced must be properly processed. The negative should be hardened before treatment to prevent damage to the softened gelatin emulsion, and the Kodak SH-1 formulation is often recommended. The formaldehyde in this formulation provides good hardening, but proper local exhaust ventilation is required when mixing and using this bath. A formaldehyde cartridge used on a personal respirator can also be used.

During treatment in the reduction bath, the negative may need to be removed and placed into a rinse bath at regular intervals to ensure that the reduction rate does not exceed the desired effect. The progress of the reduction cannot, in general, be monitored while the negative is in the bath. Proper washing of the treated negative after reduction is important, because some of the treatments can stain if residual chemicals are left in the emulsion.

Subproportional (Subtracting) Reducers, for Overexposure

FARMER'S REDUCER

This is the most common reducing bath. The solution is a mixture of potassium ferricyanide and sodium thiosulfate, and it has been studied and described continually since its introduction in 1884. The action of the image silver is described in Haist (1979, vol. 2, p. 54) as the conversion of the image silver by the ferricyanide to silver ferricyanide. This compound is not water soluble but can be dissolved by sodium thiosulfate or any of the other thiosulfates.

The solution is prepared from stock solutions and needs to be used immediately after mixing. The reducing action of the bath diminishes with time; once it loses its yellow color it has been exhausted. The solution should be mixed fresh for each treatment to ensure some continuity in the amount of reduction that takes place from one negative to another.

Kodak Farmer's Reducer R-4a
Ref.: DeCock 1990, sec. 15, p. 73

Stock Solution A
Potassium ferricyanide 37.5 g
Water to make 500.0 ml

Stock Solution B
Sodium thiosulfate 480.0 g
Water to make 2,000.0 ml

The working bath is mixed just prior to use. Add 30 ml of Stock Solution A to 120 ml of Stock Solution B and add water to this mixture to make 1,000 ml. For a less active bath, add 15 ml of Stock Solution A to 120 ml of Stock Solution B and add water to make 1,000 ml.

The negative to be treated should be allowed to soak before being reduced. The wet negative is then immersed in the treatment bath and removed at regular intervals and placed into water to allow an assessment of the degree of reduction. The treatment should be stopped before the desired reduction has been reached. The reduced negative is then thoroughly washed and dried.

POTASSIUM FERRICYANIDE

Also known as red prussiate of potash.

Skin contact: not very toxic–may cause irritation
Eye contact: not very toxic–may cause irritation
Inhalation: not very toxic
Ingestion: moderately toxic

If heated to decomposition, mixed with acid solutions, or exposed to ultraviolet light, can emit toxic fumes of hydrogen cyanide and potassium oxide gas.

Requires local exhaust ventilation, dust mask, goggles, plastic apron, and plastic or rubber gloves during mixing. Requires local exhaust ventilation, goggles or safety glasses, plastic apron, and plastic or rubber gloves during processing.

SODIUM THIOSULFATE, PENTAHYDRATE

Also known as sodium hyposulfite or hypo.

Skin contact: not very toxic
Eye contact: not very toxic–may cause temporary discomfort
Inhalation: not very toxic; toxic if contaminated with acid
Ingestion: moderately toxic–may cause cyanosis

If heated to decomposition or contaminated with acid, can emit toxic fumes of sulfur dioxide gas.

Requires local exhaust ventilation, safety glasses, and plastic gloves during mixing and processing.

Variations of this formula that use the addition of thiourea or potassium cyanide should not be used due to the toxicity of these chemicals. The substitution of a thiocyanate for the thiosulfate is acceptable. The formula listed below functions in the same manner as Farmer's reducer but is not mixed as separate stock solutions.

Haddon's Reducer
Ref.: Haist 1979, vol. 2 p. 59

Potassium ferricyanide	5.0 g
Ammonium thiocyanate	10.0 g
Water to make	1,000.0 ml

The negative to be reduced should be soaked in water prior to reduction. The formation of a white surface deposit may occur, and the negative should be fixed after reduction and given a proper wash.

POTASSIUM FERRICYANIDE

Also known as red prussiate of potash.

Skin contact: not very toxic–may cause irritation
Eye contact: not very toxic–may cause irritation
Inhalation: not very toxic
Ingestion: moderately toxic

If heated to decomposition, mixed with acid solutions, or exposed to ultraviolet light, can emit toxic fumes of hydrogen cyanide and potassium oxide gas.

Requires local exhaust ventilation, dust mask, goggles, plastic apron, and plastic or rubber gloves during mixing. Requires local exhaust ventilation, goggles or safety glasses, plastic apron, and plastic or rubber gloves during processing.

AMMONIUM THIOCYANATE

Also known as ammonium sulfocyanate.

Skin contact: moderately toxic–may cause irritation;
prolonged contact can result in blisters
Eye contact: moderately toxic–may cause irritation
Inhalation: not very toxic–may cause irritation
Ingestion: toxic

If heated to decomposition or contaminated with acid solutions, can emit toxic fumes of hydrogen cyanide, hydrogen sulfide, ammonia, or nitrogen dioxide gas.

Requires local exhaust ventilation, dust mask, goggles, plastic apron, and rubber or plastic gloves during mixing. Requires local exhaust ventilation, goggles, plastic apron, and plastic or rubber gloves during processing.

PERMANGANATE REDUCERS (DO NOT USE)

Reducer formulations incorporating permanganate salts should not be used. The high toxicity of these compounds and solutions by all routes of exposure and the fact that the treatment bath often produces a brown stain deposit of manganese dioxide over time removes this treatment from general consideration as a safe reducer. This process also uses concentrated acids, which require careful handling during mixing and use.

Proportional Reducers, for Overdevelopment

A negative that has been overdeveloped will have excessive contrast and very high-density values in the highlights. The removal of the image silver in proportion to the amount that is present reduces the image density and allows it to be printed.

There are two reducers listed in Haist (1979): One is a modification of the Farmer's reducer given earlier, and the second is a permanganate/persulfate treatment. The latter is formulated from toxic chemicals that are best avoided, and there is some question associated with its controllability when applied to a negative.

The ideal proportional reducer appears to be an acidified fixer bath, and this is the formulation that should be considered if a proportional re-

ducer is needed. By lowering the pH of the fixer bath and increasing agitation, the rate of reduction can be increased. This formulation also works faster on fine-grained images than on coarse-grained ones. Ammonium thiosulfates work faster than the other thiosulfates, so an acidified rapid fixer is used.

The addition of 15 to 30 grams of citric acid per liter of working dilution solution of rapid fixer results in a uniform reduction of the image contrast without shadow detail loss. Following treatment, the negative or print should be properly washed and dried.

AMMONIUM THIOSULFATE

Also known as rapid fixer.

Skin contact: not very toxic–may cause irritation
Eye contact: not very toxic–may cause irritation
Inhalation: not very toxic–highly toxic if contaminated;
 may cause irritation
Ingestion: moderately toxic

If heated to decomposition or contaminated with acid, can emit toxic fumes of ammonia, hydrogen sulfide, or sulfur dioxide gas.

Requires local exhaust ventilation, goggles, and rubber or plastic apron and gloves during mixing. Requires local exhaust ventilation, safety glasses, and plastic apron and gloves during use. Cotton clothing is also recommended.

CITRIC ACID (concentrated)

Also known as beta hydroxytricarboxylic acid.

Skin contact: moderately toxic–may cause irritation
Eye contact: moderately toxic–may cause irritation
Inhalation: moderately toxic
Ingestion: moderately toxic

If heated to decomposition, can emit toxic fumes of carbon dioxide and carbon monoxide gases.

Requires local exhaust ventilation, dust mask, goggles, plastic apron, and rubber or plastic gloves during mixing. Requires local exhaust ventilation, safety glasses or goggles, plastic apron, and rubber or plastic gloves during processing.

Superproportional Reducers, for Overexposure and Overdevelopment

The negatives produced by a combination of both overexposure and overdevelopment are likely to be few and far between for most practicing photographers. Kodak's R-8 modification of Belitski's Reducer and a subsequent substitution listed as R-8a are useful formulations for this type of reducer application, as is Kodak R-15.

The R-8 reducer is used full strength for a maximum reduction rate, or it can be diluted 1:1 with water for a slower reduction rate. A thorough wash is required after the reduction bath.

Kodak R-8a Modified Belitski Reducer
Ref.: Haist 1979, vol. 2, p. 71

Water, 125°F	750.0 ml
Ferric ammonium sulfate	45.0 g
Potassium citrate	75.0 g
Sodium sulfite, desiccated	30.0 g
Citric acid	22.5 g
Sodium thiosulfate, crystals	200.0 g
Water to make	1,000.0 ml

FERRIC AMMONIUM SULFATE

Also known as iron ammonium sulfate.

Skin contact: not very toxic–may cause irritation
Eye contact: moderately toxic–may cause irritation
Inhalation: moderately toxic
Ingestion: moderately toxic

If heated to decomposition, can emit toxic fumes of sulfur dioxide, nitrogen dioxide, and ferric oxide gas.

Requires local exhaust ventilation, dust mask, safety glasses, plastic apron, and plastic or rubber gloves during mixing. Requires local exhaust ventilation, safety glasses, plastic apron, and plastic or rubber gloves during processing.

POTASSIUM CITRATE

Also known as tri-potassium citrate.

Skin contact: not very toxic
Eye contact: not very toxic–may cause temporary discomfort

Inhalation: not very toxic–may cause irritation
Ingestion: not very toxic

If heated to decomposition, can emit toxic fumes of carbon dioxide and carbon monoxide gases.

Requires local exhaust ventilation, dust mask, safety glasses, and plastic gloves during mixing. Requires local exhaust ventilation, safety glasses, and plastic gloves during processing.

SODIUM SULFITE

Also known as sulfurous acid, sodium salt.

Skin contact: not very toxic–may cause irritation
Eye contact: not very toxic–may cause irritation
Inhalation: moderately toxic–may cause irritation
Ingestion: toxic–could cause death if consumed in
significant amounts

If heated to decomposition or mixed with acid, can emit toxic sulfur dioxide and sodium oxide fumes.

Requires local exhaust ventilation, dust mask, goggles, plastic apron, and plastic or rubber gloves during mixing. Requires local exhaust ventilation and plastic gloves during processing.

CITRIC ACID (concentrated)

Also known as beta hydroxytricarboxylic acid.

Skin contact: moderately toxic–may cause irritation
Eye contact: moderately toxic–may cause irritation
Inhalation: moderately toxic
Ingestion: moderately toxic

If heated to decomposition, can emit toxic fumes of carbon dioxide and carbon monoxide gases.

Requires local exhaust ventilation, dust mask, goggles, plastic apron, and rubber or plastic gloves during mixing. Requires local exhaust ventilation, safety glasses or goggles, plastic apron, and rubber or plastic gloves during processing.

SODIUM THIOSULFATE, PENTAHYDRATE

Also known as sodium hyposulfite or hypo.

Skin contact: not very toxic
Eye contact: not very toxic–may cause temporary discomfort

Inhalation: not very toxic; toxic if contaminated with acid
Ingestion: moderately toxic–may cause cyanosis

If heated to decomposition or contaminated with acid, can emit toxic fumes of sulfur dioxide gas.

Requires local exhaust ventilation, safety glasses, and plastic gloves during mixing and processing.

The R-15 persulfate superproportional reducer softens the gelatin emulsion, and a hardening bath is recommended before treatment. The Kodak SH-1 hardener is recommended, but local exhaust ventilation or a personal respirator with a formaldehyde cartridge is required. The hardener should be used for 3 minutes, followed by a thorough wash. The negative should be placed into the reducer bath and treated until the desired effect has almost been achieved. At completion of the reduction cycle, the negative is fixed in an acid fixer for several minutes followed by a thorough wash before drying.

Kodak Formalin Hardener SH-1
Ref.: DeCock 1990, sec. 15, p. 55

Water	500.0 ml
Formaldehyde (37% solution)	10.0 ml
Sodium carbonate, monohydrated	5.0g
Water to make	1,000.0 ml

Mixing this hardener requires local exhaust ventilation or a mask with a formaldehyde cartridge.

FORMALDEHYDE
(Use With Extreme Caution)

Also known as formalin.

Skin contact: toxic–burns; may cause irritation
Eye contact: toxic–burns; may cause irritation
Inhalation: toxic–may cause irritation to mucous membranes
Ingestion: toxic

Formaldehyde is a suspected carcinogen.

If heated to decomposition, can emit acrid smoke and fumes.

Requires local exhaust ventilation, fume hood or respirator (formaldehyde cartridge), goggles, rubber apron, and nitrile gloves during mixing. Requires local exhaust ventilation, respirator (formaldehyde

cartridge), goggles or safety glasses, rubber or plastic apron, and nitrile gloves during processing.

SODIUM CARBONATE

Also known as soda ash.

Skin contact: moderately toxic–may cause burns or irritation
Eye contact: moderately toxic–may cause burns or irritation
Inhalation: moderately toxic
Ingestion: moderately toxic–can be fatal in large quantities

Concentrated forms are corrosive to skin and eyes; dilute solutions may irritate.

If heated to decomposition, can emit toxic fumes of sodium oxide gas.

Requires local exhaust ventilation, dust mask, goggles, and plastic apron and gloves during mixing. Requires local exhaust ventilation, goggles or safety glasses, and plastic gloves during processing.

Kodak R-15 Reducer
Ref.: DeCock 1990, sec. 15, p. 75

Stock Solution A
Water	1,000.0 ml
Potassium persulfate	30.0 g

Stock Solution B
Water	250.0 ml
Sulfuric acid (10% solution)	15.0 ml
Water to make	500.0 ml

For use, take 2 parts of Stock Solution A and add to 1 part of Stock Solution B. The working solution should be mixed just prior to use and discarded after use.

POTASSIUM PERSULFATE

Also known as potassium peroxydisulfate or dipotassium persulfate.

Skin contact: moderately toxic–may cause irritation
Eye contact: moderately toxic–may cause irritation
Inhalation: moderately toxic
Ingestion: moderately toxic

If heated to decomposition, can emit toxic fumes of sulfur dioxide gas. It can react explosively when contacting combustible materials.

Requires local exhaust ventilation, dust mask, goggles, and plastic apron and gloves during mixing. Requires local exhaust ventilation, goggles or safety glasses, and plastic apron and gloves during processing.

SULFURIC ACID (concentrated)
(Use With Extreme Caution)

Also known as oil of vitriol.

> Skin contact: toxic–may cause burns, dermatitis,
> and irritation; corrosive
> Eye contact: toxic–may cause burns and irritation; corrosive
> Inhalation: toxic–may cause irritation of mucous membranes
> and upper respiratory system
> Ingestion: toxic–fatal even in small amounts

If heated to decomposition, can emit toxic fumes of sulfur dioxide gas.

Requires local exhaust ventilation, positive pressure fume hood or respirator (acidic gas cartridge), goggles and shield, rubber apron, and nitrile gloves during mixing. Requires local exhaust ventilation, goggles or safety glasses, rubber apron, and rubber or nitrile gloves during processing (diluted solutions).

Reduction by Bleach and Redevelopment, for Underexposure and Overdevelopment

It is also possible to reduce an overdeveloped negative by bleaching it and redeveloping to a lower contrast. The bleach can be taken from the Kodak IN-4a intensifier bath. Once the silver image has been whitened, it is redeveloped in a buffered metol-sulfite developer, rinsed, and fixed in an acid fixing bath, followed by thorough washing.

Kodak IN-4a Intensifier Bleach
Ref.: Haist 1979, vol. 2, p. 81

Potassium dichromate	8.0 g
Hydrochloric acid, concentrated	6.0 ml
Potassium bromide	5.0 g
Water to make	1,000.0 ml

After the negative is bleached, the redeveloper provides the reduced contrast. An interesting observation about this redeveloper treatment

sequence is that the lower- density shadow areas appear to be somewhat intensified, and the high-density highlight areas are reduced. This quality has been referred to as "harmonizing."

Metol Redeveloper

Metol	2.0 g
Sodium sulfite, desiccated	10.0 g
Sodium carbonate, anhydrous	10.0 g
Water to make	1,000.0 ml

POTASSIUM DICHROMATE
(Do Not Use)

Also known as potassium bichromate.

Skin contact: toxic–may cause allergies, ulcers, or burns
Eye contact: toxic–may cause allergies or burns
Inhalation: toxic
Ingestion: toxic

Dichromates and most chromate salts are carcinogens or suspected carcinogens.

If heated to decomposition or contaminated with acid solutions, can emit toxic fumes of chromium oxide gas or form dangerous chromic acid.

Requires a self-contained respirator or a dust mask and a positive pressure fume hood as well as local exhaust ventilation, goggles, and rubber apron and gloves during mixing. Requires local exhaust ventilation, goggles, and rubber apron and gloves during processing. Solution spills must be washed clean before they dry to prevent the formation of dichromate dusts.

HYDROCHLORIC ACID (concentrated)
(Use With Extreme Caution)

Also known as muriatic acid.

Skin contact: toxic–burns, causes tissue damage
Eye contact: toxic–burns, causes tissue damage
Inhalation: toxic–burns, causes tissue damage
Ingestion: toxic–burns, causes tissue damage

If heated to decomposition, can emit toxic fumes of hydrogen chloride gas.

Requires local exhaust ventilation and fume hood or respirator (acidic gas cartridge), goggles, rubber apron, and rubber or plastic gloves

during mixing. Requires local exhaust ventilation, goggles or safety glasses, rubber or plastic apron, and rubber or plastic gloves during processing. Always add the acid to the water.

POTASSIUM BROMIDE

Also known as bromide salt of potassium.

>Skin contact: not very toxic–prolonged exposure can cause skin rash
>Eye contact: not very toxic–temporary discomfort
>Inhalation: moderately toxic
>Ingestion: moderately toxic–harmful in large amounts

If heated to decomposition, can emit toxic fumes of bromine gas.

Requires local exhaust ventilation, dust mask, goggles, plastic apron, and plastic gloves during mixing. Requires local exhaust ventilation and plastic gloves during processing.

SODIUM SULFITE

Also known as sulfurous acid, sodium salt.

>Skin contact: not very toxic–may cause irritation
>Eye contact: not very toxic–may cause irritation
>Inhalation: moderately toxic–may cause irritation
>Ingestion: toxic–could cause death if consumed in significant amounts

If heated to decomposition or mixed with acid, can emit toxic sulfur dioxide and sodium oxide fumes.

Requires local exhaust ventilation, dust mask, goggles, plastic apron, and plastic or rubber gloves during mixing. Requires local exhaust ventilation and plastic gloves during processing.

SODIUM CARBONATE

Also known as soda ash.

>Skin contact: moderately toxic–may cause burns or irritation
>Eye contact: moderately toxic–may cause burns or irritation
>Inhalation: moderately toxic
>Ingestion: moderately toxic–can be fatal in large quantities

Concentrated forms are corrosive to skin and eyes; dilute solutions may irritate.

If heated to decomposition, can emit toxic fumes of sodium oxide gas.

Requires local exhaust ventilation, dust mask, goggles, and plastic apron and gloves during mixing. Requires local exhaust ventilation, goggles or safety glasses, and plastic gloves during processing.

METOL
(Use With Caution)

Metol has been in use since 1891 and is also known by the trade names Atolo, Elon, Genol, Graphol, Monol, Pictol, Photol, Rhodol, Satrapol, Scalol, or Viterol. Its chemical name is metol or monomethyl-para-aminophenol sulfate.

Skin contact: moderately toxic–may cause allergic reaction or
 irritation; repeated contact may result in dermatitis
Eye contact: moderately toxic–may cause irritation
Inhalation: moderately toxic–may cause respiratory tract irritation
Ingestion: toxic

If heated to decomposition, can emit toxic fumes of sulfur dioxide and nitrogen oxide.

Requires local exhaust ventilation, dust mask, goggles, plastic apron, and rubber gloves during mixing. Requires local exhaust ventilation, goggles or safety glasses, and rubber or plastic gloves during processing.

IMAGE MODIFICATION SUMMARY

The processes described in this section on image modification include some of the most hazardous materials found in photography. The need for reducers and intensifiers can be eliminated by following good photographic practice but they may be called upon from time to time for particular images that lack the appropriate density. The heavy-metal salts commonly used for these baths, as well as the very active oxidizing and reducing agents that make up some of the formulations, place the photographer at greater risk than that involved in normal photographic processes.

When these processes are being contemplated for use, the photographer should spend preparation time to determine the added demands these processes will put on the equipment and resources available. Additional equipment may be needed to create a safe working environment. Additional respirator cartridges or upgrades to the lab might be required.

Those processes based on metal compounds such as mercury and uranium MUST NOT BE USED. The historic literature contains an abundance of formulas that appear to be the perfect solution to a given problem, but these chemicals were not characterized for their damaging effects on the human body. These hazardous chemicals require special handling environments that are often not worth the additional expense to set up.

COLOR PHOTOGRAPHIC PROCESSESES

INTRODUCTION

The chemistries used in color processes are generally more toxic and have greater hazards than those found in black-and-white processes. In black-and-white processing it is possible to choose a developer processing system that makes use of less hazardous and safer developer agents and other processing chemicals. This is not the case with color processing. In fact, most developer agents used in color photographic processes are based on the derivatives of p-phenylenediamine, one of the more toxic developer agents and one that was recommended to be avoided in black-and-white processing.

Another factor is the constant evolution that commercial color products are subjected to by the manufacturers and the fact that the actual formulations are never clearly defined. The information on the toxicity of these chemical products is therefore incomplete, since the chemical formulations are often protected by the manufacturer. In addition, there is scarcity of data based on actual use, due to the relative newness of some of these chemicals.

The exposure of photographers and their staffs to color chemistries requires greater care and control of the environment than most black-and-white processes. The automation of many color processing services, notably one-hour labs, helps reduce many of the exposure problems associated with color chemistry. The most significant problem area would be a photographer working in a small lab operation using tray or rotary drum processing for color photographic images.

For the purposes of exploring the hazards associated with the various color processes, the discussion has been broken up into the most commonly used color processes based on the chromogenic system, and which is found in most of the color processing kits. A brief discussion is also included on some of the less popular color processes that may be of interest to photographers as they begin to examine new or alternative color technologies.

CHROMOGENIC DEVELOPMENT

Most contemporary color products use the chromogenic dye process. Chromogenic dye color development processes are based on the reaction of oxidized developer agents with a coupler, a long-chained hydrocarbon used to anchor the dye molecules to their respective locations in the gelatin binder layer to form the dye. One of the earliest applications of this process came in 1936 when Agfa introduced a color reversal film that improved the processing sequence required for the Kodachrome process, which was initially introduced in 1935. This encouraged Kodak to develop an incorporated coupler, which eventually led to the introduction of Kodacolor film in December 1941. This process formed the basis for other improvements, including color print processes such as Type C Ektacolor paper to the present Ektacolor papers. The same product developments took place with color reversal films, beginning with a Kodacolor reversal film in 1943 and evolving through Ektachrome films from 1946 to the present E-6 process. (See Haist 1979, vol. 2, pp. 447–48.)

Most of the present color chromogenic development processes use subtractive dyes formed by the reaction of a developer agent's oxidation product, formed during the development of the black-and-white image, and a coupler contained within the film layers or the processing solutions. The process, after the development of the latent image and the formation of an associated dye image, is completed with the bleaching and removal of the silver image in a bleaching and fixing bath, followed by washing and stabilization of the image.

In the color negative application, the oxidized developing agent from the black-and-white development step is used to form the subtractive dyes making up the image. For the transparency or reversal processes, the negative silver image is reexposed. Early process sequences used a physical exposure to bright light, but contemporary processes use a chemical fogging process to replace this light re-exposure step. The color developer is then applied to develop the color dye image from the

reaction with the couplers and to produce the subtractive dyes. The negative silver image is then bleached and fixed out, leaving the positive color dye image behind.

The hazards associated with the process involve the very alkaline developer solutions and the toxic developer agents, often derivatives of p-phenylenediamine, and the use of dichromate salts in the bleach baths. Mixing of the processing solutions involves the use of powders and concentrated liquids containing acids, bases, and organic solvents as well as metal salts. The use of goggles, dust masks, and gloves is required, as well as adequate local exhaust ventilation.

SILVER DYE BLEACH

Cibachrome, now called Ilfochrome Classic, represents the silver dye bleach type of color process. The dyes used in the silver dye bleach processes tend to be of better quality than those used in the chromogenic development process. Notable among these improvements is increased dye stability in the processed photograph, thereby providing improved image stability and permanence. The image has also been described as having improved luminosity and brilliance (Haist 1979, vol. 2, p. 451.)

The film has a tripack structure. Within each of the three layers is an azo dye—a complementary color to the color sensitization of that layer. The image is developed with a black-and-white developer agent, and the silver image is subsequently bleached in a dye-bleach bath. The silver image destroys the associated dye in proportion to the amount of silver present and is then dissolved out of the image layer, followed by washing and drying.

The introduction of Gasparcolor in Germany in 1933 was the first commercially based dye-bleach process, and it eventually died out in 1952. Ciba introduced its Cibachrome product in 1958 to provide color prints from color transparencies and in 1963 color print material for prints from color negatives.

The hazards and safety precautions associated with the process are the same as those for the chromogenic system.

SILVER DIFFUSION TRANSFER

Diffusion transfer processes are represented by the Polaroid products. Polaroid provides a number of color diffusion transfer processes as well as black-and-white products. The diffusion transfer process has three

component parts: the silver halide emulsion, the transfer or receptor layer, and the processing gel. The exposed image is contacted with the receptor layer and the processing gel. The processed silver negative image forms on the light-sensitive side, and a silver halide solvent in the gel allows the unexposed silver to diffuse from the light-sensitive layer across to the receptor layer, where the silver ions are reduced to a metallic silver image, forming the positive image.

Color diffusion transfer materials are more complex than the black-and-white products. The basis of the process is for a dye developing agent to react with the exposed silver halide to form the oxidized dye developing agent. The oxidized dye is immobilized to form an image with the silver image. The available dye developer is immobilized in proportion to the amount of exposure and development of the silver halide, and the unreacted dye developer is free to diffuse from the silver halide layer to the receiver layer, where the dye developer is mordanted. This forms the positive dye image.

The hazards associated with the Polaroid color diffusion transfer products include exposure to the developing solutions contained in the gel, which are quite alkaline, and possible exposure to the color dyes. If the receptor sheet is immediately removed after activation of the developer gel and contacted to a paper sheet as the receptor—now being practiced as a photographic art process—contact with the dyes and developer gel is possible.

DYE TRANSFER

The dye transfer process is a Kodak product that is based on the older three-color processes, such as the carbro process. Carbro made use of three separation negatives to produce three bromide prints. These prints were then contacted to three sensitized and pigmented but unhardened gelatin tissues, the gelatin being hardened in proportion to the amount of silver present in the print image. Processing involved removal of the soluble gelatin with hot water to form a color relief image that was then transferred in register to the final support. This imbibition method is also the basis of the Kodak dye transfer process.

Dye transfer involves printing three separation negatives onto unhardened film. Development is done in a tanning developer such as pyrogallol. A wash in hot water removes the unhardened gelatin to form a clear gelatin relief positive image. Dyes are imbibed into the separate gelatin relief images using cyan, yellow, and magenta dyes, and the dyed

relief is then transferred in register onto a final support of paper that has a mordant to set the dyes.

The hazards associated with this process involve the developer, which includes both the tanning developer agent and strongly alkaline additives that can act as irritants to skin and eyes. Care needs to be taken when mixing the processing solutions and powders. The dye solutions pose potential problems, largely because of the limited health hazard data on the effects of exposure and because they are often used in open trays, creating an increased risk of exposure.

COLOR DEVELOPING AGENTS

The formulas that appear as part of the following text include several of the more commonly used color developing agents. They are based on p-phenylenediamine derivatives and, as mentioned earlier, are particularly toxic. These developing agents are unstable in air and so are found as salts of either organic or inorganic acids. The common organic acid salt is p-toluenesulfonic acid. The developer is formed when these salts are mixed in alkaline processing solutions.

The full chemical names are quite long and involved, and a short-hand notation is often used when describing the formulas containing the agents. Presently, color developers CD-3 and CD-4 are the most commonly used. Earlier formulations such as CD-1 and CD-2 tend to be slower or have other undesirable characteristics that the CD-3 and CD-4 forms have improved on.

CD-3 is also known by the trade names Kodak Color Developing Agent CD-3, Johnson's Activol No. 3, and May and Baker Mydochrome. Its chemical name is N-ethyl-N-(beta-methylsulfonamidoethyl)-3-methyl-p-phenylenediamine sesquisulfate monohydrate or 4-amino-N-ethyl-N-(beta-methanesulfonamidoethyl)-m-toluidine sesquisulfate mono-hydrate.

CD-4 is also known by the trade name Kodak Color Developing Agent CD-4. Its chemical name is N-ethyl-N-(beta-hydroxyethyl)-3-methyl-p-phenylenediamine sulfate or 4-amino-3-methyl-N-ethyl-N-(beta-hydroxyethyl)-aniline sulfate.

COUPLING AGENTS

The coupling agents are generally incorporated into the film gelatin layers and are not of immediate concern, but the most typical cyan, ma-

genta, and yellow commercial couplers are listed here for general information:

- Kodak coupling agent C-16, Cyan Coupler, is N-(o-acetamidophenethyl)-1-hydroxy-2-naphthamide.
- Kodak coupling agent M-38, Magenta Coupler, is 1-(2,4,6-trichlorophenyl)-3-p-nitroanilino-5-pyrazolone.
- Kodak coupling agent Y-54, Yellow Coupler, is gamma-benzoyl-o-methoxyacetanilide.

CHROMOGENIC COLOR PROCESSES

The balance of this chapter examines the processing chemistry of the chromogenic processes in detail, using chemistry formulations that have recently appeared in the photographic literature. If additional information has been found concerning the chemical components of other suppliers of color chemistries, this information has been added. The purpose of listing these formulas is not to encourage individuals to mix solutions from scratch but rather to provide information on the types of chemical hazards typically found in color processing chemistries. The examples given may be somewhat dated, largely because the manufacturers of these products have continued to change and improve the working qualities of the product and processing chemistries. The examples can be taken to be similar to the commercially available products but not exactly the same.

COLOR NEGATIVE PROCESSES

These include the Kodak C-41, Unicolor K-2, and Beseler CN2 type chemistries.

The Kodak C-41 Flexicolor process has replaced the older C-22 color negative process. The notable difference is the increased processing temperature of the developer. C-22 was run entirely at 75°F; the newer C-41 runs the developer at 100°F and the other solutions at 75°F.

The developer is followed by the bleach bath, wash, fix, second wash, stabilizer bath, and drying. The total processing time runs a little more than 24 minutes with fresh chemistry.

Unicolor provides two kits based on the C-41 chemistry: the K-2 color negative kit and the Unicolor total color kit, which can process

both negatives and color prints. Both processes use the same processing schedule and make use of a combined bleach and fix bath, thereby eliminating a wash-and-processing step from the standard C-41 sequence. The total processing time with fresh chemistry is just under 13 minutes. The advantages of the kits include the reduced hazards associated with mixing the working solutions from liquid concentrates rather than powders, since the exposure to chemical dusts has been eliminated.

The *Photo Lab Index* (DeCock 1990, sec. 8, p. 143) provides information on some of the chemicals contained in the various concentrates in the Unicolor Kits. The following are included:

- Developer part A, sodium carbonate; developer B, hydroxylamine sulfate; developer C, 4-amino-3-methyl-N-(beta-hydroxyethyl)-aniline sulfate, also known as CD-4.
- Blix part A, ammonium thiosulfate; blix part B, acetic acid; blix part C, ethylenediamine tetraacetic acid.
- Developer additive (when used for prints), benzyl alcohol.
- Stabilizer, formaldehyde.

Compare these components with the detailed formulas provided for C-41 process chemistries in the next section.

Beseler also provides a kit for processing color negative film. The CN2 chemistry also uses a combined bleaching and fixing bath, but it can be run at lower temperatures, 75°F or 85°F, as well as the normal 100°F. Considerably longer processing times are required at the reduced temperatures, but they provide increased control. This can be an important consideration in facilities that do not have adequate temperature control. It should also be noted that elevated temperatures for some types of chemistry can result in higher risk of exposure to hazardous gases if baths are contaminated or overheated.

As was the case with the Unicolor kits, some of the chemical hazards are identified in the *Photo Lab Index* (DeCock 1990, sec. 8, p. 210). They include in step 1, part A, sodium bromide; in part B, sodium sulfite and paraphenylene diamine; and in part C, potassium carbonate; in step 2, mercapto-triazole; and in step 3, formaldehyde.

Formulas and Hazards

The information on the formulation of C-41 type chemistries was taken from Haist (1979, vol. 2, p. 597) and "Home Processing" (1991, p. 171).

The C-42 process has the same processing steps, times, and sequences as C-41. The formulations of the respective baths are given below.

COLOR DEVELOPER

	C-42	C-41
Water, 70°–80.6°F	800.0 ml	800.0 ml
Potassium carbonate, anhydrous	37.5 g	37.5 g
Sodium sulfite, anhydrous	4.25 g	4.25 g
Potassium iodide	0.002 g	—
Sodium bromide	1.3 g	1.5 g (potassium bromide)
Hydroxylamine sulfate	2.0 g	2.0 g
Kodak anti-calcium, no. 3	2.5 g	2.0 g (calgon, sodium hexametaphosphate)
Color developing agent Kodak CD-4	4.75 g	4.75 g
Water to make	1,000.0 ml	1,000.0 ml

POTASSIUM CARBONATE

Also known as potash.

Skin contact: moderately toxic–may cause burns or irritation
Eye contact: moderately toxic–may cause burns or irritation
Inhalation: moderately toxic–may cause irritation
Ingestion: toxic–can be fatal in large quantities

Concentrated forms are corrosive to skin and eyes; dilute solutions may irritate.

If heated to decomposition, can emit toxic fumes of potassium oxide and carbon dioxide gases.

Requires local exhaust ventilation, dust mask, goggles, and plastic apron and gloves during mixing. Requires local exhaust ventilation, goggles or safety glasses, and plastic gloves during processing.

SODIUM SULFITE

Also known as sulfurous acid, sodium salt.

Skin contact: not very toxic–may cause irritation
Eye contact: not very toxic–may cause irritation
Inhalation: moderately toxic–may cause irritation
Ingestion: toxic–could cause death if consumed in significant amounts

If heated to decomposition or mixed with acid, can emit toxic sulfur dioxide and sodium oxide fumes.

Requires local exhaust ventilation, dust mask, goggles, plastic apron, and plastic or rubber gloves during mixing. Requires local exhaust ventilation and plastic gloves during processing.

POTASSIUM IODIDE

Skin contact: not very toxic
Eye contact: moderately toxic–may cause temporary discomfort
Inhalation: moderately toxic
Ingestion: moderately toxic

If heated to decomposition, can emit toxic fumes of iodine gas.

Requires local exhaust ventilation, dust mask, goggles, plastic apron, and plastic gloves during mixing. Requires local exhaust ventilation, safety glasses, plastic apron, and rubber or plastic gloves during processing.

SODIUM BROMIDE

Skin contact: not very toxic
Eye contact: moderately toxic–may cause temporary discomfort
Inhalation: moderately toxic–may cause temporary discomfort
Ingestion: moderately toxic–high concentrations may
cause irritation

If heated to decomposition, can emit toxic fumes of bromine gas.

Requires local exhaust ventilation, dust mask, goggles, plastic apron, and plastic gloves during mixing. Requires local exhaust ventilation, safety glasses, plastic apron, and plastic gloves during processing.

POTASSIUM BROMIDE

Also known as bromide salt of potassium.

Skin contact: not very toxic–prolonged exposure can cause skin rash
Eye contact: not very toxic–temporary discomfort
Inhalation: moderately toxic
Ingestion: moderately toxic–harmful in large amounts

If heated to decomposition, can emit toxic fumes of bromine gas.

Requires local exhaust ventilation, dust mask, goggles, plastic apron, and plastic gloves during mixing. Requires local exhaust ventilation and plastic gloves during processing.

HYDROXYLAMINE SULFATE

Also known as hydroxylammonium sulfate.

> Skin contact: moderately toxic–may cause allergies, irritation,
> and dermatitis
> Eye contact: moderately toxic–may cause irritation
> Inhalation: moderately toxic
> Ingestion: moderately toxic

This compound is a suspected teratogen.

If heated to decomposition, can emit toxic fumes of ammonia, nitrogen dioxide, and sulfur dioxide gases.

Requires local exhaust ventilation, dust mask, goggles, plastic apron, and rubber or plastic gloves during mixing. Requires local exhaust ventilation, safety glasses, plastic apron, and rubber or plastic gloves during processing.

KODAK ANTI-CALCIUM, NO. 3

MSDS not located.

SODIUM HEXAMETAPHOSPHATE

Also known as Calgon.

> Skin contact: moderately toxic–may cause irritation
> Eye contact: moderately toxic–may cause irritation
> Inhalation: not very toxic–may cause irritation
> Ingestion: moderately toxic

If heated to decomposition, can emit toxic fumes of phosphorous oxide gas.

Requires local exhaust ventilation, dust mask, goggles, plastic apron, and rubber or plastic gloves during mixing. Requires local exhaust ventilation, safety glasses, plastic apron, and plastic or rubber gloves during processing.

COLOR DEVELOPER 4
(Use With Extreme Caution)

Also known as CD-4, 4-(N-ethyl-N-2-hydroxyethyl)-2-methylphenylenediaminesulfate, N-ethyl-N-(beta-hydroxyethyl)-3-methyl-p-phenylenediamine sulfate or 4-amino-3-methyl-N-ethyl-N-(beta-hydroxyethyl)-aniline sulfate.

Skin contact: toxic–may cause irritation, blisters
Eye contact: toxic–may cause irritation, burns
Inhalation: toxic–may cause irritation of mucous membranes
Ingestion: toxic

The information on this compound has not been completely established or is not available. It should be treated as dangerous. Problems with skin sensitivity have been noted with this group of developer agents due in large part to its ease of penetration of the outer skin layer.

Requires local exhaust ventilation, dust mask, goggles, plastic apron and sleeves, and nitrile gloves during mixing. Requires local exhaust ventilation, goggles or safety glasses, plastic apron, and nitrile or plastic gloves during processing.

BLEACH

	C-42	C-41
Water, 70°–80.6°F	600.0 ml	—
Ammonium bromide	150.0 g	50.0 g (Potassium bromide)
Kodak bleaching agent, BL-1	175.0 ml	100.0 g (EDTANaFe)
Glacial acetic acid	10.5 ml	6.0 ml (Ammonia, 20%)
Potassium nitrate	41.2 g	—
Water to make	1,000.0 ml	1,000.0 ml

AMMONIUM BROMIDE

Skin contact: not very toxic–prolonged contact may cause rash
Eye contact: moderately toxic–may cause temporary discomfort
Inhalation: moderately toxic–may cause temporary discomfort
Ingestion: moderately toxic

If heated to decomposition, can emit toxic fumes of ammonia and bromine gases.

Requires local exhaust ventilation, dust mask, goggles, and plastic apron and gloves during mixing. Requires local exhaust ventilation, safety glasses, and plastic apron and gloves during processing.

POTASSIUM BROMIDE

Also known as bromide salt of potassium.

Skin contact: not very toxic–prolonged exposure can cause skin rash
Eye contact: not very toxic–temporary discomfort

Inhalation: moderately toxic
Ingestion: moderately toxic–harmful in large amounts

If heated to decomposition, can emit toxic fumes of bromine gas.

Requires local exhaust ventilation, dust mask, goggles, plastic apron, and plastic gloves during mixing. Requires local exhaust ventilation and plastic gloves during processing.

KODAK BLEACHING AGENT BL-1

MSDS not located.

SODIUM FERRIC EDTA

Also known as EDTANaFE, ethylenedinitrilotetra acetic acid, ferric monosodium salt.

Skin contact: not very toxic
Eye contact: not very toxic
Inhalation: not very toxic
Ingestion: moderately toxic

If heated to decomposition, can emit toxic fumes of sodium oxide and nitrogen dioxide gas.

Requires local exhaust ventilation, dust mask, goggles, plastic apron, and plastic or rubber gloves during mixing. Requires local exhaust ventilation, safety glasses, plastic apron, and plastic or rubber gloves during processing.

GLACIAL ACETIC ACID (concentrated)
(Use With Extreme Caution)

Also known as vinegar acid and ethanoic acid.

Skin contact: toxic–causes burns, dermatitis, and ulcers; corrosive
Eye contact: toxic–causes burns, severe irritation; corrosive
Inhalation: moderately toxic–causes irritation of
mucous membranes; corrosive
Ingestion: toxic–causes burns; corrosive

If heated to decomposition, can emit toxic fumes of carbon dioxide and carbon monoxide gases.

Requires fume hood and local exhaust ventilation, respirator (organic vapor cartridge), plastic or rubber apron, goggles, and nitrile gloves during mixing. Requires local exhaust ventilation, respirator (organic

vapor cartridge), plastic or rubber apron, goggles, and plastic gloves during processing.

ACETIC ACID (dilute)
(Use With Caution)

Skin contact: not very toxic–may cause allergic reaction or irritation
Eye contact: not very toxic–may cause allergic reaction or irritation
Inhalation: not very toxic–may cause allergic reaction, irritation,
 or possibly chronic bronchitis
Ingestion: not very toxic

If heated to decomposition, can emit toxic fumes of carbon dioxide and carbon monoxide gases. Contamination of the stop bath solution by developer during processing can result in the emission of toxic sulfur dioxide gas when sulfur-based chemicals are part of the bath's formulation.

Requires local exhaust ventilation, respirator (organic vapor cartridge), plastic or rubber apron, goggles, and plastic gloves during processing.

AMMONIA, concentrated (28%)
(Use With Extreme Caution)

Also known as ammonium hydroxide.

Skin contact: toxic–highly corrosive
Eye contact: toxic–highly corrosive
Inhalation: toxic–severe irritation
Ingestion: toxic–can be fatal

Concentrated forms are corrosive to all body tissues, resulting in burns and scarring. Dilute solutions are also very corrosive and have similar hazards.

If heated to decomposition, can emit toxic fumes of ammonia and nitrogen dioxide gases.

Requires local exhaust ventilation, respirator (ammonia vapor cartridge), goggles, rubber apron, and rubber or nitrile gloves during mixing. Requires local exhaust ventilation, respirator (ammonia vapor cartridge), plastic or rubber apron, and plastic or rubber gloves during use.

POTASSIUM NITRATE

Also known as nitrate of potash and saltpeter.

Skin contact: moderately toxic
Eye contact: moderately toxic–may cause temporary discomfort

Inhalation: moderately toxic–may cause temporary discomfort
Ingestion: moderately toxic

If heated to decomposition, can emit toxic fumes of nitrogen oxide gas.

Requires local exhaust ventilation, dust mask, goggles, and plastic apron and gloves during mixing. Requires local exhaust ventilation, safety glasses, and plastic apron and gloves during processing.

FIXER

	C-42	C-41
Water, 70°–80.6°F	800.0 ml	800.0 ml
Ammonium thiosulfate, 58.6% solution	162.0 ml	120.0 g (Ammonium thiosulfate)
(Ethylenedinitrilo)-tetra-acetic acid, disodium salt	1.25 g	20.0 g (sodium sulfite, anhydrous)
Sodium bisulfite, anhydrous	12.4 g	20.0 g (Potassium meta-bisulfite, crystalline)
Sodium hydroxide	2.4 g	—
Water to make	1,000.0 ml	1,000.0 ml

AMMONIUM THIOSULFATE

Also known as rapid fixer.

Skin contact: not very toxic–may cause irritation
Eye contact: not very toxic–may cause irritation
Inhalation: not very toxic; highly toxic if contaminated–
may cause irritation
Ingestion: moderately toxic

If heated to decomposition or contaminated with acid, can emit toxic fumes of ammonia, hydrogen sulfide, or sulfur dioxide gases.

Requires local exhaust ventilation, goggles, rubber or plastic gloves, and apron during mixing. Requires local exhaust ventilation, safety glasses, plastic gloves, and apron during use. Cotton clothing is also recommended.

ETHYLENEDIAMINE TETRAACETIC ACID, DISODIUM SALT

Also known as disodium EDTA salt, EDTANa and ethylenedinitrilotetra acetic acid, disodium salt.

Skin contact: toxic
Eye contact: toxic–may cause irritation
Inhalation: toxic
Ingestion: toxic

If heated to decomposition, can emit toxic nitrogen oxide gas.

Requires local exhaust ventilation, dust mask, goggles and plastic apron and gloves during mixing. Requires local exhaust ventilation, safety glasses and plastic apron and gloves during processing.

SODIUM SULFITE

Also known as sulfurous acid, sodium salt.

Skin contact: not very toxic–may cause irritation
Eye contact: not very toxic–may cause irritation
Inhalation: moderately toxic–may cause irritation
Ingestion: toxic–could cause death if consumed in
significant amounts

If heated to decomposition or mixed with acid, can emit toxic sulfur dioxide and sodium oxide fumes.

Requires local exhaust ventilation, dust mask, goggles, plastic apron, and plastic or rubber gloves during mixing. Requires local exhaust ventilation and plastic gloves during processing.

SODIUM BISULFITE

Also known as sodium hydrogen sulfite and potassium hydrogen sulfite.

Skin contact: moderately toxic–may cause allergic reaction
or irritation
Eye contact: moderately toxic–may cause irritation
Inhalation: moderately toxic
Ingestion: toxic

If heated to decomposition or mixed with acid solutions, can emit toxic fumes of sulfur dioxide gas.

Requires local exhaust ventilation, dust mask, goggles, and plastic apron and gloves during mixing. Requires local exhaust ventilation, goggles or safety glasses, and plastic gloves during processing.

POTASSIUM METABISULFITE

Also known as potassium pyrosulfite.

Skin contact: moderately toxic–may cause burns or irritation
Eye contact: moderately toxic–may cause burns or irritation
Inhalation: moderately toxic–may cause irritation
Ingestion: moderately toxic

If heated to decomposition or mixed with acid, can emit toxic sulfur dioxide and sodium oxide fumes.

Requires local exhaust ventilation, dust mask, goggles, plastic apron, and plastic or rubber gloves during mixing. Requires local exhaust ventilation and plastic gloves during processing.

SODIUM HYDROXIDE
(Use With Caution)

Also known as caustic soda, soda lye, and sodium caustic.

Skin contact: toxic–corrosive; causes burns to skin and
mucous membranes
Eye contact: toxic–corrosive; causes burns to eyes
Inhalation: toxic–corrosive; causes burns to respiratory system
Ingestion: toxic–can be fatal; damages all body tissues

Concentrated forms are corrosive to all body tissues, resulting in burns and scarring. Dilute solutions are also very corrosive and have similar hazards.

Requires local exhaust ventilation, dust mask, goggles, rubber apron, and rubber or nitrile gloves during mixing. Requires local exhaust ventilation, plastic or rubber apron, and rubber gloves during use.

STABILIZER

	C-42	*C-41*
Water, 70°-80.6°F	800.0 ml	800.0 ml
Formaldehyde	5.0 ml	6.0 ml
(Formalin), 37% solution		
Kodak rinse additive, MX812	0.8 ml	10.0 ml
(wetting agent, 10% solution)		
Water to make	1,000.0 ml	1,000.0 ml

FORMALDEHYDE
(Use With Extreme Caution)

Also known as formalin.

Skin contact: toxic–burns, may cause irritation
 Eye contact: toxic–burns, may cause irritation
 Inhalation: toxic–may cause irritation to mucous membranes
 Ingestion: toxic

Formaldehyde is a suspected carcinogen.
If heated to decomposition, can emit acrid smoke and fumes.
Requires local exhaust ventilation, fume hood or respirator (formaldehyde cartridge), goggles, rubber apron, and nitrile gloves during mixing. Requires local exhaust ventilation, respirator (formaldehyde cartridge), goggles or safety glasses, rubber or plastic apron, and nitrile gloves during processing.

KODAK RINSE ADDITIVE MX812
(Wetting Agent)

MSDS not located.

Many of the chemicals in this process are toxic, and the precautions that should be taken include working in a properly ventilated space with local exhaust ventilation that efficiently removes the gases and fumes associated with the processing chemistries. It may be necessary to curtail or stop processing if the ventilation is not sufficient to remove these fumes.

The processing chemistry, if used in trays, needs to be located within a sink with an appropriate depth and with sufficient space around the trays to prevent contamination of the various processing baths and to minimize solution carryover. Drum processing is preferable to using open trays, and automated machine processing can be considered the best processing method.

COLOR SLIDE PROCESSES

The Kodak E-6 color reversal process is used for all Ektachrome film products except for Ektachrome Infrared and Photomicrographic Color 2483, which use the older E-4 process. The E-6 process is run at higher

temperatures than the older E-4—100°F versus 85°F. The E-6 process sequence is about 10 minutes shorter due in part to the higher processing temperature, but also because some of the E-4 processing steps were eliminated. The first developer is followed by a wash, the reversal bath, color developer, conditioner, bleach, fixer, wash, stabilizer, and finally drying.

Unicolor provides an E-6 processing kit based on seven liquid concentrates. One of the advantages of the kit is that all the solutions are liquid concentrates, which eases mixing and eliminates exposure to chemical dust hazards associated with powders. The chemistry is used at 100°F for conventional film tanks and at 105°F for the Unicolor film drum.

The chemical hazards associated with this kit are listed in the *Photo Lab Index* (DeCock 1990, sec. 8, p. 135). The first developer, part A, contains hydroquinone, and part B contains sodium carbonate. The color developer, part A, contains sodium phosphate; and part B contains 4-amino-N-ethyl-N-(beta-methanesulfonamidoethyl)-m-toluidene-sesquisulfite, or CD-3. The stop bath contains acetic acid. The bleach contains potassium bromide and potassium ferricyanide. It should be noted that the use of ferricyanide-bleach-bath formulations in processing baths has been discontinued by most manufacturers. The fixer contains ammonium thiosulfate, the stabilizer contains formaldehyde, and the reversal bath contains propionic acid.

Beseler also markets an E-6 processing chemistry kit. The process uses a seven-solution chemistry and is run at 100°F. The hazardous chemicals listed in the *Photo Lab Index*, (DeCock 1990, sec. 8, p. 200) include the following:

- First developer, a hydroquinone derivative, potassium carbonate, sodium bromide, and sodium thiocyanate.
- Reversal bath, tin chloride and sodium salts of carbonic acid.
- Color developer, part A, sodium hydroxide, sodium sulfite, and sodium bromide. Color developer, part B, sodium sulfite and a paraphenylene diamine derivative.
- Conditioner, potassium sulfite and thioglycerin.
- Bleach, part A, ammonium hydroxide, ammonium, and ammonium ferric salts of ethylenediamine tetraacetic acid, and mercapto-triazole disulfide. Bleach, part B, acetic acid.
- Fixer, ammonium thiosulfate and sodium sulfite.
- Stabilizer, formaldehyde.

Compare these components with the detailed formulas provided for E-6 process chemistries in the next section.

Formulas and Hazards

These formulations may not be the exact formulation that constitutes a Kodak E-6 process chemistry, but they will give comparable quality.

FIRST DEVELOPER

Ref.: "Home Processing" 1991, p. 170

Calgon	2.0 g
Sodium sulfite, anhydrous	15.0 g
Potassium hydroquinone monosulfonate, pure	20.0 g
Diethylene glycol	15.0 ml
Potassium carbonate, anhydrous	15.0 g
Phenidone	0.4 g
Sodium thiocyanate, 20% solution	8.0 ml
Potassium bromide	1.8 g
Potassium iodide, 1% solution	4.0 ml
Water to make	1,000.0 ml

SODIUM HEXAMETAPHOSPHATE

Also known as Calgon.

> Skin contact: moderately toxic–may cause irritation
> Eye contact: moderately toxic–may cause irritation
> Inhalation: not very toxic–may cause irritation
> Ingestion: moderately toxic

If heated to decomposition, can emit toxic fumes of phosphorous oxide gas.

Requires local exhaust ventilation, dust mask, goggles, plastic apron, and rubber or plastic gloves during mixing. Requires local exhaust ventilation, safety glasses, plastic apron, and plastic or rubber gloves during processing.

SODIUM SULFITE

Also known as sulfurous acid, sodium salt.

> Skin contact: not very toxic–may cause irritation
> Eye contact: not very toxic–may cause irritation
> Inhalation: moderately toxic–may cause irritation

Ingestion: toxic–could cause death if consumed in
significant amounts

If heated to decomposition or mixed with acid, can emit toxic sulfur
dioxide and sodium oxide fumes.

Requires local exhaust ventilation, dust mask, goggles, plastic apron,
and plastic or rubber gloves during mixing. Requires local exhaust venti-
lation and plastic gloves during processing.

POTASSIUM HYDROQUINONE MONOSULFONATE

MSDS not located.

DIETHYLENE GLYCOL
(Use With Caution)

Also known as diglycol.

Skin contact: moderately toxic–may cause irritation
Eye contact: moderately toxic–may cause irritation
Inhalation: moderately toxic–may cause irritation
Ingestion: toxic–small amounts may be fatal

This chemical is a suspected carcinogen.

This chemical slowly decomposes to form peroxides on exposure to
light and air.

Requires local exhaust ventilation, respirator (organic vapor car-
tridge), goggles, and plastic apron and gloves during mixing. Requires
local exhaust ventilation, safety glasses, and plastic apron and gloves dur-
ing processing.

POTASSIUM CARBONATE

Also known as potash.

Skin contact: moderately toxic–may cause burns or irritation
Eye contact: moderately toxic–may cause burns or irritation
Inhalation: moderately toxic–may cause irritation
Ingestion: toxic–can be fatal in large quantities

Concentrated forms are corrosive to skin and eyes; dilute solutions
may irritate.

If heated to decomposition, can emit toxic fumes of potassium oxide
and carbon dioxide gases.

Requires local exhaust ventilation, dust mask, goggles, and plastic

apron and gloves during mixing. Requires local exhaust ventilation, goggles or safety glasses, and plastic gloves during processing.

PHENIDONE

Phenidone was discovered in 1890 and applied as a developer in 1940. It is also known by the trade names Phenidone and Graphidone and the identifier P-Q (phenidone-quinone) developers. Its chemical name is phenidone or l-phenyl-3-pyrazolidone.

Skin contact: not very toxic
Eye contact: moderately toxic
Inhalation: moderately toxic
Ingestion: toxic

If heated to decomposition, can emit toxic fumes of nitrogen oxides.
Requires local exhaust ventilation, dust mask, goggles, plastic apron, and rubber gloves during mixing. Requires local exhaust ventilation, goggles or safety glasses, plastic apron, and rubber or plastic gloves during processing.

SODIUM THIOCYANATE

Also known as sodium rhodanate.

Skin contact: moderately toxic–may cause irritation and skin rash
Eye contact: moderately toxic–may cause irritation and
 temporary discomfort
Inhalation: moderately toxic
Ingestion: moderately toxic

If heated to decomposition or contaminated with acid solutions, can emit toxic fumes of hydrogen cyanide, hydrogen chloride, sulfur dioxide, and sodium oxide gases.
Requires local exhaust ventilation, fume hood and dust mask, goggles or safety glasses, and rubber or plastic gloves during mixing. Requires local exhaust ventilation, safety glasses, and rubber or plastic gloves during processing.

POTASSIUM BROMIDE

Also known as bromide salt of potassium.

Skin contact: not very toxic–prolonged exposure can cause skin rash
Eye contact: not very toxic–temporary discomfort

Inhalation: moderately toxic

Ingestion: moderately toxic–harmful in large amounts

If heated to decomposition, can emit toxic fumes of bromine gas.

Requires local exhaust ventilation, dust mask, goggles, plastic apron, and plastic gloves during mixing. Requires local exhaust ventilation and plastic gloves during processing.

POTASSIUM IODIDE

Skin contact: not very toxic

Eye contact: moderately toxic–may cause temporary discomfort

Inhalation: moderately toxic

Ingestion: moderately toxic

If heated to decomposition, can emit toxic fumes of iodine gas.

Requires local exhaust ventilation, dust mask, goggles, plastic apron, and plastic gloves during mixing. Requires local exhaust ventilation, safety glasses, plastic apron, and rubber or plastic gloves during processing.

REVERSAL BATH

Ref.: "Home Processing" 1991, p. 170

Propionic acid	12.0 ml
Stannous chloride	1.65 g
p-aminophenol	0.5 g
Sodium hydroxide	4.8 g
BDH Calcium Complexing Agent no. 4	15.0 ml
Water to make	1,000.0 ml

PROPIONIC ACID (concentrated)

Also known as methylacetic acid

Skin contact: toxic–may cause irritation

Eye contact: toxic–burns, may cause irritation

Inhalation: moderately toxic–may cause irritation

Ingestion: moderately toxic

If heated to decomposition, can emit acrid fumes.

Requires local exhaust ventilation with a respirator (acidic gas cartridge), goggles, plastic apron, and plastic gloves during mixing. Requires local exhaust ventilation, safety glasses, and plastic apron and gloves during processing.

STANNOUS CHLORIDE

Also known as tin dichloride dihydrate.

Skin contact: moderately toxic–may cause irritation
Eye contact: moderately toxic–may cause irritation
Inhalation: moderately toxic–may cause irritation
Ingestion: toxic

If heated to decomposition, can emit toxic fumes of chlorine gas.

Requires local exhaust ventilation, dust mask, goggles, plastic apron, and rubber gloves during mixing. Requires local exhaust ventilation, safety glasses, plastic apron, and rubber gloves during processing.

PARA-AMINOPHENOL

Para-aminophenol was first used in 1888. It is also known by the trade names Kodelon, Para, Rodinal, Azol, Activol, or Certinal. Its chemical name is para-aminophenol hydrochloride or para-hydroxyaniline hydrochloride.

Skin contact: moderately toxic–may cause allergic reaction
 or irritation; may cause dermatitis if absorbed
 through the skin
Eye contact: moderately toxic–may cause irritation
Inhalation: moderately toxic
Ingestion: moderately toxic

If heated to decomposition, can emit toxic fumes of hydrogen chloride and nitrogen dioxide.

Requires local exhaust ventilation, dust mask or respirator (organic vapor cartridge), goggles, plastic apron, and rubber gloves during mixing. Requires local exhaust ventilation, plastic apron, and rubber or plastic gloves during processing.

SODIUM HYDROXIDE
(Use With Caution)

Also known as caustic soda, soda lye, and sodium caustic.

Skin contact: toxic–corrosive; causes burns to skin
 and mucous membranes
Eye contact: toxic–corrosive; causes burns to eyes
Inhalation: toxic–corrosive; causes burns to respiratory system
Ingestion: toxic–can be fatal; damages all body tissues

Concentrated forms are corrosive to all body tissues, resulting in burns and scarring. Dilute solutions are also very corrosive and have similar hazards.

Requires local exhaust ventilation, dust mask, goggles, rubber apron, and rubber or nitrile gloves during mixing. Requires local exhaust ventilation, plastic or rubber apron, and rubber gloves during use.

BDH CALCIUM COMPLEXING AGENT NO. 4
MSDS not located.

COLOR DEVELOPER
Ref.: "Home Processing" 1991, p. 170

EDTANa4	3.0 g
Potassium carbonate, anhydrous	40.0 g
Sodium sulfite, anhydrous	4.0 g
Potassium bromide	0.5 g
Potassium iodide, 1% solution	3.0 ml
Citrazinic acid	1.2 g
Hydroxylamine hydrochloride	1.5 g
CD-3 or CD-4	10.0 g or 7.5 g
Water to make	1,000.0 ml

ETHYLENEDIAMINE TETRAACETIC ACID, TETRASODIUM SALT
(Use With Extreme Caution)

Also known as tetrasodium EDTA salt, EDTANa4 and ethylenedinitrilotetra acetic acid, tetrasodium salt.

Skin contact: toxic—may cause irritation
Eye contact: toxic—may cause irritation
Inhalation: toxic
Ingestion: toxic

This chemical is a suspected teratogen.

If heated to decomposition, can emit toxic fumes of nitrogen dioxide gas.

Requires local exhaust ventilation, dust mask, goggles, plastic apron, and plastic or rubber gloves during mixing. Requires local exhaust ventilation, safety glasses, plastic apron, and plastic or rubber gloves during processing.

POTASSIUM CARBONATE

Also known as potash.

Skin contact: moderately toxic–may cause burns or irritation
Eye contact: moderately toxic–may cause burns or irritation
Inhalation: moderately toxic–may cause irritation
Ingestion: toxic–can be fatal in large quantities

Concentrated forms are corrosive to skin and eyes; dilute solutions may irritate.

If heated to decomposition, can emit toxic fumes of potassium oxide and carbon dioxide gases.

Requires local exhaust ventilation, dust mask, goggles, and plastic apron and gloves during mixing. Requires local exhaust ventilation, goggles or safety glasses, and plastic gloves during processing.

SODIUM SULFITE

Also known as sulfurous acid, sodium salt.

Skin contact: not very toxic–may cause irritation
Eye contact: not very toxic–may cause irritation
Inhalation: moderately toxic–may cause irritation
Ingestion: toxic–could cause death if consumed in
significant amounts

If heated to decomposition or mixed with acid, can emit toxic sulfur dioxide and sodium oxide fumes.

Requires local exhaust ventilation, dust mask, goggles, plastic apron, and plastic or rubber gloves during mixing. Requires local exhaust ventilation and plastic gloves during processing.

POTASSIUM BROMIDE

Also known as bromide salt of potassium.

Skin contact: not very toxic–prolonged exposure can cause skin rash
Eye contact: not very toxic–temporary discomfort
Inhalation: moderately toxic
Ingestion: moderately toxic–harmful in large amounts

If heated to decomposition, can emit toxic fumes of bromine gas.

Requires local exhaust ventilation, dust mask, goggles, plastic apron, and plastic gloves during mixing. Requires local exhaust ventilation and plastic gloves during processing.

POTASSIUM IODIDE

Skin contact: not very toxic
Eye contact: moderately toxic–may cause temporary discomfort
Inhalation: moderately toxic
Ingestion: moderately toxic

If heated to decomposition, can emit toxic fumes of iodine gas.
Requires local exhaust ventilation, dust mask, goggles, plastic apron, and plastic gloves during mixing. Requires local exhaust ventilation, safety glasses, plastic apron, and rubber or plastic gloves during processing.

CITRAZINIC ACID, CONCENTRATED

Skin contact: moderately toxic–may cause irritation
Eye contact: moderately toxic–may cause irritation
Inhalation: moderately toxic–may cause irritation
Ingestion: moderately toxic

The information on this compound has not been completely established or is not available.
Requires local exhaust ventilation, dust mask, goggles, rubber apron, and nitrile gloves during mixing. Requires local exhaust ventilation, safety glasses, plastic apron, and rubber or plastic gloves during processing.

HYDROXYLAMINE HYDROCHLORIDE

Also known as hydroxyl ammonium chloride.

Skin contact: toxic–may cause irritation, dermatitis
Eye contact: toxic–may cause irritation
Inhalation: moderately toxic–may cause irritation
Ingestion: moderately toxic

This compound is a suspected teratogen.
If heated to decomposition, can emit toxic fumes.
Requires local exhaust ventilation, dust mask, goggles, plastic apron, and plastic or rubber gloves during mixing. Requires local exhaust ventilation, safety glasses, plastic apron, and plastic or rubber gloves during processing.

COLOR DEVELOPER 3
(Use With Extreme Caution)

Also known as CD-3, 4-(N-ethyl-N-2-methanesulfonylaminoethyl)-2-methylphenylenediamine sesquisulfate monohydrate and 4-amino-N-ethyl-N-(beta-methanesulfonamidoethyl)-m-tolosesquisulfate monohydrate

Skin contact: toxic–may cause irritation, blisters
Eye contact: toxic–may cause irritation, burns
Inhalation: toxic–may cause irritation of mucous membranes
Ingestion: toxic

The information on this compound has not been completely established or is not available. It should be treated as dangerous. Problems with skin sensitivity have been noted with this group of developer agents due in large part to its ease of penetration of the outer skin layer.

Requires local exhaust ventilation, dust mask, goggles, plastic apron and sleeves, and nitrile gloves during mixing. Requires local exhaust ventilation, goggles or safety glasses, plastic apron, and nitrile or plastic gloves during processing.

COLOR DEVELOPER 4
(Use With Extreme Caution)

Also known as CD-4, 4-(N-ethyl-N-2-hydroxyethyl)-2-methylphenylenediamine sulfate, N-ethyl-N-(beta-hydroxyethyl)-3-methyl-p-phenylenediamine sulfate or 4-amino-3-methyl-N-ethyl-N-(beta-hydroxyethyl)-aniline sulfate.

Skin contact: toxic–may cause irritation, blisters
Eye contact: toxic–may cause irritation, burns
Inhalation: toxic–may cause irritation of mucous membranes
Ingestion: toxic

The information on this compound has not been completely established or is not available. It should be treated as dangerous. Problems with skin sensitivity have been noted with this group of developer agents due in large part to its ease of penetration of the outer skin layer.

Requires local exhaust ventilation, dust mask, goggles, plastic apron and sleeves, and nitrile gloves during mixing. Requires local exhaust ven-

tilation, goggles or safety glasses, plastic apron, and nitrile or plastic gloves during processing.

CONDITIONING BATH
Ref.: "Home Processing" 1991, p. 170

Sodium sulfite, anhydrous	10.0 g
EDTA acid	8.0 g
Thioglycerol	0.5 ml
Water to make	1,000.0 ml

SODIUM SULFITE
Also known as sulfurous acid, sodium salt.

Skin contact: not very toxic–may cause irritation
Eye contact: not very toxic–may cause irritation
Inhalation: moderately toxic–may cause irritation
Ingestion: toxic–could cause death if consumed in significant amounts

If heated to decomposition or mixed with acid, can emit toxic sulfur dioxide and sodium oxide fumes.

Requires local exhaust ventilation, dust mask, goggles, plastic apron, and plastic or rubber gloves during mixing. Requires local exhaust ventilation and plastic gloves during processing.

ETHYLENEDIAMINE TETRAACETIC ACID
(Use With Extreme Caution)
Also known as EDTA.

Skin contact: toxic–may cause irritation
Eye contact: toxic–may cause irritation
Inhalation: toxic
Ingestion: toxic

If heated to decomposition, can emit toxic fumes of nitrogen oxide gas.

Requires local exhaust ventilation, dust mask, goggles, plastic apron, and rubber or plastic gloves during mixing. Requires local exhaust ventilation, safety glasses, plastic apron, and rubber or plastic gloves during processing.

THIOGLYCEROL

Also known as monothioglycerol and 1-thioglycerol.

> Skin contact: toxic
> Eye contact: toxic
> Inhalation: toxic
> Ingestion: toxic

If heated to decomposition, can emit toxic fumes of sulfur dioxide gas.

Requires local exhaust ventilation, dust mask, goggles, plastic apron, and rubber or plastic gloves during mixing. Requires local exhaust ventilation, safety glasses, plastic apron, and plastic or rubber gloves during processing.

BLEACH BATH

Ref.: "Home Processing" 1991, p. 170

Potassium nitrate, crystalline	30.0 g
Potassium bromide	110.0 g
EDTANaFe	110.0 g
Water to make	1,000.0 ml

POTASSIUM NITRATE

Also known as nitrate of potash and saltpeter.

> Skin contact: moderately toxic
> Eye contact: moderately toxic–may cause temporary discomfort
> Inhalation: moderately toxic–may cause temporary discomfort
> Ingestion: moderately toxic

If heated to decomposition, can emit toxic fumes of nitrogen oxide gas.

Requires local exhaust ventilation, dust mask, goggles, and plastic apron and gloves during mixing. Requires local exhaust ventilation, safety glasses, and plastic apron and gloves during processing.

POTASSIUM BROMIDE

Also known as bromide salt of potassium.

> Skin contact: not very toxic–prolonged exposure can cause skin rash
> Eye contact: not very toxic–temporary discomfort
> Inhalation: moderately toxic
> Ingestion: moderately toxic–harmful in large amounts

If heated to decomposition, can emit toxic fumes of bromine gas.

Requires local exhaust ventilation, dust mask, goggles, plastic apron and plastic gloves during mixing. Requires local exhaust ventilation and plastic gloves during processing.

SODIUM FERRIC EDTA

Also known as EDTANaFE, ethylenedinitrilotetra acetic acid, ferric monosodium salt.

Skin contact: not very toxic
Eye contact: not very toxic
Inhalation: not very toxic
Ingestion: moderately toxic

If heated to decomposition, can emit toxic fumes of sodium oxide and nitrogen dioxide gas.

Requires local exhaust ventilation, dust mask, goggles, plastic apron, and plastic or rubber gloves during mixing. Requires local exhaust ventilation, safety glasses, plastic apron, and plastic or rubber gloves during processing.

FIXER BATH

Ref.: "Home Processing" 1991, p. 170

Ammonium thiosulfate, crystalline	70.0 g
Potassium metabisulfite, crystalline	12.0 g
Sodium sulfite, anhydrous	7.0 g
Water to make	1000.0 ml

AMMONIUM THIOSULFATE

Also known as rapid fixer.

Skin contact: not very toxic–may cause irritation
Eye contact: not very toxic–may cause irritation
Inhalation: not very toxic—highly toxic if contaminated;
may cause irritation
Ingestion: moderately toxic

If heated to decomposition or contaminated with acid, can emit toxic fumes of ammonia, hydrogen sulfide, or sulfur dioxide gases.

Requires local exhaust ventilation, goggles, and rubber or plastic gloves and apron during mixing. Requires local exhaust ventilation, safety glasses, and plastic gloves and apron during use. Cotton clothing is also recommended.

POTASSIUM METABISULFITE

Also known as potassium pyrosulfite.

Skin contact: moderately toxic–may cause burns or irritation
Eye contact: moderately toxic–may cause burns or irritation
Inhalation: moderately toxic–may cause irritation
Ingestion: moderately toxic

If heated to decomposition or mixed with acid, can emit toxic sulfur dioxide and sodium oxide fumes.

Requires local exhaust ventilation, dust mask, goggles, plastic apron, and plastic or rubber gloves during mixing. Requires local exhaust ventilation and plastic gloves during processing.

SODIUM SULFITE

Also known as sulfurous acid, sodium salt.

Skin contact: not very toxic–may cause irritation
Eye contact: not very toxic–may cause irritation
Inhalation: moderately toxic–may cause irritation
Ingestion: toxic–could cause death if consumed in
significant amounts

If heated to decomposition or mixed with acid, can emit toxic sulfur dioxide and sodium oxide fumes.

Requires local exhaust ventilation, dust mask, goggles, plastic apron, and plastic or rubber gloves during mixing. Requires local exhaust ventilation and plastic gloves during processing.

STABILIZER BATH
Ref.: "Home Processing," 1991, p. 170

Aerosol OT, wetting agent	5.0 ml
Formaldehyde, 37% solution	6.0 ml
Water to make	1000.0 ml

AEROSOL OT, WETTING AGENT

MSDS not located.

FORMALDEHYDE
(Use With Extreme Caution)

Also known as formalin.

> Skin contact: toxic–burns; may cause irritation
> Eye contact: toxic–burns; may cause irritation
> Inhalation: toxic–may cause irritation to mucous membranes
> Ingestion: toxic

Formaldehyde is a suspected carcinogen.

If heated to decomposition, can emit acrid smoke and fumes.

Requires local exhaust ventilation, fume hood or respirator (formaldehyde cartridge), goggles, rubber apron, and nitrile gloves during mixing. Requires local exhaust ventilation, respirator (formaldehyde cartridge), goggles or safety glasses, rubber or plastic apron, and nitrile gloves during processing.

Many of the chemicals in this process are toxic, and the precautions that should be taken include working in a properly ventilated space with local exhaust ventilation that efficiently removes the gases and fumes associated with the processing chemistries. It may be necessary to curtail or stop processing if the ventilation is not sufficient to remove these fumes.

The processing chemistry, if used in trays, needs to be located within a sink with an appropriate depth and with sufficient space around the trays to prevent contamination of the various processing baths and to minimize solution carryover. Drum processing is preferable to using open trays, and automated machine processing can be considered the best processing method.

COLOR PRINT PROCESSES

Examples of these products include Kodak Ektaprint 2, Unicolor Total Color, Unicolor R-2, and Beseler 2 Step for negatives printed on color papers, and the Kodak R-1000 chemistries for printing from color slides.

The prints printed from negatives use a color paper such as Kodak's Ektacolor 74RC and 78RC. Color papers such as Kodak's Ektachrome RC Type 2203 are used for prints printed from slides and processed in Kodak's Ektaprint R-1000 type chemistry.

The Ektaprint 2 Process

The Ektaprint 2 process takes place at 91°F and has a three-solution chemistry.

The Unicolor Total Color product was discussed under the C-41 chemistry section because it can be used for the processing of color negatives and has a four-solution processing chemistry. Unicolor also has the R-2 chemistry kit identified specifically for the 74/78 papers. It is a four-solution process, and the *Photo Lab Index* (DeCock 1990, sec. 8, p. 161) identifies the following chemical hazards in this kit:

- Developer, part A, benzol alcohol and 4-amino-N-ethyl-N-(methane sulfanamidoethyl)-m-toluidene sesquisulfate, also known as CD-3; developer, part B, sodium carbonate; developer, part C, hydroxylamine sulfate. The developer starter contains acetic acid.
- Stop bath, acetic acid.
- Blix, ammonium thiosulfate.
- Stabilizer, formaldehyde.

The Beseler 2 Step kit has just two steps in the processing chemistry and has the greatest flexibility in development time and temperature used during processing. The *Photo Lab Index* (DeCock 1990, sec. 8 p. 215) identifies the following chemical hazards in this chemistry:

- Step 1, part A, hydroxylamine sulfate; part B, diethylene glycol, benzyl alcohol, diethanolamine, and a paraphenylene diamine derivative; part C, potassium carbonate, tri-potassium phosphate, potassium sulfite, and potassium hydroxide; Part D (part of the 10L kit), potassium carbonate, sodium sulfite, and potassium polyphosphate.
- Step 2, part A, ferric ammonium ethylenediamine tetraacetic acid; part B, ammonium thiosulfate, sodium disulfite, and potassium sulfite.

The R-1000 Process

The Kodak Ektaprint R-1000 process is run at 100°F and has a five solution chemistry.

Unicolor provides an RP-1000 three-step processing chemistry. The

chemistry is available in liquid concentrates, which reduces chemical exposure to powders. The three-step chemistry also reduces the number of processing baths, increasing the ease of processing and handling the solutions. The hazardous chemicals identified in the *Photo Lab Index* (DeCock 1990, sec. 8, p. 172) are as follows:

- First developer, hydroquinone.
- Color developer, part A, 4-amino-N-ethyl-N-(b-methanesulfonamido-ethyl)-m-toluidene sesquisulfate, or CD-3; part B, sodium carbonate; part C, hydroxylamine sulfate.
- Blix, part A, ammonium thiosulfate; part B, ethylenediamine tetraacetic acid; part C, sodium sulfite.

The Beseler kit is also a three-step processing chemistry kit, and the *Photo Lab Index* (DeCock 1990, sec. 8, p. 205) provides the following information about its chemical hazards:

- Step 1, part A, potassium carbonate, potassium sulfite, and potassium thiocyanate; part B, potassium carbonate, potassium sulfite, and potassium thiocyanate; part C, hydroquinone and diethyleneglycol.
- Step 2, part A, benzyl alcohol; part B, hydroxylamine sulfate; Part C, sodium bisulfite and a paraphenylenediamine sulfate derivative; part D, potassium carbonate and potassium hydroxide.
- Step 3, part A, an ammonium iron salt of EDTA; part B, contains mercapto-triazole disulfide and ammonium thiosulfate.

Color Print Process Formula, Ektaprint Type

These formulations may not be the exact formulation that constitutes a Kodak Ektaprint process chemistry, but they will give comparable quality.

COLOR DEVELOPER
Ref.: "Home Processing" 1991, p. 172

Calgon	2.0 g
Hydroxylamine sulfate	3.4 g
Sodium sulfite, anhydrous	2.0 g
Potassium carbonate, anhydrous	32.0 g
Potassium bromide	0.4 g

Benzyl alcohol, 50% solution	30.0 ml
CD-3	4.4 g
Water to make	1,000.0 ml

SODIUM HEXAMETAPHOSPHATE

Also known as Calgon.

> Skin contact: moderately toxic–may cause irritation
> Eye contact: moderately toxic–may cause irritation
> Inhalation: not very toxic–may cause irritation
> Ingestion: moderately toxic

If heated to decomposition, can emit toxic fumes of phosphorous oxide gases.

Requires local exhaust ventilation, dust mask, goggles, plastic apron, and rubber or plastic gloves during mixing. Requires local exhaust ventilation, safety glasses, plastic apron, and plastic or rubber gloves during processing.

HYDROXYLAMINE SULFATE

Also known as hydroxylammonium sulfate.

> Skin contact: moderately toxic–may cause allergies, irritation
> and dermatitis
> Eye contact: moderately toxic–may cause irritation
> Inhalation: moderately toxic
> Ingestion: moderately toxic

This compound is a suspected teratogen.

If heated to decomposition, can emit toxic fumes of ammonia, nitrogen dioxide, and sulfur dioxide gases.

Requires local exhaust ventilation, dust mask, goggles, plastic apron, and rubber or plastic gloves during mixing. Requires local exhaust ventilation, safety glasses, plastic apron, and rubber or plastic gloves during processing.

SODIUM SULFITE

Also known as sulfurous acid, sodium salt.

> Skin contact: not very toxic–may cause irritation
> Eye contact: not very toxic–may cause irritation
> Inhalation: moderately toxic–may cause irritation

Ingestion: toxic–could cause death if consumed in
significant amounts

If heated to decomposition or mixed with acid, can emit toxic sulfur
dioxide and sodium oxide fumes.

Requires local exhaust ventilation, dust mask, goggles, plastic apron,
and plastic or rubber gloves during mixing. Requires local exhaust venti-
lation and plastic gloves during processing.

POTASSIUM CARBONATE

Also known as potash.

Skin contact: moderately toxic–may cause burns or irritation
Eye contact: moderately toxic–may cause burns or irritation
Inhalation: moderately toxic–may cause irritation
Ingestion: toxic–can be fatal in large quantities

Concentrated forms are corrosive to skin and eyes; dilute solutions
may irritate.

If heated to decomposition, can emit toxic fumes of potassium oxide
and carbon dioxide gases.

Requires local exhaust ventilation, dust mask, goggles, and plastic
apron and gloves during mixing. Requires local exhaust ventilation, gog-
gles or safety glasses, and plastic gloves during processing.

POTASSIUM BROMIDE

Also known as bromide salt of potassium.

Skin contact: not very toxic–prolonged exposure can cause skin rash
Eye contact: not very toxic–temporary discomfort
Inhalation: moderately toxic
Ingestion: moderately toxic–harmful in large amounts

If heated to decomposition, can emit toxic fumes of bromine gas.

Requires local exhaust ventilation, dust mask, goggles, plastic apron,
and plastic gloves during mixing. Requires local exhaust ventilation and
plastic gloves during processing.

BENZYL ALCOHOL

Also known as phenyl carbinol.

Skin contact: not very toxic–may cause irritation
Eye contact: not very toxic–may cause irritation

Inhalation: not very toxic–may cause irritation
Ingestion: not very toxic

Requires local exhaust ventilation and respirator (organic solvent cartridge), goggles or safety glasses, nitrile apron, and nitrile gloves during mixing. Requires local exhaust ventilation, safety glasses, nitrile apron, and nitrile gloves during processing.

COLOR DEVELOPER 3
(Use With Extreme Caution)

Also known as CD-3, 4-(N-ethyl-N-2-methanesulfonylaminoethyl)-2-methylphenylenediamine sesquisulfate monohydrate and 4-amino-N-ethyl-N-(beta-methanesulfonamidoethyl)-m-tolosesquisulfate monohydrate.

Skin contact: toxic–may cause irritation, blisters
Eye contact: toxic–may cause irritation, burns
Inhalation: toxic–may cause irritation of mucous membranes
Ingestion: toxic

The information on this compound has not been completely established or is not available. It should be treated as dangerous. Problems with skin sensitivity have been noted with this group of developer agents due in large part to its ease of penetration of the outer skin layer.

Requires local exhaust ventilation, dust mask, goggles, plastic apron and sleeves and nitrile gloves during mixing. Requires local exhaust ventilation, goggles or safety glasses, plastic apron, and nitrile or plastic gloves during processing.

BLEACH FIX (BLIX) BATH
Ref.: "Home Processing" 1991, p. 173

EDTANaFe	40.0 g
EDTA acid	4.0 g
Potassium iodide	1.0 g
Ammonia, 20% solution	10.0 ml
Ammonium thiosulfate, crystalline	100.0 g
Sodium sulfite, anhydrous	2.0 g
Sodium thiocyanate, 20% solution	50.0 ml
Water to make	1,000.0 ml

SODIUM FERRIC EDTA

Also known as EDTANaFE, ethylenedinitrilotetra acetic acid, ferric monosodium salt.

Skin contact: not very toxic
Eye contact: not very toxic
Inhalation: not very toxic
Ingestion: moderately toxic

If heated to decomposition, can emit toxic fumes of sodium oxide and nitrogen dioxide gases.

Requires local exhaust ventilation, dust mask, goggles, plastic apron, and plastic or rubber gloves during mixing. Requires local exhaust ventilation, safety glasses, plastic apron, and plastic or rubber gloves during processing.

ETHYLENEDIAMINE TETRAACETIC ACID
(Use With Extreme Caution)

Also known as EDTA.

Skin contact: toxic–may cause irritation
Eye contact: toxic–may cause irritation
Inhalation: toxic
Ingestion: toxic

If heated to decomposition, can emit toxic fumes of nitrogen oxide gas.

Requires local exhaust ventilation, dust mask, goggles, plastic apron, and rubber or plastic gloves during mixing. Requires local exhaust ventilation, safety glasses, plastic apron, and rubber or plastic gloves during processing.

POTASSIUM IODIDE

Skin contact: not very toxic
Eye contact: moderately toxic–may cause temporary discomfort
Inhalation: moderately toxic
Ingestion: moderately toxic

If heated to decomposition, can emit toxic fumes of iodine gas.

Requires local exhaust ventilation, dust mask, goggles, plastic apron and plastic gloves during mixing. Requires local exhaust ventilation, safety glasses, plastic apron and rubber or plastic gloves during processing.

AMMONIA, concentrated (28%)
(Use With Extreme Caution)

Also known as ammonium hydroxide.

Skin contact: moderately toxic–highly corrosive
Eye contact: moderately toxic–highly corrosive
Inhalation: toxic–severe irritation
Ingestion: toxic–can be fatal

Concentrated forms are corrosive to all body tissues, resulting in burns and scarring. Dilute solutions are also very corrosive and have similar hazards.

If heated to decomposition, can emit toxic fumes of ammonia and nitrogen dioxide gases.

Requires local exhaust ventilation, respirator (ammonia vapor cartridge), goggles, rubber apron, and rubber or nitrile gloves during mixing. Requires local exhaust ventilation, respirator (ammonia vapor cartridge), plastic or rubber apron, and plastic or rubber gloves during use.

AMMONIUM THIOSULFATE

Also known as rapid fixer.

Skin contact: not very toxic–may cause irritation
Eye contact: not very toxic–may cause irritation
Inhalation: not very toxic; highly toxic if contaminated—
may cause irritation
Ingestion: moderately toxic

If heated to decomposition or contaminated with acid, can emit toxic fumes of ammonia, hydrogen sulfide, or sulfur dioxide gases.

Requires local exhaust ventilation, goggles, and rubber or plastic gloves and apron during mixing. Requires local exhaust ventilation, safety glasses, and plastic gloves and apron during use. Cotton clothing is also recommended.

SODIUM SULFITE

Also known as sulfurous acid, sodium salt.

Skin contact: not very toxic–may cause irritation
Eye contact: not very toxic–may cause irritation
Inhalation: moderately toxic–may cause irritation
Ingestion: toxic–could cause death if consumed in
significant amounts

If heated to decomposition or mixed with acid, can emit toxic sulfur dioxide and sodium oxide fumes.

Requires local exhaust ventilation, dust mask, goggles, plastic apron, and plastic or rubber gloves during mixing. Requires local exhaust ventilation and plastic gloves during processing.

SODIUM THIOCYANATE

Also known as sodium rhodanate.

> Skin contact: moderately toxic–may cause irritation and skin rash
> Eye contact: moderately toxic–may cause irritation and temporary discomfort
> Inhalation: moderately toxic
> Ingestion: moderately toxic

If heated to decomposition or contaminated with acid solutions, can emit toxic fumes of hydrogen cyanide, hydrogen chloride, sulfur dioxide, and sodium oxide gases.

Requires local exhaust ventilation, fume hood and dust mask, goggles or safety glasses, and rubber or plastic gloves during mixing. Requires local exhaust ventilation, safety glasses and rubber or plastic gloves during processing.

STABILIZER BATH

Ref.: "Home Processing" 1991, p. 173

Sodium carbonate, anhydrous	2.5 g
Acetic acid, glacial	12.5 ml
Citric acid, crystalline	7.0 g
Water to make	1,000.0 ml

SODIUM CARBONATE

Also known as soda ash.

> Skin contact: moderately toxic–may cause burns or irritation
> Eye contact: moderately toxic–may cause burns or irritation
> Inhalation: moderately toxic
> Ingestion: moderately toxic–can be fatal in large quantities

Concentrated forms are corrosive to skin and eyes; dilute solutions may irritate.

If heated to decomposition, can emit toxic fumes of sodium oxide gas.

Requires local exhaust ventilation, dust mask, goggles, and plastic apron and gloves during mixing. Requires local exhaust ventilation, goggles or safety glasses, and plastic gloves during processing.

GLACIAL ACETIC ACID (concentrated)
(Use With Extreme Caution)

Also known as vinegar acid and ethanoic acid.

> Skin contact: toxic–causes burns, dermatitis, and ulcers; corrosive
> Eye contact: toxic–causes burns, severe irritation; corrosive
> Inhalation: moderately toxic–causes irritation of mucous
> membranes; corrosive
> Ingestion: toxic–causes burns; corrosive

If heated to decomposition, can emit toxic fumes of carbon dioxide and carbon monoxide gases.

Requires fume hood and local exhaust ventilation, respirator (organic vapor cartridge), plastic or rubber apron, goggles, and nitrile gloves during mixing. Require local exhaust ventilation, respirator (organic vapor cartridge), plastic or rubber apron, goggles, and plastic gloves during processing.

ACETIC ACID (dilute)
(Use With Caution)

> Skin contact: not very toxic–may cause allergic reaction or irritation
> Eye contact: not very toxic–may cause allergic reaction or irritation
> Inhalation: not very toxic–may cause allergic reaction,
> irritation, or possibly chronic bronchitis
> Ingestion: not very toxic

If heated to decomposition, can emit toxic fumes of carbon dioxide and carbon monoxide gases. Contamination of the stop bath solution by developer during processing can result in the emission of toxic sulfur dioxide gas when sulfur-based chemicals are part of the bath's formulation.

Requires local exhaust ventilation, respirator (organic vapor cartridge), plastic or rubber apron, goggles, and plastic gloves during processing.

CITRIC ACID (concentrated)

Also known as beta hydroxytricarboxylic acid.

Skin contact: moderately toxic–may cause irritation
Eye contact: moderately toxic–may cause irritation
Inhalation: moderately toxic
Ingestion: moderately toxic

If heated to decomposition, can emit toxic fumes of carbon dioxide and carbon monoxide gases.

Requires local exhaust ventilation, dust mask, goggles, plastic apron, and rubber or plastic gloves during mixing. Requires local exhaust ventilation, safety glasses or goggles, plastic apron, and rubber or plastic gloves during processing.

Many of the chemicals in this process are toxic, and the precautions that should be taken include working in a properly ventilated space with local exhaust ventilation that efficiently removes the gases and fumes associated with the processing chemistries. It may be necessary to curtail or stop processing if the ventilation is not sufficient to remove these fumes.

The processing chemistry, if used in trays, needs to be located within a sink with an appropriate depth and with sufficient space around the trays to prevent contamination of the various processing baths and to minimize solution carryover. Drum processing is preferable to using open trays, and automated machine processing can be considered the best processing method.

SUMMARY

The chemicals involved in the color chemistries generally present greater hazards than many of those used in the black-and-white processes. The ability to substitute less hazardous chemicals is also restricted by the lack of detailed information about the chemicals used and the complexity of the chemical process itself.

Photographers who processes color images need to maximize the working environment's local exhaust ventilation and educate themselves about the chemicals that have been identified by manufacturers on labeling, through product literature and MSDSs. All of the procedures

outlined in Chapter 2 must be included as part of the information package associated with the color processes being used in the darkroom.

Whenever possible, commercial photo-finishing services should be used for processing color materials. These facilities tend to be automated, reducing contact with many of the hazards, and also tend to have ventilation systems that address many of the inhalation concerns. In situations in which photographers feel that control of the process is required—perhaps because of a quality-control issue—developing the proper working environment is a prerequisite to performing the work.

BIBLIOGRAPHY

HEALTH-RELATED INFORMATION

BDH Material Health and Safety Data Reference binders.

Canadian Centre for Occupational Health and Safety. CCINFO MSDA CD, Read-Only Memory Compact Disk.

CLARK, NANCY, THOMAS CUTTER, and JEAN-ANN MCGRANE, 1984. *Ventilation.* New York: Lyons & Burford.

DOULL, JOHN, CURTIS D. KLASSER, and MARY O. AMDUR, (eds.). 1980. *Caserelt and Doull's Toxicology, The Basic Science of Poisons.* 2d. ed., New York: Macmillian.

"D-23: An Old Friend Revisited." Sept. 1991. *Camera and Darkroom.*

Laboratory Health and Safety Handbook. Aug. 1982. Worker's Compensation Board of British Columbia.

*MCCANN, MICHAEL. 1985. *Health Hazards Manual for Artists.* New York: Lyons & Burford.

MCCANN, MICHAEL. 1992. *Artist Beware.* New York: Lyons & Burford.

Protecting Your Skin: The Causes and Prevention of Industrial Dermatitis. 1979. Worker's Compensation Board of British Columbia.

SAX, N. IRVING. 1984. *Dangerous Properties of Industrial Materials.* 6th ed. New York: Van Nostrand Reinhold.

SAX, N. IRVING, and RICHARD J. LEWIS. 1987. *Hazardous Chemicals Desk Reference.* New York: Van Nostrand Reinhold.

*SAX, N. IRVING, and RICHARD J. LEWIS, 1990. *Dangerous Properties of Industrial Materials.* 7th ed. New York: Van Nostrand Reinhold.

*SHAW, SUSAN D., and MONONA ROSSOL. 1991. *Overexposure, Health Hazards in Photography.* 2d ed., New York: Allworth Press.

*These books represent the next set of reference books to be consulted when attempting to locate additional information on other photographic processes or other health hazard–related topics.

Workplace Hazardous Materials Information System. Jan. 1989. B.C. Regulations 299/88, 258/88. Worker's Compensation Board of British Columbia.

Workplace Hazardous Materials Information System: WHMIS Core Material— A Resource Manual for the Application and Implementation of WHMIS. Jan. 1989. Worker's Compensation Board of British Columbia.

PHOTOGRAPHY-RELATED INFORMATION

ADAMS, ANSEL. 1981. *The Negative.* Boston: Little, Brown and Company.

DECOCK, LILIANE, Ed. 1990. *Photo Lab Index.* 41st ed. Dobbs Ferry, NY: Morgan and Morgan.

GLAFKIDES, PIERRE. 1960. *Photographic Chemistry.* 2 vols. Translated by Keith M. Hornsby. London: Fountain Press.

HAIST, GRANT. 1979. *Modern Photographic Processing.* 2 vols. New York: John Wiley and Sons.

"Home Processing." 1991. *British Journal of Photography Annual.* pp. 167–75. HORENSTEIN, HENRY. 1989. *The Photographer's Source.* New York: Simon and Schuster.

HUTCHINGS, GORDON. 1991. *The Book of Pyro.* Granite Bay, CA: Gordon Hutchings.

WALL, E. J., FRANKLIN I. JORDAN, and JOHN S. CARROLL, eds. 1975. *Photographic Facts and Formulas.* New York: Prentice-Hall and American Photographic Book Publishing Co.

OTHER SOURCES

ACTS FACTS, a newsletter published by Arts, Crafts and Theater Safety, 23-181 Thompson St., New York, NY. 10012.

A. M. Best Company, *Best's Safety Directory*, a directory of safety equipment and supply sources. Ambest Rd. Oldwick, NJ 08858; (908) 439-2200.

Art Hazards News, a newsletter published by the Center for Safety in the Arts, 5 Beekman St., 10th Floor, New York, NY. 10012.

OSHA Publications Office, Room N-3101, 200 Constitution Ave., N.W., Washington, DC. 20210.

Safety Supply Canada, 90 West Beaver Creek Rd., Richmond Hill, ON, L4B 1E7; (416) 222-4111.

SAFETY EQUIPMENT SUPPLIERS

American Optical Corporation, Safety Products Division, 14 Mechanic Street, Southbridge, MA 01550, (508) 765-9711.

Eastern Safety Equipment Company, 59-20 56 Avenue, Maspeth, NY 11378, (718) 894-7900.

Fisher Scientific Company, 711 Farbes Avenue, Pittsburg, PA 15219, (412) 562-8300.

Fisher Scientific Ltd. (Canada), 112 Colonnade Road N., Nepean, ON K2E 706, (613) 226-8874.

Lab Safety Supply Company, PO Box 1368, Janesville, WI 53547-1368, (800) 356-0783.

The Ontario Glove Manufacturing Co., 500 Dotzert Court, Waterloo, ON N2L 6A7, (519) 886-3590.

Safety Supply Canada, 90 West Beaver Creek Road, Richmond Hill, ON L4B 1E7, (416) 222-4111.

3M Canada Inc., PO Box 5757, London, ON N6A 4T1, (519) 451-2500.

3M Company, Occupational Safety and Health Division, 3M Center, St. Paul, MN 55101, (612) 733-1110

Veritas Incorporated, 4209 N. 64th St., Scottsdale, AZ 85251, (800) 247-9542.

Additional suppliers can be located in the A.M. Best Company Source *Best's Safety Directory* or *Directory of OH&S Suppliers* available from Margaret Nearing, OH&S Canada, 1450 Don Mills Road, Don Mills, ON M3B 2X7.

INDEX